A PRACTICAL GUIDE TO GRAPHICS REPORTING:
INFORMATION GRAPHICS FOR PRINT, WEB & BROADCAST

A PRACTICAL GUIDE TO
GRAPHICS REPORTING

INFORMATION GRAPHICS
FOR PRINT, WEB & BROADCAST

Jennifer George-Palilonis
Ball State University

AMSTERDAM • BOSTON • HEIDELBERG • LONDON
NEW YORK • OXFORD • PARIS • SAN DIEGO
SAN FRANCISCO • SINGAPORE • SYDNEY • TOKYO

Focal Press is an imprint of Elsevier

Acquisitions Editor: Amy Jollymore
Project Manager: Paul Gottehrer
Assistant Editor: Cara Anderson
Marketing Manager: Christine Veroulis

Focal Press is an imprint of Elsevier
30 Corporate Drive, Suite 400, Burlington, MA 01803, USA
Linacre House, Jordan Hill, Oxford OX2 8DP, UK

Recognizing the importance of preserving what has been written, Elsevier prints its books on acid-free paper whenever possible.

Library of Congress Cataloging-in-Publication Data
Application submitted

British Library Cataloguing-in-Publication Data
A catalogue record for this book is available from the British Library.

ISBN 13: 978-0-240-80707-2
ISBN 10: 0-240-80707-3
ISBN 13: 978-0-240-80708-9 (CD-ROM)
ISBN 10: 0-240-80708-1 (CD-ROM)

For information on all Focal Press publications
visit our website at www.books.elsevier.com

06 07 08 09 10 10 9 8 7 6 5 4 3 2 1

Printed in China

CONTENTS

ABOUT THE AUTHOR

JENNIFER GEORGE-PALILONIS became the journalism graphics sequence coordinator at Ball State University in 2001 after working as the deputy news design editor at the *Chicago Sun-Times* from 1999 to 2001 and as a news and business section designer at the *Detroit Free-Press* from 1996 to 1999. At Ball State, she teaches several upper-level courses in visual journalism, including a number of courses focused on visual editing and reporting. She is also the design and graphics adviser for the award-winning student newspaper, *The Ball State Daily News*, and is the faculty adviser for the student chapter of the Society for News Design. George-Palilonis also teaches courses in media convergence and multimedia graphics reporting. In addition to her work at Ball State, George-Palilonis is also a project director for Garcia Global Group, Inc., a media design consulting firm that has been responsible for more than 400 publication redesigns around the world. As a consultant, she has worked on the redesigns of more than 20 publications, including *The Portland Press-Herald* (Maine), *Crain's Chicago Business* and *The Harvard Crimson*. She has spoken at more than 25 design, education and editing seminars across the country and is the author of several design- and graphics-oriented pieces, including *Design Interactive*, an electronic textbook focused on basic design principles. George-Palilonis received her master's degree from Ball State in 2004 in Composition and Rhetoric and her bachelor's from Ball State's journalism graphics sequence in 1996.

ACKNOWLEDGMENTS

This book is, first and foremost, dedicated to my husband, Jim. No matter what sorts of obstacles I may face in life, the strength of our marriage is the one thing I *never* doubt. We have accomplished so much together. Without your love, support and complete devotion, I would have never finished this book. You are my inspiration, my heart, my whole world; and I could never adequately thank you for all you do for me.

Along with Jim, I dedicate this book to my sons, Quinn and Gage. Even as newborns, your strength amazes me, your beautiful faces leave me speechless. While my career will always be important to me, and while I will continue to reach toward new goals, nothing will ever mean more to me than your health and happiness. You are the most important, most amazing, most fulfilling accomplishment of my life.

I would also like to thank the rest of my family for your love, wisdom and guidance, not just now, but for a lifetime of support. To my mother, Jan, for teaching me how to be a successful wife, mother and professional woman. To my father, Jerry, for always encouraging me to strive toward excellence in everything I do, and thank you for continuing to love me, even when I pushed you to your limits. To my brother, Chris, for your generosity of spirit, your good-natured outlook on life and your enormous heart. To my sister-in-law, Kari, for being the sister I always wanted. And, to my beautiful niece, Taya, for keeping us all on our toes and for influencing our decision to have kids of our own. Thank God for all of you.

This book would also not be possible without the support, wisdom and guidance of my most cherished friends and mentors. Thanks to Angela for being the best friend anyone could ever hope for. You have loved and always will love me no matter what I do or where I land, and you mean so much more to me than you'll ever know.

Thanks to Ron Reason for bringing me along for the ride on so many exciting and challenging projects. I learn something new each time we work together. Thanks to Dr. Mario Garcia for presenting me with so many wonderful opportunities in our business. Over the years, you and your family have come to mean so much to me. Thanks to Deborah Withey for opening new doors for me very early in my career. Thanks to all of the amazing, talented and supportive journalists I have worked with, especially those at the *Detroit Free-Press* and the *Chicago Sun-Times*. And, thanks to Pamela Leidig-Farmen, Ryan Sparrow, Alfredo Marin-Carle, Lori Demo, Marilyn Weaver and the rest of the faculty at Ball State for both nurturing me as a student and later supporting me as your colleague.

I would also like to extend special thanks to all of my students, former, present and future, especially Miranda Mulligan. I learn so many new things from each of you with every semester. I grow with you, and I hope that I have influenced you the way so many others did for me.

Thanks also, to all those who contributed to this book, including J. Ford Huffman, Don Wittekind, Michael Price, Jeff Goertzen, Ron Reason, George Rorick, Angie Smith, Kris Goodfellow and Nigel Holmes. Your expertise lends credibility to my work, and your willingness to share your ideas strengthens our craft.

Finally, I would like to acknowledge that many of the materials that inspired this book were created by Michael Price as lecture tools and assignments used in the visual reporting course at Ball State University. Michael first developed this course in the early 1990s, and I took the course over when I replaced him as graphics sequence coordinator in 2001. The course continues to evolve with the industry but still rests on the foundation Michael established for it when he helped develop the journalism graphics program at Ball State, of which I am a graduate. His early work at Ball State helped establish our program as one of the country's finest, and for his dedication and commitment to establishing graphics reporting as a primary sequence of study, all of the program's graduates owe him a debt of gratitude.

A PRACTICAL GUIDE TO GRAPHICS REPORTING:
INFORMATION GRAPHICS FOR PRINT, WEB & BROADCAST

Mastering the Art of Visual Storytelling

As a visual journalist who also really enjoys writing, I have often said that information graphics reporting provides the best of both worlds. At once a "word" person and a "design" junkie, I have always been fascinated by the notion that the combination of words and visuals within a story package have an extreme impact on catching a reader's attention, keeping it and even ensuring that he or she retains the information much longer than when a story is provided in the form of words alone. Information graphics generally stimulate more brainpower because they appeal to both the literal and visual regions of the brain. Information graphics can tell stories with a degree of detail that is often otherwise impossible. Information graphics provide consumers with an incredibly rich "reading" experience. And, information graphics provide journalists with a powerful tool for telling a variety of different kinds of stories.

Although it is still a fairly specialized field, the development of Web technologies, new and better graphics software and a greater variety of media options has caused information graphics reporting to gain prominence in a variety of news organizations. Although newspapers and magazines have been making good use of information graphics for about 20 years, interactive, animated and 3D graphics are presented with more and more frequency on information or news Web sites and television news broadcasts. Regardless of the media format, information graphics serve an extremely important role in visual storytelling – a concept that has a profound impact on journalism in our increasingly visual culture.

GRAPHICS HISTORY

3800 B.C.: Assyrian maps on clay tablets exist.

 3000 B.C.: Egyptians develop the first 365-day calendar and use it to map the floodplains of the Nile. The hieroglyphic for "month" appears above.

2200 B.C.: Diagrams providing bird's eye views from Mesopotamian elevations exist.

540 B.C.: Greek philosopher Anaximander creates the first world map.

500 B.C.: Chinese etch maps in stone tablets.

200: Ptolemy maps the world's landmasses.

Mid-1200s: English scientist Roger Bacon develops multiple systems for examining abstract statistics in conceptual visual data displays.

Late 1400s: Leonardo da Vinci integrates diagrams with text in his notebooks.

History

People have been communicating through visual imagery for centuries. Before there were written words, there were pictographs, cave paintings and hieroglyphics. Archeological discoveries suggest that symbolic, iconic images used by the ancient Egyptians as a form of written communication represent the oldest forms of writing. Ancient cultures in China, Mesopotamia and the Americas also first used similar iconic systems before evolving native alphabets and modern written language systems.

Thus, information graphics have always been a part of civilized culture. And, as human knowledge evolved through the Renaissance and the ages of Enlightenment and Reason, so did the use of maps, charts and diagrams as a method for recording important scientific, economic and social data, and later, as a method for communicating important information related to news and current events to the masses.

From about the late 1800s through the middle of the 1900s, newspapers increasingly incorporated illustrations, charts and maps into the coverage of major news. With the invention of the linotype machine in 1886, typesetting became automated, allowing publishers and editors an opportunity to include more and larger graphics and illustrations in their newspapers. In fact, through both world wars, U.S. newspapers frequently employed the use of maps to help provide readers with important information about the status of the conflicts. And, during the 1960s and 1970s, charts and diagrams began to appear with some daily regularity in most American newspapers.

However, it wasn't until the proliferation of the Macintosh computer in the early 1980s that information graphics reporting became a prominent method for visual storytelling in most newsrooms. With the development of the Mac, as well as graphics software – some still in use, others now dinosaurs – the creation of detailed maps, charts and diagrams became much easier and more efficient on deadline. Newspaper page design and production was simplified, computer pagination was born and graphic artists were provided with more tools and editorial space to showcase their work and advance journalistic storytelling through the marriage of words and visual imagery.

Considered by many industry experts to be the catalyst for an

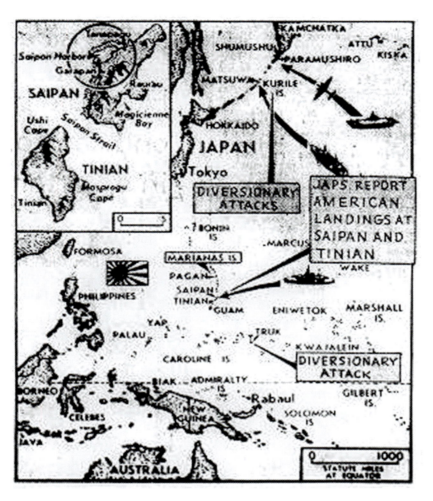

On Thursday June 15, 1944, The Birmingham News (Alabama) ran this rudimentary map explaining the U.S. attack on Japan and Tinian.

GRAPHICS HISTORY

1637: René Descartes outlines the "Cartesian Grid," a system of plotting points on a graph made of intersecting lines, called "coordinates." Descartes' contributions to geometry are the basis for contemporary charts and graphs.

1786: William Playfair (Scotland) publishes The Commercial Political Atlas, a collection of 44 statistical charts. One used bars to illustrate imports and exports.

1801 to 1805: Playfair publishes books that use circles to represent amounts.

1861: Charles Joseph Minard (France) plots the progression and recession of Napoleon's army through its invasion of Russia in 1812. Minard plots six variables, including size, location, direction, time and temperatures.

information graphics explosion that began to take place in the 1980s, *USA Today* was founded in September of 1982. Its editorial mission was simple: cater to the time-starved reader with tightly edited story packages in an entertaining and easy-to-read format. This meant shorter stories, innovative use of color and a multitude of maps, charts, polls and other color graphics in the place of the more traditional, long-form, text-driven stories common in most newspapers. At *USA Today*, editors viewed information graphics as equally, if not more, effective than word-driven story structures in conveying news and information in simple, easy-to-understand contexts for readers. According to Lori Demo, a former *USA Today* editor, "If the story starts to get too bogged down by explanation, it's

NEWSPAPER GRAPHICS

1875: The Times, in London, publishes first weather map.

1876: New York Daily Herald publishes first U.S. weather map.

Early to mid-1900s: During World War I and II, U.S. newspapers used maps to inform readers of the latest developments.

1930s: Large U.S. newspapers, such as the New York Times and Chicago Tribune use maps and charts more regularly.

1960s and 1970s: Most U.S. newspapers add charts and graphs to coverage of a variety of topics on a regular basis.

1980s: Advances in technology and software, as well as the creation of USA Today, a newspaper committed to graphics reporting, contribute to the information graphics explosion occurring at most American newspapers.

2001: The New York Times receives national attention for its use of maps and diagrams during coverage of the Sept. 11 attacks on the World Trade Center. Maps of blocked-off neighborhoods and damaged utilities, among others, were provided for readers just one day after the attacks.

time for a graphic." *USA Today* has continued to evolve this philosophy for more than 20 years, and many newspapers across the country have adopted similar formats.

Now, most newspapers across the country and around the world employ a number of information graphics reporters and editors, and many devote a considerable amount of space to information graphics, either as portions of larger story packages or as free-standing visual story displays.

Our Visual Culture

More than ever before, publications editors must be visually sophisticated to keep up with the visual demands of consumers. Ours is an increasingly visual culture in which consumers are daily faced with a barrage of options from which to obtain news and information. During the mid- to late1800s, technological development was rampant, and three advancements in particular prompted what photographer Lloyd Eby calls, "a profound change in human culture…taking us from a literary culture, based primarily on words and printing, to an increasingly image-based, or visual culture" (1999).

The first of these was the invention of photography in 1839. The ability to capture real-life still images was foundational for the development of visual storytelling in all forms of media. And, although then-publisher of the *Chicago Daily News* Melville Stone called it a "temporary fad," the *New York Daily Graphic's* first use of a photograph in 1880 set the stage for the positioning of photojournalism as an essential component to newspaper journalism. The second development that contributed to a shift in culture was Thomas Edison's invention of the "kinetoscope" in the early 1890s. This first motion picture camera is the foundation for the film industry that is such an integral part of our culture today. The third innovation was the invention of television. And, although the television wasn't actually invented until the early 1900s, work began in the late 1890s, and many consider it the single most culturally defining invention of the Twentieth Century.

As all of these media have evolved, and with more recent innovations like the World Wide Web, consumers are provided with a greater number of sources for information. And, in a time-starved society

filled with individuals looking for ways to make their lives more efficient, the process of "reading" has changed as well. After all, cable television provides us with hundreds of channels, several of which offer all news, all the time or special interest topics like history, art or science. Why spend hours reading when you can get a quick fix in full moving color on CNN or the Discovery Channel? The Internet provides us with more control over how we navigate news and information. Why spend too much time trying to find what you're looking for in print, when you can just "Google" it on the net? We have more access to information than ever before, and the consumption of visual messages is often faster and easier than reading.

Right about now, the avid writers in the audience are probably thinking, "Oh, great, you're telling me my skill is worthless!" But hold on. Relax. It's not that dramatic. Good writing is good writing, and by and large, people are still interested in that. After all, contrary to what some of the more panicked folks have said about certain inventions, radio did not replace books; television did not replace radio; and so far, the Internet has not replaced newspapers, magazines and other prominent forms of print media.

However, these innovations have and must change our approaches to the development and presentation of print media. For several years, newspapers in particular, have been looking for ways to increase visual appeal through both page design and graphics reporting. And, as mentioned before, information graphics, whether for print, broadcast or the Web, provide a method for simplifying complicated or numerically dense information, not only making it easier to understand but more palatable for the time-starved consumer as well. Thus, information graphics should be viewed as a way to better explain, enhance and complement written stories in news coverage, as well as a viable form of storytelling independent of text-driven stories.

The Role of the Graphics Reporter

Today, the organizational hierarchy of most newsrooms includes a "graphics" or "art" department that is home to any number of graphics reporters. In newspapers, this number is generally proportional to the circulation size and/or the number of graphics the

GRAPHICS RESEARCH

Eye-Trac Research
Conducted by Dr. Mario Garcia and Pegie Stark Adam on behalf of the Poynter Institute for Media Studies in 1991, Eye-Trac research examined how readers navigate a newspaper and what elements are most salient. Eye-Trac findings reflected some interesting implications for information graphics use in newspapers. Perhaps most significant was that readers tended to engage with more photos and artwork than text and headlines, indicating that visual elements act as main points of entry onto a page.

Dual Coding Theory
Developed by cognitive psychologist Allan Paivio in the 1970s, DCT proposes that memory consists of two separate but interrelated codes for processing information – one verbal and one visual. By integrating illustrations with text or elaborating on illustrations with explanations, the brain will encode information in both verbal and nonverbal forms, and memory is likely to be enhanced. Put simply, graphics stimulate more brainpower than words or visuals alone, leaving a greater impression on memory.

paper tends to run on a daily basis. In some cases, a graphics editor heads up this department, and in other cases, a design director is in charge of both graphics and page design. These editors then work closely with other department heads, such as the news editor, photo editor and feature editor to help plan and edit story packages for the daily paper. Many newspapers also employ graphics reporters for their Web sites, and some Web-based news organizations and wire services, such as MSNBC.com, employ graphics reporters dedicated to creating animated or interactive graphics packages.

Before addressing the specific responsibilities of the graphics reporter in a typical newsroom, it is important to note that while most people in the newspaper business use the terms "graphic artist" and "graphics reporter" interchangeably, I have deliberately chosen "graphics reporter." Certainly, both artistic and journalistic skills are equally important to the job. Just as a good news reporter must be capable of writing interesting stories, a strong graphics reporter must be capable of creating visually engaging illustrations. However, a graphic's merit should first be judged by its ability to advance a reader's understanding of a story or event through clean, clear and accurate presentation. Thus, a truly successful graphics reporter is a journalist first and an artist second. In other words, every artistic decision should be made with the information needs of the readers, the nature of the story and the clarity of the message in mind.

Graphics reporters' roles and responsibilities are, in many ways, similar to those of any other reporter. They engage in research for both the visual and textual elements of the graphic. They consult a variety of sources including, but not limited to, encyclopedias, almanacs, reports, documents and individuals who are experts in their fields. Graphics reporters often go out on assignment to gather information for their work. They often attend news meetings and work with other reporters, editors and photographers on developing story packages. And, they are inherently concerned with accuracy in reporting, ethical journalistic practices and serving as credible sources of information for the readers their publications serve.

However, the nature of precision differs a bit between a reporter who uses words as the primary form of expression and one who uses charts, graphs, illustrations and maps. A reporter who writes, for

example, makes use of precise and descriptive language in regard to events and scenes. A graphics reporter, on the other hand, has the unique ability to truly show what happened and how it happened. Diagrams can illustrate objects in direct proportion to their real counterparts. Thus, a graphic can show exactly "what happened," "when" and "in what order," "how much," "how close," "how far away" or "how to" in a much more realistic fashion than words. After all, would you rather read a paragraph that breaks down the racial makeup of the United States by percentage, or would you rather see it in a pie chart? In this and other cases, without the visual aid, the numbers become rather meaningless because they are more difficult to process in comparison to one another. And, sometimes, a graphic is also a more space-efficient way to provide that information.

So, a graphics reporter often asks different kinds of questions, searches for different kinds of reference material, and consults different kinds of sources than a reporter who writes. In many newsrooms, the graphics reporter is responsible for daily, deadline-oriented graphics, such as locator maps, charts and simple diagrams for breaking news stories, as well as more complicated, larger package graphics for future news and features stories. And, a savvy graphics reporter is one who is constantly looking for opportunities to present information visually by combing through the daily story budgets, talking to other reporters and editors about what they're working on and keeping an eye on the daily news wires, television and the Internet for potential graphic stories.

Spotting Graphics Potential

In his book, *The Visual Display of Quantitative Information*, Edward Tufte writes, "Graphical excellence is that which gives to the viewer the greatest number of ideas in the shortest time, with the least amount of ink in the smallest amount of space." This notion is also referred to as the "data-ink ratio." In other words, the best graphics are the ones that provide a ton of information in a small amount of space or using the least amount of ink. Even though this concept may seem quite simple, it actually takes quite a bit of forethought and planning to develop an effective graphic or graphics package. Graphics should be overly researched, clearly illustrated,

concisely written and inherently relevant to readers' lives.

Thus, the graphics reporter's responsibilities shouldn't begin with illustration. Spotting graphics potential in a story is, perhaps, one of the most important responsibilities of the graphics reporter; and ideally, conversations about whether a specific story warrants graphic support should occur as the story is developing, not after it's complete. Now, if you don't know this already, you'll soon find out that in a newsroom, the ideal is not always so easy to come by. Deadlines, breaking news and sometimes a simple breakdown in communication often prevent a graphics reporter from getting in on the planning and development of a story in its early stages. So, in most settings, graphics reporters should be prepared to assess graphics potential on two levels: (1) early in the story development process, before the story is written, and (2) after the story is finished and ready to run.

The first scenario requires that a graphics reporter be on her toes, aware of the stories that other reporters are working on and ready to contribute to the reporting process. You can't expect that a reporter or editor is always going to alert you as to what stories are coming up that may need graphic support. Although, more and more, reporters and editors on the "word side" are getting better and better at spotting graphics potential in their stories, and many of them have been trained to do so, they often have too many other responsibilities and are dealing with their own deadlines to follow through with this part of the process. A reporter's primary concern is writing a story, and graphics are sometimes an afterthought. This is where a strong graphics reporter can really make a difference in the reporting process.

If you're a graphics reporter, get to know the other reporters in the newsroom. Let them know that you want to be kept informed about what they are working on. Offer to take some of the reporting burden off their plates by helping track down information for story packages that may be better displayed in graphic form. Ask them to share any materials they gather during the reporting process that could be used as reference material for graphics. Stop by their desks regularly, and find out what they're working on for today's deadline as well as any advance stories or special investigative or news features coming up. Establish yourself as a fellow journalist interested

in enhancing the story as opposed to an artist who is more concerned with making things look good. Don't be afraid to ask questions about the story and make suggestions for improvement. I have found that most reporters appreciate having a sounding board for their work, and if nothing else, most reporters are happy to have help ironing out the more visual elements of the story.

Of course, you should also plan how you will approach the reporter. Make sure that you avoid dropping by when a reporter is right in the throes of a tight deadline. And, always be sure your attempt to help doesn't come off as a chance to interfere or impede the reporting process. Your goal should always be to help move the story forward, not backward. Some organizations formalize this process by establishing a regular meeting among designers, graphics reporters, photographers, reporters and copy editors in a specific department. Planning meetings offer these groups a chance to get together and brainstorm ideas, share information and find ways to enhance stories on all levels. It also puts each decision about the story in the hands of the person who's best qualified to assess its potential in a given area. Let photographers determine what would make a great picture. Let designers contribute to developing the overall presentation of the story package. And, let graphics reporters determine the graphics potential for a story coming up at a later date.

Sometimes, however, in a deadline-oriented situation, it's not realistic to think that there will always be time for leisurely water cooler banter about what stories we're working on or formal brainstorming meetings where everyone shares until they're blue in the face. In fact, more often than not, deadlines alone inhibit us from always having the time to plan for tomorrow's news. So, in this scenario, a graphics reporter must become good at analyzing a story that has already been written for its graphic potential and quickly determining what types of visual elements can best advance or complement the story. In this case, a graphics reporter must walk a tightrope between the amount of time he can devote to a graphic created on deadline and the amount of illustrative detail the graphic can exhibit. Obviously, the more time you have, the more extensive and detailed the graphic can be. But, regardless of whether a graphic is planned in advance or developed after the story has been writ-

VISUAL CUES FOR GRAPHICS REPORTERS

You can often determine whether a graphic should accompany a story by simply looking for certain words and phrases in the story itself. If a story contains any of the words and phrases listed below, it may be time to introduce an information graphic to the presentation.

NUMERICAL CHARTS
– Amount(s)
– Taxes
– Budget
– Figures

MAPS
– An address
– Escape routes
– Expansion
– Police chase
– Trail of crime

DIAGRAMS
– How to
– Expansion
– Reorganization
– Organization

TABLES
– Key players
– Pros and cons
– Who's who
– The victims
– Schedule
– Key points

TIME LINES
– Chronology
– Key dates
– Looking back
– Looking ahead
– What's next?

ten, the same types of exercises should be used to determine a story's graphics potential.

LOOK FOR VISUAL CUES WITHIN A STORY, and propose a graphic when the answers to the questions who, what, when, where, why or how are visual. Sometimes this means paying close attention as a reporter or editor is describing the story, always listening for words, phrases and concepts that suggest a graphic. This could also mean carefully scanning a story that has already been written for words, looking for numbers and descriptions that set off visual signals in your head. This may even mean searching for holes in the storytelling: What pieces were overlooked or missed because they don't lend themselves to verbal descriptions but are better served through visual devices?

SIMPLIFY COMPLICATED INFORMATION. Specific numbers, visual descriptions of objects or events and identifiable locations don't always jump out, and a graphic may not always present itself right away. A good graphics reporter will often discover graphics potential in less obvious ways. Is the explanation in a story getting bogged down and hard to follow? If so, can the information be organized differently? Perhaps in a more graphic manner? Is there information that can be conveyed conceptually to put a thought or idea into a more visual perspective? Visual metaphors (or "data metaphors" in the case of mathematical or quantifiable information) often make it easier for people to digest information.

LOOK FOR COMPARISONS, DATES OR OTHER ORGANIZATIONAL FACTS outlined in the story. Who are the key players, and why? What are the key dates? How did we get here? Where do we go from here? What's at issue, and what does it mean for the reader? These types of questions often lead to discovering graphics potential for a story, and by presenting the answers in a graphic manner, you provide readers with a quickly accessible and easily understood context for the rest of the story.

DO YOUR OWN RESEARCH. After reading a story, talking with a reporter or attending a planning meeting, dig a little deeper. Find your own sources, both textual and visual. Ask your own questions.

Graphics don't always have to come directly from the story. Often, they can serve as visual sidebars that not only enhance the story, but build on it as well.

KNOW WHEN TO SAY "NO." I have been involved in so many discussions that involve a graphics reporter trying to convince another member of the newsroom that, in fact, a graphic is not appropriate for a particular story. You must make sure that all of the necessary information is present or obtainable for the creation of a graphic, and you must put a stop to graphics that merely state the obvious, are a waste of space or actually complicate the story.

LEARN TO ARTICULATE YOUR IDEAS for graphics in a thoughtful and thorough manner. If your primary job is to simplify complicated information, then you have to be able to articulate your ideas in layman's terms as well. Try explaining the point of your graphic in five words or less. For example, "how blood flows through the heart." (Okay, that's six words, but you get the point!) Make sure your description contains a subject and an active verb. Get to the point quickly. If you can't, chances are your graphic isn't focused enough yet.

The Visual Editor

Chapter Three will deal more extensively with writing, editing and reporting for information graphics, but it's important to note that visual thinking and visual editing can come from anywhere in the newsroom. Spotting graphics potential is not the sole responsibility of the graphics reporter, and all reporters and editors should work toward enhancing visual editing skills. You don't need to be able to illustrate or even use graphics software to think visually. It just takes a clear understanding of some basic graphics principles and a willingness to approach stories from a visual perspective.

GRAPHICS SHOULD BE PLANNED, WRITTEN AND DEVELOPED TO STAND-ALONE. Even when a graphic is accompanied by a story, we can't always count on the reader to get that far. Scanning readers often don't engage with stories at all. Rather, they browse the page, often reading only display type and visual elements. And, even those who

intend to read the story often engage with the graphics first because they tend to be more eye-catching. In both cases, you simply can't create a graphic that isn't complete without the story. Readers should finish an information graphic feeling confident that they understand the information it presents. This isn't to say that you must tell the entire story with the graphic. However, the portions of the story that are represented in the graphic must be complete and clear.

UNDERSTAND THE INFORMATION. There's nothing worse than a reporter who hasn't taken the time to personally make sense of the information. All visual editors and reporters should make certain that they completely understand the information to be displayed in the graphic before attempting to execute the graphic. If you don't get it, how can you possibly explain it to a reader?

MAKE USE OF A SIMPLE DATA METAPHOR. Regardless of the concept you are trying to convey with an information graphic, you must make sure that the visual metaphor (i.e., a circle to represent a whole, as with a pie chart) be clear and logical. Don't get so caught up in being clever that you make illogical comparisons or use unclear metaphors. In other words, don't make your readers have to think too hard to get the point. They'll appreciate you for it!

Hiring strong visual thinkers and visual editors has become a priority for all kinds of publications, and many newspapers in particular have recognized a vested interest in increasing not only the number of information graphics they publish, but the number of reporters and editors in the newsroom who can write, edit and design from a more visual perspective. Good visual editors understand how to articulate ideas graphically, "sell" graphics ideas to others in the newsroom and understand the journalistic function of information graphics in storytelling. And, visual editors/reporters and word editors/reporters who work together can provide an extremely rich reader service by developing story packages that tap a variety of storytelling methods.

In the Eyes of an Expert

What is your philosophy of visual storytelling?

Tell your story in whatever form makes sense.

What was it like to be one of the founding members of the USA Today *staff?*

Those were 70-hour weeks in which you couldn't turn back and say, wait a minute, putting out a national newspaper is too hard, so let's not do it anymore.

What was the driving philosophy for graphics reporting at the time in that newsroom?

I was involved in the overall design during first prototype editions a year before start-up. During the start-up, Managing Editor for Graphics and Photography Richard Curtis was the force behind the figures. I believe he saw the possibility that *USA Today* could make reading easier for readers by telling information visually. It must have worked. The paper averages six million readers a day.

How has graphics reporting at USA Today changed in the past 20 years?

I left six months after the start-up (in 1982) and came back to *USA Today* 17 years later (in 1999) when I believed they would have all the kinks worked out. They didn't. *USA Today* has the reputation for being graphics-minded but after being around for 20 years, the product didn't always reflect the reputation. There's been a renewed emphasis on getting back to our roots but in a more sophisticated way.

What's the graphics reporter's role in the newsroom? What makes for a strong graphics reporter?

Everything that makes a good reporter of any kind: curiosity, varied interests, writing skills, creativity, math skills and the ability to find facts even when they're not obvious. Plus? A strong visual sense.

J. FORD HUFFMAN

Deputy Managing Editor, USA Today

As deputy managing editor, graphics and photography, Huffman's responsibilities include Page One art direction and design. He was on the committee that developed the first prototypes of USA Today in early 1981 and was a content editor in the Life section at the start-up in September 1982. He was also on the "New Media Task Force" exploring online platforms for Gannett in 1984 and returned to USA Today in August 1999. Before returning to USA Today, he was managing editor for features, graphics and photography for the 40,000-graphic Gannett Graphics Network, at Gannett News Service for 13 years. He has visited more than 50 Gannett newsrooms to advise on presentation and content, including Gannett's Military Times newspapers, which were redesigned in 1999.

What's the greatest challenge most often faced by graphics reporters?

1. Working with staffers who believe graphics are what you do if the story comes up short or the layout needs brightening.
2. Time, space, execution. But every news staffer has the same foes. So, just do it!

Can you offer some tips for spotting graphics potential in a story?

Think of the graphic as a visual sidebar.
Think of a graphic as the place for context.
Then find the hints in the copy: numbers, totals, comparisons and trends.

What are some of the most common mistakes made by graphics reporters?

Not seeing themselves as equal players in the newsroom. Being afraid to edit.

How do you recommend training "word" people to be better visual editors for graphics?

Tell them about context. Graphics are just visual context. They explain your story and they allow your story to be free of lots of mindless numbers. If you get the numbers out of your story, there's more room for poetry.

Who do you think are among the best newspaper and magazine graphics staffs? In other words, who's doing it well; who's leading the way?

Anybody who thinks of an idea, who gets that idea into the paper, who gets one more reader to understand one more story: These are my heroes, whether they're at a major metro or at a community daily.

Could you offer five tips to all graphics reporters?

1. There are figures to be found. Keep asking. Use resources, such as the library. Dealing with a graphic-less reporter? Ask the reporter how he can write about a trend if there are no statistics to back up that trend.

2. Graphics give context to content.

3. The best graphics are the concise ones. I learned that from John Monahan (formerly at Gannett News Service and The Associated Press).

4. Readers look at the graphic before they look at the story. Stories accompany graphics, and not vice versa. Make sure the graphic is written well. Edit needless words.

5. The best writer-reporters are the ones, in my experience, who also are most concerned about telling part of their stories visually, via graphics.

Chapter One Exercise

Read the story that follows and then complete the provided graphics potential analysis form. Search for visual cues in the story and answer the questions provided on the form to help develop a visual focus for the story package.

Public schools across the country face an ironic dilemma. On one hand, principals and superintendents are being forced to allow classroom sizes to increase as a result of cutbacks in tax dollars for teachers' pay and educational materials, causing some classrooms to reach enrollments of 30, sometimes 40 students per teacher. On the other hand, these same principals and teachers often blame larger classroom sizes as one of the leading obstacles to giving individual students the attention they need to pass their classes.

One fairly recent answer to this problem has been the creation of alternative school classrooms, geared to assist students who are falling between the cracks, so to speak, because of behavioral problems or learning disabilities. Most alternative classrooms cut the student/teacher ratio down to 10 to one, giving teachers the opportunity to spend more time with each student and students the opportunity to receive more intense tutoring in the courses with which they struggle.

Bill Jones, the principal of Market Elementary School, says many of his teachers face class sizes of 40-45 students. "It's not fair to any of the kids, or the teachers for that matter," he said.

"But, schools everywhere have a hard time fighting it when they can't pay enough teachers to even out the numbers."

Yet, in spite of the increasing demand for alternative schools, if push comes to shove, they may be the first programs to go if the schools aren't given specific financial support to keep them alive.

Aside from a few small grants from large foundations dedicated to advances in education, little to no financial support exists for schools that want to create alternative classrooms. Now, those schools are forced to devote a considerable amount of money from their general funds each semester to pay for them.

Furthermore, if school districts don't perform well enough on the new yearly tests mandated by President Bush's education package passed late last year, they risk losing the federal tax dollars they already receive.

According to Delta High School alternative school teacher Brad Himes, smaller classrooms often deter students from misbehaving. "In the alternative school, there's no audience for students who don't want to follow the rules," he said. "Kids who cause trouble often do so because they are looking for attention. In my classroom, they're already getting more attention than they know what to do with."

However, as Indiana schools take steps to implement reform measures outlined in Bush's plan, many principals and superintendents are left wondering how to pay for programs that address their most pressing issues. Add to that Bush's commitment to a $1.6 trillion tax cut and war in the Middle East, and these same principals begin to question what kind of a future alternative education will have.

Patrick Mapes, Delta High School principal, has devoted a great deal of his school's time and money to building an alternative classroom that serves 28 students at a time, 14 in a morning session and 14 in the afternoon. He says the alternative classroom is absolutely essential to ensuring the best opportunity of graduation for many of his students.

"There are enough kids who have trouble succeeding in the traditional classroom to make this a priority," he said.

"Some of them have gotten so far behind that they have to be given special attention. Some have kids of their own and are struggling to support them. Without the alternative school, they likely would not make it."

For Jim Smith, an 18-year-old junior from Delaware County, the alternative school was a second chance to graduate on time. "I came here to see what it's like to get away from people…to be less distracted," he said. "I wanted out of my school because I am way too distracted and couldn't or didn't want to learn anything. I'm in trouble. Here, it is easier to stay out of trouble and keep on task."

According to U.S. Department of Education statistics, of the country's 14,859 school districts, 5,800 sponsor an alternative school program, and those numbers continue to grow each year.

Delaware and Randolph counties are not the only school systems in the state or the country using alternative classrooms to reach struggling students. In 2002, the Indiana Council of Administrators of Special Education reported that five to 15 percent of students in Indiana are considered "at-risk" because they have trouble succeeding in a regular classroom, and "many of these students require special, individual intervention."

This trend is also reflected nationwide. In its 2001 statistical analysis report, 85 percent of the school systems in the United States that reported sponsoring an alternative school cited large classroom sizes as one of the leading factors that make the alternative classrooms necessary.

Chicago, Los Angeles and Philadelphia are just a few of the nation's larger cities whose school systems have opted to pay for alternative schools as a way to retain students without jeopardizing the quality of their education.

When asked what will happen to alternative schools if the question of how to pay for them isn't addressed soon, Mapes' answer is simple: "They'll be cut. Math, science and social studies won't go. Of course they won't," he added. "If you have to start looking for ways to cut back, it's the extras that will go, like the gifted and talented programs and the alternative schools."

Himes says he, too, is worried about where the money needed

to pay his salary and support the program will come from. However, he's a bit more optimistic about the community's commitment to keep the programs going.

He says that because Bush's plan stresses increased graduation rates, schools will need alternative schools even more. "Realistically, I don't worry about there not being a need for alternative schools," he said. "It's not the trend. Society knows that it has to find a way to keep these kids in school, and it will."

Still, Himes admits that these programs could fail, even in the face of high demand. "These programs could fall apart due to the financial dynamics. But I have to believe that because there's such a huge need, society will find a way to make it work."

Graphics Potential Packaging Form

USE THIS FORM to help determine the graphics potential for news, features or sports stories. Answer the following questions to find the visual focus for a story package, and fill in the requested information to help brainstorm ideas for your graphics strategy.

STORY NAME: _____ PUBLICATION: _____

GRAPHICS POTENTIAL

What are the three most important points of this story? Why should the reader care?

 a.

 b.

 c.

What are some possible headlines for this story?

 a.

 b.

 c.

Does the story refer to comparisons, breakdowns, trends, how to, how much, numbers, a time series or other concepts that can be illustrated? If so, outline the key points of those references.

 a.

 b.

 c.

 d.

 e.

GRAPHICS STRATEGY

Check the types of graphics that apply to your story, and give a short, one-sentence description of how:

☐ Pie chart: _____

☐ Bar chart: _____

☐ Fever/Line chart: _____

☐ Table: _____

☐ Timeline: _____

☐ Diagram: _____

☐ Map: _____

Multimedia Storytelling: How Different Media Use Graphics

Print publications such as newspapers and magazines have, in many ways, pioneered the field of information graphics reporting. And, as technology and software continue to improve, so do the methods graphics reporters use to create visual story packages. In recent years, information graphics have begun to evolve beyond the traditional print format, as newspapers, television stations and other news organizations have begun to make better use of the multimedia storytelling capabilities of the Web. Additionally, with improvements in 3D and animation graphics software, such as Newtek Lightwave and Macromedia Flash, information graphics for broadcast, Web and even print have become more visually rich and realistic.

Regardless of the format, many of the basic rules for creating effective information graphics remain unchanged. Subsequent chapters will address these principles and combine them with more detailed descriptions of the various types of information graphics used in news reporting. However, before we go there, it's important to address some of the driving philosophies behind how different media use information graphics in news coverage. Obviously, some fundamental differences do exist. After all, an information graphic in a newspaper isn't likely to start dancing and spinning around the page, but this is a distinct possibility for broadcast or Web graphics.

The ways in which the audience consumes and navigates an information graphic is different depending on what form the delivery mechanism takes (i.e., newspapers, Web sites, TV broadcasts). And, in an industry saturated with talk of

media convergence and cross-platform partnerships, it's increasingly important for graphics reporters to understand these differences. In fact, a number of agencies are beginning to employ graphics reporters who are able to create graphics for print, Web and broadcast, and knowing the different software programs is only half the battle. Becoming a well-rounded graphics reporter also means understanding the driving philosophies behind graphics reporting for each media format and then knowing how to apply the appropriate software and basic graphics knowledge to each.

All types of journalists frequently talk about defining the audience as a means for determining the proper presentation approach for a story. Of course, when you're talking about *mass* media, you're essentially targeting *all* people in a given community or society with your publication. But, as journalists, we know that some stories are more interesting to certain types of people based on location, sex, race, age, culture, community or other demographic characteristics. And, different types of people may engage with the media differently depending on some of those characteristics. Likewise, while print, broadcast or online media generally target the same individuals with their news content, the ways in which those individuals navigate and consume different types of media are varied primarily because the nature of each format is quite different. Thus, recognizing the strengths and weaknesses of a particular format, as well as defining the ways in which a consumer will generally engage with it, is essential to developing an effective information graphic.

Print Graphics & News Coverage

For years, information graphics have played a significant role in journalistic storytelling for newspapers, magazines and other print publications. Charts, diagrams and maps provide print journalists with an opportunity to enhance traditional story packages with graphics that serve both a visual and explanatory function. Information graphics, such as simple charts and maps, are often more space efficient and more quickly understood at a glance than the written word. And, although photographs are often most effective at capturing a moment, an information graphic is better suited for serving as a visual play-by-play of an event. When used in break-

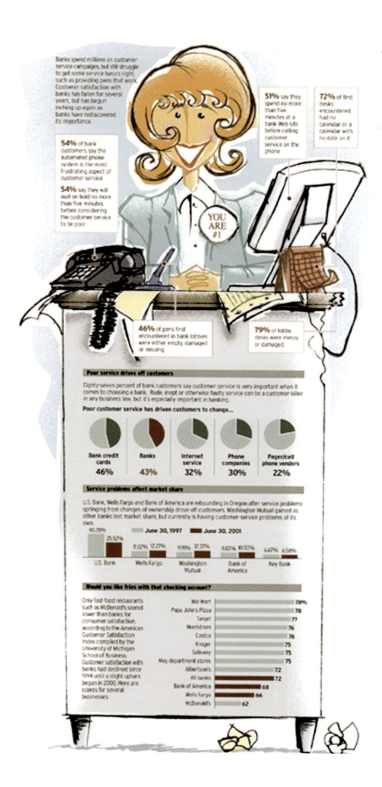

Perhaps the most common types of information graphics found in print publications are statistical charts. Pie, fever and bar charts provide journalists with an effective method for simplifying complicated information by using a visual data metaphor (i.e., a circle to represent a whole or variations in length to represent importance) to convey a comparison, breakdown or trend. This illustrative graphic from The Oregonian uses diagrammatic and chart-based references to present a number of complicated statistical facts in a simple, easy-to-read and understand format.

Graphic by Derrik Quenzer. Copyrighted The Oregonian. All rights reserved. Used with permission.

ing news coverage, information graphics can often take us where photos cannot and explain events when words are insufficient. In fact, coverage of breaking news events such as the Columbine (Colorado) High School shootings (1999), the tragic deaths of public figures such as Princess Diana (1997) or John Kennedy Jr. (1999) or major air disasters like the crash of Airbus A300 (2001) in New York or the Concorde Jet in Paris (2000) is, in many ways, driven by visual devices. The presentation of photographs and information graphics can both convey the impact and importance of a story, as well as relay a more immediate degree of emotion than other forms of storytelling. And, graphics in particular can serve a significant explanatory function for stories that require an efficient account of moment-by-moment details of how a particular event unfolded.

However well planned, an effective information graphic does not make itself. Even the simplest of charts can take a great deal of time and planning on the part of a graphics reporter, particularly if there are a great deal of numbers or statistical data that need careful analysis and understanding prior to determining the presentation method. Additionally, print journalists are often under extremely tight deadlines, especially in breaking news situations, and it's not always possible to create the most highly illustrative, highly detailed graphics on daily deadlines. Thus, graphics reporters must balance time and talent with the amount of visual detail they are able to put into a graphic.

Print graphics reporters must also always remember that one slight and even unintentional distortion of the information not only renders the graphic completely useless, but also renders the reader thoroughly confused and misled as well. Furthermore, when editing a graphic after it has been created, a copy editor may not always know that a numerical or illustrative mistake has been made. They are, in fact, difficult to detect if the original information from which the graphic was developed isn't readily available. The deadline structure alone of most newsrooms may not lend itself to a thorough review of all of that information in conjunction with the copy-editing process. Thus, graphics can be easily distorted and consequently can become a burden to the story instead of an asset. Graphics reporters must always make sure they understand the information at hand before attempting to synthesize it into graphic form for read-

A tour of Chicago's Millennium Park

By Haeyoun Park, Phil Geib, Chris Soprych and Dino Muñoz

Chicago's long-awaited Millennium Park officially opens Friday, six years after Mayor Richard Daley first proposed it. Daley envisioned the 24.5-acre park as a way to welcome the 21st Century and solidify the "City in a Garden" image set forth by the city's original founders in 1837. To refuel Chicago's reputation for architecture and culture, the city commissioned artists from all over the world to piece together the $475 million addition to Grant Park.

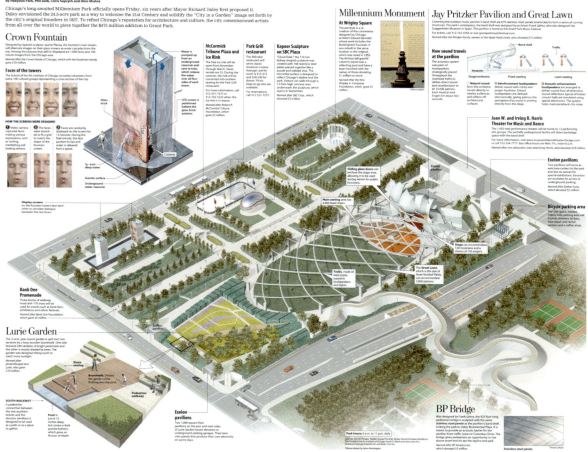

ers, and then take care to develop the organization of information in a way that promotes understanding rather than confusion.

The layout of a print graphic can also impact the audience's ability to clearly understand the information. In Western culture, we have been trained to read from left to right, top to bottom when we interact with a print publication, and readers generally follow this pattern when visually navigating information graphics as well. In fact, because this pattern is so embedded in our natural reading habits, a strong print graphic is one for which the organization of elements complements this natural eye movement. Additionally, a reader will often enter a graphic through the most eye-catching por-

▲ Newspapers sometimes allocate as much space to graphics as they would a primary story. When Millennium Park first opened to the public, the Chicago Tribune ran this map/diagram on two full broadsheet pages.

Graphic by Phil Geib, Chris Soprych and Dino Muñoz. Copyrighted 7/15/2004, Chicago Tribune Company. All rights reserved. Used with permission.

GRAPHICS SOFTWARE

Newtek Lightwave and Strata

Best known for their use in the creation of 3D video game graphics, Lightwave and Strata are tools for illustrating and modeling 3D imagery. Print graphics reporters began experimenting with 3D software in the late 1990s as a method for creating richer, more realistic looking newspaper and magazine graphics. Lightwave and Strata also include animation functions that allow a graphics reporter to put 3D illustration models into full motion for the Web and broadcast. The production process is lengthened quite a bit when 3D software is used because the rendering process (commanding the program to convert an illustration from its original vector-based model to the final 3D image) can be quite time-consuming.

tion, which is usually the illustration or visual data metaphor. Thus, the placement of elements in relation to one another is extremely influential in terms of what order and path the reader will take in reading the graphic and textual elements. (Chapter Five, "Designing Information Graphics," will address the specifics of this concept for all types of graphics in greater detail.)

Likewise, print graphics reporters must also consider how their graphics will be presented in conjunction with the other story elements on a page. Although more and more, some newspapers and magazines are allowing information graphics to serve as independent story forms, more often than not, print graphics appear together with other story elements, such as written stories, photographs, headlines and other kinds of display type. Therefore, a graphics reporter must understand that a reader's navigation of a print graphic will also be affected by the context in which it is presented. Graphics could be secondary visual elements in a news package or dominant visual elements, and depending on how much visual weight a graphic holds on a page, it may be one of the first elements a reader is attracted to. Thus, all graphics must be written and designed to stand alone, regardless of whether they will appear alone or within a story package. Readers should come away from a graphic with a clearer understanding of what the story is about. They *should not* come away from a graphic feeling more confused or asking more questions than they did before they started. Finally, space is definitely a hot commodity in newspapers and other types of print publications. Thus, print graphics reporters must always be aware of the amount of space available for their graphics. There is a fine line between trying to cram too much information into too small a space and not providing the reader with enough valuable information in too large a space. Balancing these concepts in graphics reporting isn't always easy. But, a space-efficient graphic is one that presents the most amount of information in the most organized manner in the least amount of space.

Sept. 11, 2001: A Case Study

Undoubtedly the single, most shocking news event to happen on American soil, the terrorist attacks of Sept. 11, 2001, immediate-

ly represented a profound challenge for print publications around the world. American journalists, in particular, were at once trying to cope with the devastation of the attacks, as well as serve their readers and provide accurate, in-depth coverage of the news as it developed for days after the attacks. Hundreds of maps of the cities under attack and the routes of the crashed planes, diagrams of the Twin Towers and Pentagon buildings and time lines of the days leading up to and on 9/11 were created by hundreds of newspapers and magazines as a method for helping readers understand what happened.

However, perhaps the most effective and impressive of these were the information graphics developed by *The New York Times* just one day after the attacks. Awarded "Best of Show" among more than 14,000 entries in the 2001 Society for News Design (SND) annual contest, *The New York Times'* attack graphics provided readers with an incredible amount of detail and clarity at a time when New Yorkers – *Times* graphics reporters included – and Americans were desperately trying to make sense of what had happened. In the twenty-third edition of *The Best of Newspaper Design*, SND contest judges wrote, "The work was done under stress and personal hardship but stands on its own merits.… The newspaper's graphics offered a wealth of useful information to its readers. Each graphic was a powerful tool and fulfilled the reader's need for updated information about downtown Manhattan following the tragic events of 9/11."

The New York Times' 9/11 graphics coverage chronicled the damage and destruction around the World Trade Center. Maps offered locations of medical and civic services and time lines of the simultaneous flight paths of the four planes. Diagrams provided information about where companies were located on each floor of the Twin Towers and how many people were killed on each, as well as how and why the towers collapsed, why excavating the site was so difficult and the extent of damage to surrounding buildings. All of this information was presented within days of the attacks. And, later, as more information became available, the newspaper continued to offer tightly edited but extremely comprehensive graphics showing the sequence of events that led to the collapse of the towers and the change in the New York landscape after the dust had cleared.

These graphics are a haunting, yet impressive example of how information graphics in print news coverage not only advance sto-

GRAPHICS SOFTWARE

Adobe Photoshop
Photoshop is a design and digital imaging program. Graphics reporters often use Photoshop as an illustration tool when they are seeking a richer, photo-quality appearance for their graphics. Photoshop is a raster program, meaning it constructs what you see by using pixels. When you enlarge the picture, the pixels, or dots, get larger as well, and you risk losing sharp edges. Thus, it is best to make the illustration the exact size you plan to run because you will be limited in how much sizing you can actually do. It is also not advised to set type in Photoshop because it will be less crisp in a pixel format. Rather, set the type for the graphic in either a vector program or a page design program, such as In-Design or QuarkXPress.

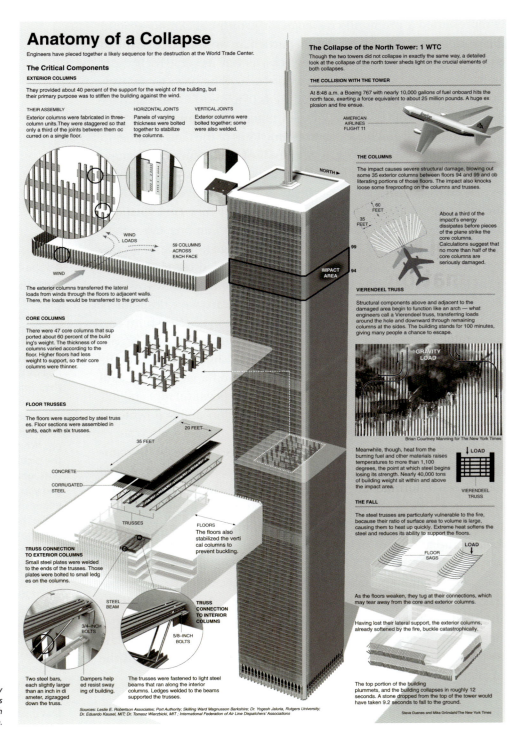

Anatomy of a Collapse

Engineers have pieced together a likely sequence for the destruction at the World Trade Center.

The Critical Components

EXTERIOR COLUMNS

They provided about 40 percent of the support for the weight of the building, but their primary purpose was to stiffen the building against the wind.

THEIR ASSEMBLY
Exterior columns were fabricated in three-column units. They were staggered so that only a third of the joints between them occurred on a single floor.

HORIZONTAL JOINTS
Panels of varying thickness were bolted together to stabilize the columns.

VERTICAL JOINTS
Exterior columns were bolted together; some were also welded.

WIND LOADS

59 COLUMNS ACROSS EACH FACE

WIND

The exterior columns transferred the lateral loads from winds through the floors to adjacent walls. There, the loads would be transferred to the ground.

CORE COLUMNS

There were 47 core columns that supported about 60 percent of the building's weight. The thickness of core columns varied according to the floor. Higher floors had less weight to support, so their core columns were thinner.

FLOOR TRUSSES

The floors were supported by steel trusses. Floor sections were assembled in units, each with six trusses.

20 FEET

35 FEET

CONCRETE

CORRUGATED STEEL

TRUSSES

FLOORS
The floors also stabilized the vertical columns to prevent buckling.

TRUSS CONNECTION TO EXTERIOR COLUMNS

Small steel plates were welded to the ends of the trusses. Those plates were bolted to small ledges on the columns.

STEEL BEAM

3/4–INCH BOLTS

5/8–INCH BOLTS

TRUSS CONNECTION TO INTERIOR COLUMNS

Two steel bars, each slightly larger than an inch in diameter, zigzagged down the truss.

Dampers help ed resist sway ing of building.

The trusses were fastened to light steel beams that ran along the interior columns. Ledges welded to the beams supported the trusses.

Sources: Leslie E. Robertson Associates; Port Authority; Skilling Ward Magnusson Barkshire; Dr. Yogesh Jaluria, Rutgers University; Dr. Eduardo Kausel, MIT; Dr. Tomasz Wierzbicki, MIT; International Federation of Air Line Dispatchers' Associations

The Collapse of the North Tower: 1 WTC

Though the two towers did not collapse in exactly the same way, a detailed look at the collapse of the north tower sheds light on the crucial elements of both collapses.

THE COLLISION WITH THE TOWER

At 8:48 a.m. a Boeing 767 with nearly 10,000 gallons of fuel onboard hits the north face, exerting a force equivalent to about 25 million pounds. A huge explosion and fire ensue.

AMERICAN AIRLINES FLIGHT 11

NORTH ▶

IMPACT AREA

THE COLUMNS

The impact causes severe structural damage, blowing out some 35 exterior columns between floors 94 and 99 and obliterating portions of those floors. The impact also knocks loose some fireproofing on the columns and trusses.

60 FEET

35 FEET

99

94

About a third of the impact's energy dissipates before pieces of the plane strike the core columns. Calculations suggest that no more than half of the core columns are seriously damaged.

VIERENDEEL TRUSS

Structural components above and adjacent to the damaged area begin to function like an arch — what engineers call a Vierendeel truss, transferring loads around the hole and downward through remaining columns at the sides. The building stands for 100 minutes, giving many people a chance to escape.

GRAVITY LOAD

Brian Courtney Manning for The New York Times

Meanwhile, though, heat from the burning fuel and other materials raises temperatures to more than 1,100 degrees, the point at which steel begins losing its strength. Nearly 40,000 tons of building weight sit within and above the impact area.

LOAD

VIERENDEEL TRUSS

THE FALL

The steel trusses are particularly vulnerable to the fire, because their ratio of surface area to volume is large, causing them to heat up quickly. Extreme heat softens the steel and reduces its ability to support the floors.

LOAD

FLOOR SAGS

As the floors weaken, they tug at their connections, which may tear away from the core and exterior columns.

Having lost their lateral support, the exterior columns, already softened by the fire, buckle catastrophically.

The top portion of the building plummets, and the building collapses in roughly 12 seconds. A stone dropped from the top of the tower would have taken 9.2 seconds to fall to the ground.

Steve Duenes and Mika Gröndahl/The New York Times

◄

Just days after the 9/11 attacks, this New York Times' graphic diagrammed the World Trade Center towers and explained how the buildings collapsed, even though they were built to withstand such an attack. These diagrams provided context for the devastating results of the attacks.

rytelling capabilities, but also in many cases, serve as the best way to tell a dramatic story with such far-reaching implications for a nation and a culture.

Digital Media Formats: Animation & Interactivity

The same foundational concepts graphics reporters apply to print are applied to online graphics. Of course, they should be well illustrated, visually and textually accurate, overly researched, well written (if text is a factor) and should promote enhanced understanding. However, the difference between the print and online interface is such that two additional aspects of online graphics should be considered: *animation* and *interactivity*. These two very significant concepts fundamentally change the ways in which a consumer engages with and navigates through an information graphic, and subsequently introduce a few new and different challenges for information graphics reporters. Thus, a strong, well-versed graphics reporter for online media understands how to effectively combine the basic principles of the different types of information graphics (addressed in detail in the following chapters) to animated, interactive storytelling methods.

One of the great challenges graphics reporters of print media face is how to illustrate and convey action when the medium is inanimate. Newspaper and magazine graphics reporters, for example, often strive to efficiently and effectively convey progression, motion and dramatic action armed only with a few common visual metaphors for those concepts such as arrows, numbers or rhythmic organization and directional lines. However, due to developments in animation software and the efforts of a number of news and

GRAPHICS SOFTWARE

Macromedia Flash
Flash is primarily used for animating information graphics that have already been created using another illustration software program like Illustrator, FreeHand or Photoshop. Based on ActionScript language, Flash makes it possible for graphics reporters or multimedia developers to create onscreen environments that can respond to user input through the keyboard or mouse. Thus, ActionScript is an object-oriented programming language that can facilitate the creation of animated and interactive information graphics because it is an event-based language. In other words, Flash allows a graphics reporter the chance to develop a graphic that animates, changes or can be navigated when a user clicks on or rolls over a certain spot.

Think Inverted Pyramid: Every graphic should follow a logical pattern; it should have a beginning, middle and end. When developing a graphic, consider the organization and flow to determine how a reader will visually navigate the information.

Find strong visual and textual reference material: The most effective graphics reporters keep source files just like any other reporter. Keep a list of people (doctors, mechanics, scientists, professors, etc.) who are willing to help you when you have a question about a graphic you are working on. Keep handy a core set of reference books (maps, encyclopedias, etc.). Develop a list of trustworthy Web sites on common topics. Conduct your own interviews, visit the scene, make sketches and take your own photos and measurements when the story allows for it.

Understand the info.: Make sure you understand the information before you try to explain it. One common cause for inaccuracy in a graphic is a reporter who doesn't get it.

Compare apples to apples: Your job is to simplify complicated information, not bog it down in more complexity.

newspaper Web sites to enrich the dissemination of information via the Internet, information graphics continue to evolve. Now, when the illustration of movement, action and progression is essential to the audience's ability to form a clear understanding of a particular story, graphics reporters have the opportunity to develop visuals that do, in fact, represent true visual motion.

Thus, animated graphics often represent a truer depiction of how something really has happened or is expected to happen. Animation permits us to actually show a rise or a fall. It provides us with an opportunity to both isolate steps in a process and illustrate a progression in real time. Finally, animated graphics have enhanced a journalist's ability to convey action in a story, which is often more engaging, more dramatic and more direct than a static print graphic.

However, like any technology, animated graphics are not perfect. In fact, as is the case with any illustration technique, design effect or visually graphic treatment of information, early use of animation software in graphics reporting has at times been overused. It is extremely important for all graphic journalists to understand that the technological ability to implement a visual effect should not be equated with free license to use it. In fact, an effective graphics reporter knows when to show restraint where animation is concerned. The decision to animate must be preceded by a carefully scripted plan for the pacing of the graphic through the creation of a storyboard that represents a fluid and concise play-by-play of the action. Storyboarding is common in other forms of live motion storytelling, such as film and television, and a well-directed storyboard can help lead to a clear and tightly edited information graphic.

Animation also introduces a more complicated technological challenge. Illustration software programs, such as Macromedia FreeHand and Adobe Illustrator, while extremely rich and complex, have relatively shallow learning curves compared to animation programs such as Macromedia Flash. Of course, the more illustratively complicated the print graphic, the more time it will take to develop. However, animated graphics not only require the same amount of time and attention during the illustration process, but they demand a great degree of technical savvy when the time comes to make them actually move. Animation programs in general are a bit deeper

and more complex than other types of illustration software. Thus, creating an effective animated graphic generally takes more time and more software knowledge than creating print graphics.

Additionally, animation for online graphics is generally accompanied by a degree of interactivity uncommon in any other form of graphic storytelling. The nature of the Internet is such that the reading experience can and should be *non-linear*. In other words, while print media – such as newspapers and magazines – generally promote a linear engagement in which the audience reads a story or visual package in a predetermined order (beginning, middle, end), the online format allows the audience the opportunity to choose the order in which they will engage with information. Online readers have a greater amount of control over the pace and order in which they receive information. And, because of the non-linear nature of online storytelling, a graphics reporter cannot assume that the audience will engage with certain portions of a graphic in any certain order. Of course, a graphic that provides a step-by-step progression of information will often require a linear presentation. However, interactive graphics that the audience gets to pick and choose, click and navigate in a random fashion must be planned and written to stand alone. In other words, the graphics reporter must assume that all portions of text are read independent of one another, changing the rules for how to make references to individuals or parts of an event. For example, if a person is referred to in one chunk of text and then again on a separate page of the graphic presentation, he or she must be referenced by first and last name on both occasions because you cannot guarantee the order in which the text will be encountered. Thus, the most effective online graphics are those presented in a manner that promotes a high degree of interactivity while at the same time observing a clear and logical organization with attention to the variety of ways different online readers may choose to engage with the content.

For example, if a graphic's focus is to show how to do something in a step-by-step fashion, the audience members should be permitted to click through each step at their own pace. If a graphic is meant to show various aspects of a particular situation or event, and order is not a key factor, the audience should be able to decide which aspect they will engage with first, second, third, etc. If the informa-

GRAPHICS TIPS

Understand the context: Find out what purpose the visual device serves in the audience's understanding of the information. When planning and creating the graphic, make sure the context is plain and easy for your audience to grasp.

Articulate the purpose: Some graphics serve as representations of real objects, such as building diagrams or land maps. Others illustrate more conceptual ideas, such as inflation, stock prices or company mergers. Decide what you want your audience to learn from your graphic, and express its purpose in five words or less.

Avoid art for art's sake: In other words, make sure that you hang as much information (whether that be in the form of text or audio) from the main illustration. The visuals should work in concert with any explanatory elements.

Movement can be great, but use it wisely: Make things grow or shrink in proportion to the actual time that correlates with it. Avoid animation that lacks an explanatory purpose. Make sure animations are clear, logical and easy to follow.

This MSNBC.com narrative graphic provides a simple explanation of Enron's dramatic rise and fall. Diagrams, detailed illustrations and rich audio commentary offer a thorough description of Enron's demise, from failed business plans to who and what was to blame.

This Sun-Sentinel graphic simulates the actual voting process for readers about to use new, touch-screen voting machines. The cursor becomes a hand, and the reader can complete a full ballot online to practice using the new machines.

This MSNBC.com explorative graphic explains the conflict between India and Pakistan and creates a highly immersive experience. This graphic is designed in three layers, and the audience can choose the order and pace to engage the content.

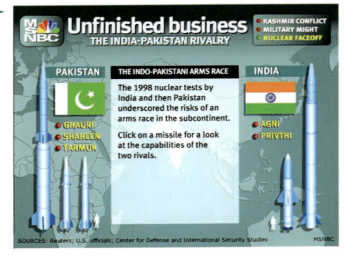

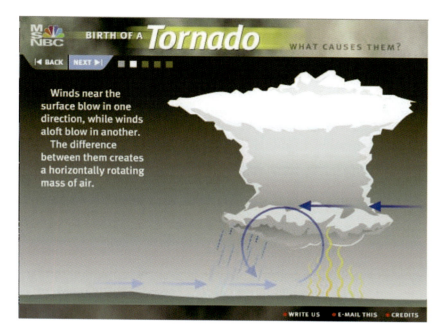

This MSNBC.com instructive graphic explains how tornados are formed by letting the audience sequentially click through the information, one step at a time. By clicking the "next" or "back" buttons, the audience controls the pacing of the navigation.

tion presented in an online graphic is complicated and complex, the audience should be given multiple methods for accessing the same information in a single graphic, and each method of entry should enhance their ability to make sense of the information on different levels. In essence, these examples illustrate the full potential of the Web as a graphic medium, and graphics reporters should take full advantage of its capabilities. Animation that provides a reader with a passive viewing experience – pure animation with no interactivity – is less engaging online and will likely be less effective in keeping the audience's interest and attention. In a nutshell, online graphics not only carry the same illustrative and organizational challenges as print graphics, but these challenges are essentially intensified by animation and interactivity.

Additionally, while online graphics are similar to print in that they generally come in the form of diagrams, charts, maps, etc., interactive graphics are categorized a bit more specifically. Four main types of interactives exist: *narratives, instructives, exploratives* and *simulatives*. In 2003, Maish Nichani and Venkat Rajamanickam provided a thorough and concise definition for each in an article titled "Interactive Visual Explainers: A Simple Classification" on elearningpost.com. They explained that the object of a *narrative* is "to explain by giving the reader a vicarious experience of the intent

GRAPHICS TIPS

Have someone else look at your graphic as you are developing it: We sometimes have a tendency to overlook confusing or missing information because we become so familiar with a topic that it just seems obvious to us. But, what is obvious to the graphics reporter who is extremely entrenched in the topic may not be so obvious to an audience that is encountering it for the first time.

Edit, edit, edit: Apply a great deal of scrutiny to both the visuals and the explanatory portions of the graphic. Your graphic is tight, easy to follow and full of valuable information.

through a story." In other words, a *narrative* involves very little inter-activity and is more closely related to a television broadcast in that it provides a relatively passive viewing experience. Strong *narrative* graphics are those that combine interesting audio voice-over with graphic depth and rich animation. An *instructive* should "explain by enabling the reader to sequentially step through the intent." Thus, *instructive* graphics are highly immersive in that they provide the reader with a chance to click through the steps of a process. *Exploratives* "give the reader an opportunity to explore and discover the intent." Like *instructives*, *exploratives* are also highly interactive, however, the main difference is that *exploratives* tend to be a bit deeper and may include multiple illustrations, audio and video clips, photo slide shows, etc., in a single graphics package. The non-linearity of *exploratives* is generally very strong, as these types of interactives often have several topical points of entry. Finally, *simulatives* "enable the user to experience the intent" and are usually a representation of some kind of real world phenomenon. *Simulative* graphics are also highly immersive in that they are meant to simulate an experience as closely as possible. Thus, the planning process for online graphics not only includes consideration for the type of data metaphor (i.e., chart, map, diagram, etc.), but it requires that a graphics reporter determine what form the actual storytelling approach should be for a particular set of information and what is the most effective approach to animation and interactivity.

Broadcast graphics share many of the same qualities as online graphics, such as animation potential and illustration challenges, with one major difference. For now – at least until interactive television is fully developed – broadcast graphics are generally comprised of straight, beginning-to-end narrative animation or static graphic imagery accompanied by audio explanations. And, like television in general, broadcast graphics represent a more passive viewing experience than Web graphics, due to a much lower level of interactivity.

Yet, statistical displays and explanatory diagrams can often greatly enhance a news broadcast by taking the viewer where video cameras cannot. In particular, maps have served an extremely important function in broadcast news reporting for stories related to weather, global and national politics and war, and the integration of maps into the presentation of broadcast news often greatly

enhances the audience's ability to conceptualize and understand the importance and impact of a related story. Like information graphics produced for the Web, broadcast graphics are often animated, providing viewers with a more realistic graphic representation of the information at hand. Additionally, due to developments in 3D illustration software, broadcast graphics are often illustrated with a degree of texture and depth that also presents an extremely realistic visual quality. Add to that the potential to mix broadcast graphics with rich audio and vivid, dynamic video clips, and you are faced with a highly engaging platform for the presentation of information graphics.

MSNBC.com: A Case Study

Truly pioneers in the multimedia graphics explosion, graphics reporters at MSNBC.com are well versed in the capabilities of online media. In fact, graphics have become an extremely prominent form of storytelling on the Web site, and multimedia stories are often accompanied by narrative, explorative, simulative and instructive graphics on a regular basis. Graphics showcased on MSNBC.com take users beyond static text and images, providing highly immersive experiences. MSNBC.com graphics are often developed using 3D software, and some also incorporate audio and even video clips as well.

Known for its commitment to providing in-depth coverage of complex stories in multimedia formats, MSNBC.com is responsible for a number of highly detailed and dynamic multimedia graphics packages. In 2004, for example, the site showcased an incredibly deep explorative graphic titled, "Unfinished Business: The India-Pakistan Rivalry." A truly multilayered graphic, MSNBC.com's account of this politically charged conflict offers two interactive maps, one that chronicles the fight for Kashmir from 1947 to the present and one that explains the intense military standoff between India and Pakistan, as well as a detailed interactive description of the nuclear weapons possessed by each country. The non-linearity of the package puts the user in control of the information-gathering experience, and strong, attractive illustrations are combined with well-written, tightly edited text. Like many MSNBC.com graphics, "Unfinished Business: The India-Pakistan Rivalry" is an excellent

example of how multimedia graphics can serve both an informational and educational function. The CD-ROM that accompanies this text contains a number of interactive graphics for you to review.

Information Graphics & Convergence

Convergence, one of the most prominent buzzwords in mass media in the early Twenty-first Century, refers to partnerships between and among various types of media organizations, such as newspapers, Web sites and broadcast news stations. Some media partnerships are a result of a common owner, such as the Media General conglomerate in Tampa, Florida, which consists of *The Tampa Tribune*, NBC Channel 8 news (WFLA) and tbo.com. All three organizations reside in the same building and share content and staff for news coverage. Other partnerships exist between separately owned organizations, such as the one between the *Miami Herald* owned by Knight-Ridder Inc. and CBS Channel 4 news (WFOR), owned by Viacom, who agree to share some content and generally promote each other's products within their own news coverage. Regardless of the organizational agreement, however, convergence presents a great opportunity for the development of information graphics for a single story across platforms.

This chapter has already outlined the strengths and weaknesses of graphical presentation in each of these types of media formats, and consequently, each of the platforms – print, online and television – the potential to serve different types of stories and different types of graphics at varying levels of effectiveness. A newspaper graphic, for example, may be better suited for showing graphics that are a bit heavier in text or graphics that provide greater visual context for an accompanying story. Web and television graphics may be more effective in showing the sequence of an event or the action attached to a graphic due to the potential for live animation. And although a television graphic generally provides the audience with a more passive experience, a Web graphic engages the user in a more interactive manner.

Thus, at the heart of convergence in graphics reporting is a question that graphics reporters have been answering on a much

Multimedia Graphics: A Comparison

	Level of audience interaction	Method of explanation	Challenges	Strengths
BROADCAST GRAPHICS	Fully animated; least interactive. The audience simply watches and listens as the graphic information unfolds.	Illustrations are accompanied by audio voice-overs.	Broadcast news spots are short. You may only have a matter of seconds to get to the point. The development of 3D and animation can be time consuming, making it difficult to create detailed broadcast graphics on deadline.	Can combine video and audio with graphic presentations. Like video, a broadcast graphic can show an event or process in real time.
PRINT GRAPHICS	Static, one-dimensional structure; reading is the interactive process through which the audience engages with content.	Text serves as the primary explanatory element.	Everything for the graphic has to fit into one scene. Motion must be implied with arrows or other static visual symbols. Space is often limited with print publications.	Graphics can be created relatively quickly on deadline.
ONLINE GRAPHICS	Greatest animation and interactive potential. The audience can actually take part in the physical navigation of the content.	Text and audio can be combined to serve explanatory functions.	May also be more time consuming on deadline.	Can show action in real time; has the potential to combine all types of media, such as text, illustration, animation, video, audio, etc.

smaller scale for years: What method of graphic presentation would best tell this story? Of course, graphics reporters have always been equipped with a multitude of ways to tell a story. And, graphics reporters at print publications have been asking this question for years as they work to determine what kinds of information graphics best serve the stories they accompany and the audience who sees them. Convergence simply puts a broader spin on the question above, while at the same time providing graphics reporters with additional options when formulating the answer. Instead of having to rely only on print graphics to accompany newspaper stories, for example, print graphics reporters are increasingly developing interactive, animated online graphics for their respective Web sites to support written stories in the paper.

The *New York Times,* the *South Florida Sun-Sentinel, The Washington Post* and others frequently publish graphics for both print and the Web to support news coverage. Likewise, partnerships between newspapers and television news stations have increasingly involved the development of information graphics for multiple media formats for a single story. In other words, a single news story – such as a presidential election – that will be published in a newspaper and online, as well as broadcast on television, may include a number of information graphics, some of which are better suited for print, some for online media and others for broadcast. Thus, a graphics reporter with convergence in mind should consider what portions of the graphic story are best told for each format based on the nature of the story, as well as the relative strengths of each format.

Graphics reporting for multiple media formats can greatly enhance the storytelling potential for a single story as well as opti-mize the number of individuals who actually see one or more of the graphic elements. Creating a graphic for a single news or feature event for each of the primary formats provides the graphics reporter with more storytelling power. In other words, the most salient por-tions of a story can be illustrated in different ways depending on the media format, and interactivity, animation, video and audio can all add to a reporter's ability to emphasize key visual points. At the same time, multimedia graphics may also have the potential to reach a greater number of people based on the notion that individ-uals may prefer one media format to another for obtaining news and information. For example, avid newspaper readers are more likely to engage with a newspaper first over other types of media. Others may be more inclined to obtain the majority of their news and information via the Internet or on television. And, to make matters even more interesting, through media partnerships brought about by convergence, each graphic in a multimedia package can reference the others, hopefully persuading consumers to engage with a story or graphic in more than one form. Thus, the strongest multimedia graphics packages take advantage of both the rich sto-rytelling potential created by a number of technologies and the strengthened potential to appeal to a greater number of individuals through convergence partnerships or a multilayered approach to graphics reporting.

One Graphic, Three Formats: A Case Study

In 2002, Florida officials tried to sink a decommissioned Navy ship, called the *Spiegel Grove*, off the coast of South Florida. Intended for use as an artificial reef, a mishap left the 5,000-ton vessel upside down and sticking out of the water for more than a week, creating a huge dilemma for local officials. In a collaborative effort with CBS Channel 4 news (WFOR), graphics reporters at the *Sun-Sentinel* covered the story by developing information graphics for print, the Web and broadcast. According to Don Wittekind, graphics editor at the paper, a team-based approach to work across media was implemented for this multimedia project, and graphics were intended to show how a salvage company brought in to properly re-sink the vessel was planning to accomplish its goal.

The team consisted of five people, each in charge of one of the following responsibilities: (1) research and reporting and print page production; (2) 3D modeling of the *Spiegel Grove*; (3) animation of the 3D *Spiegel Grove* model; (4) Web design for online animation; and (5) video production and special effects for broadcast. They started by getting the graphics reporter going on the research with the salvage company, and the 3D artist working on the model of the ship, Wittekind explained. As soon as the model was roughed out, a copy was given to the animator and a render was made for the print product. Although these were not finished images in any way, they were enough to allow work to continue on three fronts. Once the text was finalized, this was given to the Web designer, along with multiple renders of the ship, to allow him to begin the online animation. When the final render of the ship was ready, they were able to quickly place it on the print page and into the Web animation. On the broadcast side, the animation was done, but with an earlier model of the ship. So, the team had to update the model and render out the animation. The final step was taking the broadcast render into After Effects to add the arrows and other special effects.

By making sure that everyone was able to work at the same time, all three projects were ready for publication on the same day. The *Spiegel Grove* project is a phenomenal example of how information graphics can provide a convergence partnership with an amazing array of resources for a large audience of newspaper readers, Web users and television viewers looking for thorough coverage of a single topic.

Along with the "News Illustrated" graphic, the staff also created an animated graphic for the news broadcast on CBS Channel 4, as well as an interactive graphic for the Sun-Sentinel Web site (below). The animated broadcast graphic was accompanied by audio voice-over providing explanation, and was integrated with video clips that included interviews with the company that would right the Spiegel Grove and footage of divers working to get the vessel ready to be re-sunk.

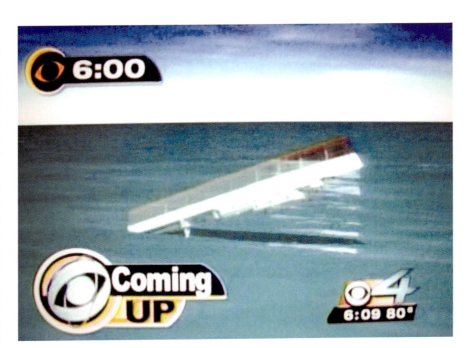

The interactive graphic presented on the Sun-Sentinel's Web site allowed users to click through the steps of the re-sinking process. Each package referred to the others to optimize the number of people who engaged all three.

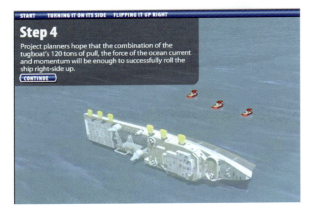

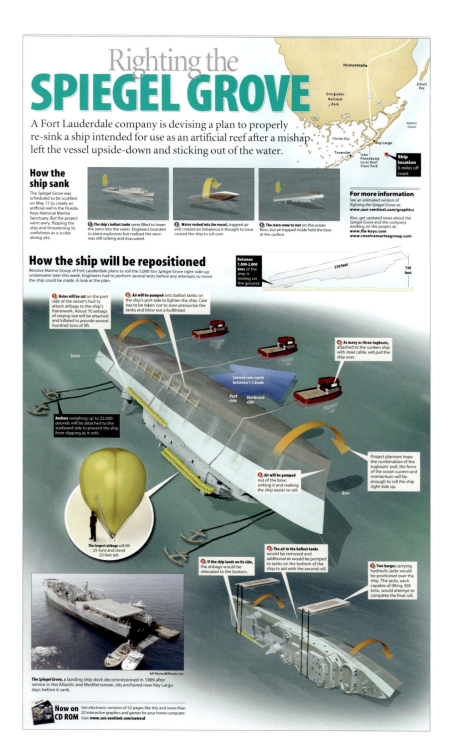

The graphics staff at the Sun-Sentinel is best known for its weekly full-page print graphics, titled "News Illustrated," on topics that range from science and technology to the War on Terror. When the Spiegel Grove incident occurred, graphics reporters quickly got to work creating a full-page "News Illustrated" graphic that explained the debacle and how it would be corrected.

Sun-Sentinel graphic copyrighted South Florida Sun-Sentinel. All rights reserved. Used with permission.

DON WITTEKIND

**Graphics Director,
South Florida
Sun-Sentinel**

Don Wittekind leads a team of 10 multimedia journalists who produce news and entertainment packages for print, online and broadcast distribution. A veteran journalist, he has also worked for the Atlanta Journal-Constitution and Melbourne's Florida Today in positions ranging from design to editing to computer support. He is a 1989 graduate of the University of Central Florida.

In the Eyes of an Expert

How have multimedia graphics evolved at the Sun-Sentinel?

Back in 1996, the *Sun-Sentinel* was undergoing an overhaul from a traditional service-based art department to a modern journalistic news graphics department. The graphics director who oversaw this transition, Leavett Biles, believed that a modern graphics department should produce for print, online and broadcast, and he began hiring with this in mind. I came on board in 1996 with the stated mission to develop online graphics.

Our early work, all produced in Macromedia Director, tended to be fairly encyclopedic, and generally made minimal use of audio and photography. And video (on the Web) was impossible at this time (due to slower dial-up modem speeds). So what we produced were basically animated versions of newspaper print graphics. Like their newspaper counterparts, they tended to tell only part of the story, and were often meant to accompany a larger package.

Today, thanks to advances in software (Macromedia Flash) and increased bandwidth, we now incorporate every form of media into our projects. This has allowed the multimedia component, which was once an accessory, to become the entire project. If you look at examples such as "Aids in the Caribbean," "Haiti: The Eroding Nation" and "Marine Parks: Below the Surface" (www.sun-sentinel.com/broadband/theedge), you'll see that the entire story is presented in a multimedia manner. And we don't ignore the text, either. It's right there with the audio, video and animations.

How are multimedia graphics viewed/approached at the Sun-Sentinel? How much prominence do they hold among editors when discussing news coverage?

Most of our multimedia efforts are extensions of major *Sun-Sentinel* print projects. This works for us because we have ample planning time to make sure the news gatherers know what we need before they go out. And, because everyone has a little more time on these kinds of stories, they are more willing

to go beyond their normal duties and collect the multimedia content we need. The project-based approach is also important on the production end. Because we have weeks of development time, we can form a relatively small team (two to three) and minimize disruption to the print product.

As for prominence, every project we do seems to gain a little more. Although multimedia was once an afterthought, it's now discussed seriously in the earliest planning meetings. This has actually raised my department's stress level a little, because where I once judged each project and decided whether I wanted to get graphics involved, I no longer have that option. I can now expect the managing editor to turn to me and say, "So what are we doing for the multimedia component?" But it is definitely a positive thing that multimedia is not just accepted, it's expected.

How do multimedia graphics enhance news coverage?

With every other media, you find yourself working with huge limitations. With print, you are limited to static text, pictures and graphics. And, because of tight printing schedules, you're often way behind on the big story. With radio and TV, you've got audio and video to help tell the story, but now you only have seconds to make your point. The depth is too often lost.

With multimedia, you get the best of all worlds. You can offer the depth of coverage from a print product, and also make use of the storytelling and explanatory power of animation, video and interactivity. Now a graphic artist can dump the arrows and blurs used in print to simulate motion and instead animate what happened. That's a powerful tool that can greatly increase the reader's understanding. Add to that the ability to seamlessly integrate photos, video and audio into the narrative, and you have something unique.

And most important is interactivity. Only on the Web can you create immersive experiences such as MSNBC.com's luggage screening simulator or our own *Hunley* Simulator and touch-screen voting graphics. The ability to put the viewer into the

story, rather than show and tell, is in my opinion the most powerful aspect of online storytelling.

What are the most significant differences in developing print, Web or broadcast graphics?

With print, you have the battle that everything has to fit into one scene, and you obviously don't have the benefits of motion or sound to help you tell the story. And the size of that scene you're trying to fit may be large or small, depending on how much space is available in the paper. The good news is that because you're using a limited tool set, you can generally produce very quickly.

With online, your space becomes virtually unlimited, and you have the ability to section your information off into scenes for better organization. Add in sound, animation, video and interactivity, and the possibilities are endless. The thing to remember here is that this can translate into a lot of production time.

With broadcast you also have to worry about time, but in this case we're talking about the length of your presentation. You still have video and audio to work with, but you have to get your entire point across in 20 to 30 seconds. That's a whole new challenge.

Who do you go to for inspiration? Who else in the industry is doing it well?

For breaking news multimedia I'm a big fan of elmundo.es. They have the benefit of a large staff, but the fact is, they explain difficult subjects in multimedia formats in the same time frame newspapers are putting it in print. Really impressive.

For project-based graphics I watch MSNBC.com, *USA Today* and the *New York Times*. If I'm just looking for general inspiration, I visit the Society for News Design's SNDies site (www.snd.org/sndies/sndies.html) to see their monthly and annual multimedia graphics contest winners.

Beyond knowing certain software programs, what are some key skills a multimedia graphics reporter should have? List five tips.

They have to be able to do everything! Here's the skill set in order of importance:

1. Research and reporting
2. Art and design
3. Technical skills/software knowledge

Basically, we expect a senior graphics reporter to be able to take a project from start to finish. This means reporting the subject, creating the art and designing and producing the print graphic. And they have to be able to produce the online component, too.

5 TIPS:

1. You are first and foremost a journalist. Never forget that.
2. Get your reporting done first. Too many people rush into multimedia before they really know what the story is. Let the content drive you in the right direction.
3. If multimedia doesn't help you tell the story, don't use it. Remember, not every subject needs a multimedia treatment.
4. Don't trust your first idea. Whether you are working in print, online or broadcast, the obvious solution is seldom the best. Brainstorm!
5. Integrate your media. The most powerful multimedia seamlessly uses different elements to form a narrative. Don't segregate.

Chapter Two Exercise

Below is a proposed story that your multimedia news organization(s) plans to cover. Sketch a graphics package idea that outlines how a graphic component will be used in the print, online and broadcast products associated with a convergence partnership.

Your scenario: You work for a media partnership in the Midwest that includes a newspaper, a news Web site and a broadcast news station. Winter is fast approaching, and your editors want you to develop a graphics package that helps people get their cars ready for the icy roads and cold temperatures to come.

Create a sketch for a print graphic, and storyboards for both an online graphic and a graphic to be used in a broadcast news report that explains to the audience(s) how to properly winterize a car. You can choose the make and model of the car you will use in your graphics.

The graphics package may share some common information, as key points may need to be repeated. However, it is important that each graphic provide some unique content so that someone who happens to read all three graphics doesn't feel like he or she is simply reading the same graphic over and over again.

References

Nichani, Maish and Venkat Rajamanickam. "Interactive Visual Explainers – A Simple Classification." elearningpost (Sept. 2003). 14 Oct. 2004 <http://www.elearningpost.com/features/archives/002069.asp>.

THREE

Research & Writing for Graphics Reporting

Regardless of the outlet or format, good journalistic writing is rarely a spontaneous exercise. In fact, in our business, research is often at the center of the wheel around which a story revolves. Whether your specialty as a journalist is pictures, text, design or graphics, strong research and writing skills are always important. Just as a good photographer writes compelling captions for her images or a successful writer engages in a good deal of in-depth research and reporting before diving into the story, so too must the dedicated graphics reporter. If we think of a graphic as a potential story form, then we must also respect research as an essential part of the process by which a graphic comes to be. Research provides a reporter with the education he needs to convey information with confidence and authority. And evidence of research in a graphic provides the reader with the proof she needs to assess the validity of a presentation. Research injects your work with credibility and your byline with respect.

Research Sources for Information Graphics

Graphics reporters often consult the same types of sources for stories as other journalists. However, it is important to note that graphics reporters may be looking for both textual *and* visual reference material for their work. In fact, graphics reporters rarely engage in an illustration for a graphic without first consulting photos, other illustrations or blueprints developed by credible sources. And, while artistic skills are certainly important to the trade, so too are a graph-

ONSITE REPORTING

More and more, graphics reporters are required to leave the newsroom and gather information from the field. In fact, it is often more effective for a graphics reporter to visit the site of a news event and conduct face-to-face interviews with expert sources just like other reporters. However, because a graphics reporter is often gathering source material for both the textual and visual elements of a graphic, there are a number of tools he should bring along.

Sketchpad, notebook and pencils: Always be prepared to take notes and sketch the scene.

Digital camera: Take pictures from different angles and varying distances from the area(s) of visual interest. Digital images can be read quickly once you get back to the office, as well as provide a more realistic visual reference for your scene.

Tape measure: In order to later provide a realistic perspective of a scene, you may need to know the exact dimensions of the news site.

ics reporter's ability to spot good visual reference materials and replicate them for his own graphics. In this regard, graphics reporters may consult a variety of sources and conduct research for both the textual and illustrative pieces of their visual stories.

Kathleen A. Hansen and Nora Paul (2004) cite four contributors for information commonly used by communicators: *informal* sources, *institutional* sources, *scholarly* sources and *journalistic* sources.[1] All four can be extremely valuable to a graphics reporter, and understanding how each can contribute to the development of a graphic is important. Additionally, a skilled graphics reporter should be ready to consult books, legal documents, annual reports, Web sites, newspapers, magazines, experts in the field and even television when gathering information for a graphic. With all of these potential sources in your arsenal, most graphics should come together pretty efficiently.

Unfortunately, one of the biggest mistakes an inexperienced graphics reporter makes is failing to exhaust all of the source options before throwing in the towel on a project. Thus, it is extremely important that you understand the nature and potential of each possible source of information and how to use them in the context of various types of graphics.

Making good use of *informal* sources is dependent upon a reporter's ability to monitor and observe her surroundings. In other words, pay attention to what's going on around you. Hansen and Paul write, "*Informal* sources include observations about audiences, messages, and the environment in which the communicator operates, as well as networks of supervisors, colleagues, clients, neighbors, and friends the communicator deals with every day." Informal sources can provide a journalist with a great source for story ideas, as well as methods for interpreting those stories. In particular, *informal* sources can be extremely valuable to a graphics reporter when she is on assignment collecting information for a graphic related to a place or news event. Often, in both breaking news situations *and* advance project-oriented stories, a graphics reporter will be required to get

[1] In their 2004 textbook, *Behind the Message: Information Strategies for Communicators*, Hansen and Paul provide a thorough analysis of the various types of sources commonly used by communicators. The sources they cite have been adopted for this discussion, and definitions have been modified to better illustrate their usefulness to graphics reporters.

out from behind the computer, leave the comforts of the office and actually visit the site of a story to collect reference materials to be used for both the visual and textual elements of a graphic. For example, when a crazed tourist attacked the Liberty Bell with a sledgehammer in Philadelphia in 2000, a graphics reporter from the *Philadelphia Inquirer* rushed out to the Liberty Bell Pavilion to talk with witnesses and sketch the crime scene.

Institutional sources are generally represented by social or cultural organizations with particular special interests, political positions, professional goals or governmental roles. Obviously a reporter who writes has a number of reasons to consult these types of sources when writing a story, not the least of which is the fact that very often, news stories are in many ways driven by or generated by the actions of *institutional* sources. Likewise, a savvy graphics reporter should be aware of the ways in which *institutional* sources can provide valuable material for a graphic. For example, *institutional* sources are often the foundation for the simplest information graphics, charts and graphs. In the public sector, sources like the Bureau of Labor Statistics (www.bls.gov) provide a plethora of information about the state of the U.S. economy, such as inflation and consumer spending, national wages, earnings and benefits indexes, productivity, safety and health in the workplace, import and export indexes, demographic characteristics of the American labor force and employment and unemployment figures, to name a few. Similarly, the U.S. Geological Survey (www.usgs.gov) acts as a federal source for information about natural and living resources, natural hazards and the environment. The Web site provides a stockpile of data related to regional geology, minerals, water and land, as well as countless geologically focused maps and charts developed through official U.S. geologic surveys. In the private sector, businesses, industry associations, religious organizations and others can also provide informa-

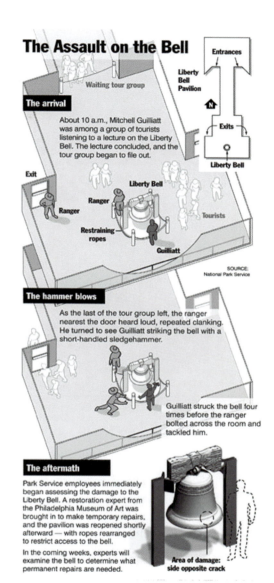

Graphics reporters interviewed witnesses to determine the chain of events that led to an attack on the Liberty Bell.

Graphic by William Neff and Kevin Burkett. Copyrighted Philadelphia Inquirer. All rights reserved. Used with permission.

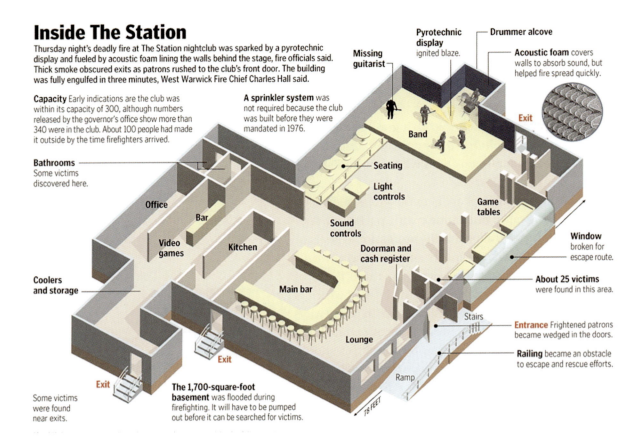

Inside The Station

Thursday night's deadly fire at The Station nightclub was sparked by a pyrotechnic display and fueled by acoustic foam lining the walls behind the stage, fire officials said. Thick smoke obscured exits as patrons rushed to the club's front door. The building was fully engulfed in three minutes, West Warwick Fire Chief Charles Hall said.

Capacity Early indications are the club was within its capacity of 300, although numbers released by the governor's office show more than 340 were in the club. About 100 people had made it outside by the time firefighters arrived.

A sprinkler system was not required because the club was built before they were mandated in 1976.

Pyrotechnic display ignited blaze.

Drummer alcove

Missing guitarist

Acoustic foam covers walls to absorb sound, but helped fire spread quickly.

Band

Exit

Bathrooms Some victims discovered here.

Seating

Light controls

Office

Bar

Sound controls

Game tables

Video games

Kitchen

Doorman and cash register

Window broken for escape route.

Coolers and storage

Main bar

About 25 victims were found in this area.

Stairs

Entrance Frightened patrons became wedged in the doors.

Lounge

Railing became an obstacle to escape and rescue efforts.

Ramp

Exit

Exit

Some victims were found near exits.

The 1,700-square-foot basement was flooded during firefighting. It will have to be pumped out before it can be searched for victims.

76 FEET

▲ **When a tragic fire broke out at a local bar, the Boston Globe graphics reporters relied on video footage shot by someone in the bar at the time of the fire, as well as a member of a band who had played there once before to determine the floor plan of the building and create this graphic on deadline.**

Graphic by Peter Demarco, Ed Wiederer, James Bennett and Joan McLaughlin. Copyrighted Boston Globe. All rights reserved. Used with permission.

tion that is relevant to graphics. Annual reports, earnings reports, historical records or organization officials are just a few of the resources graphics reporters should consult when dealing with *institutional* sources.

Scholarly sources, such as academic institutions or medical and scientific research centers exist to expand the body of knowledge about related topics, and the results of their research are often useful to journalists. In particular, scholarly institutions often develop their own information graphics, such as charts, graphs and even diagrams as a method of reporting findings. Journalists should be aware of the many electronic indexes, databases and search engines through which many scholarly reports, abstracts and journals are archived, such as Academic Search Premier or Lexis-Nexis.

Often, journalists rely on what has already been reported about a specific topic when developing a foundation for new stories or

angles for coverage. In this regard, journalistic sources, such as newspapers, magazines, trade publications, television and news and information Web sites, can be extremely helpful to graphics reporters. Of course, a good journalist never simply copies another's work. However, a journalist who fails to do some searching for previous reporting on a given subject could risk breaking one of the cardinal rules of reporting: tell the reader something new. Additionally, consulting other media outlets as references for visual reference material, textual information and ideas about where others have gone for information can often help graphics reporters build new useful graphics. For example, when a tragic bar fire killed about 100 people during a rock concert, graphics reporters at the *Boston Globe* worked to create an information graphic that explained the disaster in detail. The building had burned to the ground, and just hours after the fire, survivors and blueprints of the building were difficult to track down, and city officials weren't quick to talk about events that led to the fire while an investigation was just getting under way. Although *Globe* reporters had their work cut out for them, they managed to come up with a few possible sources for their graphic, including a video shot by one of the concertgoers that captured the start of the fire and the panic that ensued as a result. The video was first aired on a local broadcast news station. Graphics reporters at the *Globe* obtained the video and watched it over and over again, hoping it would help determine the layout of the inside of the bar. Although the video wasn't their only source, it certainly helped answer some basic questions about the stage setup and floor plan.

Although each of these types of sources can often provide the bulk of information that you may be looking for on any given topic, stronger stories are those which employ multiple and varying sources. In other words, don't settle for one type of source. Consult all possible sources for each graphic you intend to create. A variety of sources and more important, multiple sources, add credibility to your story because it shows the reader you put considerable time and effort into reporting before you settled on a final graphic. Additionally, consult multiple sources within each category as well. A single source on a single topic is rarely enough to confirm its accuracy. For example, informal sources can sometimes be tainted by

DOMAIN DEFINITIONS

Web sites are partially classified by the types of groups that sponsor them. Sites are identified by the suffix in the domain name. While these designations don't necessarily imply that one is better or more reliable than others, knowing what they mean can help determine the primary sponsor for the site.

.com sites are generally used by commercial organizations or individuals. These domain names are easy to obtain, and graphics reporters should be careful when using information posted on a .com because there is no guarantee the source is reputable.

.net sites are used by organizations that provide Internet connection services. Although there are no special criteria for registering for a .net as opposed to a .com, most .net sites rarely contain more generalized information. Nonetheless, it is important to make sure information from a .net is accurate and credible.

.edu sites are for educational institutions, which nearly always use the .edu suffix.

individual opinions or misconceptions. Information from institutional sources can be developed with specific political or cultural agendas, causing them to be one-sided or self-serving. Research reported by scholarly sources has generally already met certain standards and criteria prior to publication. However, different types of research methods are often considered more valid than others. So, as a graphics reporter, you must make an effort to understand the data and the methods by which researchers arrived there. Finally, while journalistic sources have often been pretty thoroughly researched as well, no single piece of reference material should be taken at face value, and it is always a good idea to double check sources for accuracy.

Sifting Through the Rubble

Whether they are printed sources, electronic sources or people, finding the most up-to-date, accurate, credible sources should be every graphics reporter's first priority when sifting through potential resources. For example, there are no less than four million Web sites about or that mention breast cancer – four million! And, no doubt, there are likely just as many, if not more, books, periodicals and other printed publications that address breast cancer, as well as hundreds of thousands of experts on the topic in the United States alone. So, how do you know what the most reliable sources are? While there may be no one good answer to that question, there are some things you can keep in mind when conducting your search that will help you through the process of elimination.

PRINT SOURCES: Books, periodicals, published reports and other types of printed publications are often great sources of information because you can generally rest assured that the information contained within has either been subject to review as with scholastic journals, encyclopedias and journalistic reports or written by experts in a given area, as is the case with many books. And even though the Internet can often provide reporters with easier, quicker access to information, the library should still be a primary resource for journalists. However, just because something is printed doesn't make it true or accurate. And, even within the realm of printed

work, some sources, primarily those that are subject to peer review or heavy fact checking, are generally more reputable than others.

Graphics reporters often rely on special topic encyclopedias, atlases or medical documents for visual and textual reference materials for their work. For example, aeronautics or automotive encyclopedias contain illustrations and diagrams of every type of airplane or car ever made. Likewise, atlases and almanacs often include valuable sources for maps and charts common to communications graphics. However, when conducting research using printed publications, consider a few safeguards: (1) Do a background check on the author(s) to make sure they are reputable sources on the relative topic; (2) when consulting annual reports and other publications submitted by a specific company or organization, scrutinize the data, double check it against other sources and work to determine whether there is any bias present; (3) make sure the date of publication is as recent as possible or that an earlier publication date won't affect the accuracy of the information at hand.

ELECTRONIC SOURCES: When I am conducting research for a graphic or story, I sometimes wonder how I ever survived without the Internet! With search engines like Lycos, Google and Yahoo!, you can simply type in the word or topic you are interested in, and, voilà, hundreds of potential sources at your fingertips! However, it's important to remember to approach Web sources with care. After all, just about anyone can purchase the rights to a URL and then publish just about anything he or she wants on that site. Thus, certain types of sites are often safer than others. Sites used by the U.S. government (.gov), non-profit organizations (.org) and educational institutions (.edu), for example, are generally considered to be more reputable than sites administered to commercial organizations or individuals (.com). However, while the sponsoring organizations of these sites may carry more clout than the average person, it's still important to remember that even government or education sites may contain biased or self-serving statements. So, when conducting research using the Web, make sure you determine the name of the individual, organization or group responsible for the site's publication so you can check up on them and find out if they are reputable; make sure the site includes a revision date so that you can

DOMAIN DEFINITIONS

.org sites are most often used by non-profit organizations or industry standard groups. Again, it is no more difficult to obtain a .org than a .com. So, there are no guarantees that a .org site is more reputable. Additionally, because .org sites are more often used by special interest organizations, you must be wary of biased or self-serving information. However, it is generally safe to say that a .org site is run by a group or organization with some degree of knowledge about the topic.

.gov and .mil sites are sanctioned by the U.S. federal government. And even though you shouldn't necessarily take everything contained within a .gov or .mil site as 100 percent accurate, you can rest assured that government officials endorsed information on a .gov site before it was posted.

.int sites are generally related to international treaties or containing international databases. Information obtained from a .int site is generally sanctioned by an official political or governmental agency.

determine whether the information published there is up-to-date; and find multiple sources that corroborate your primary source to ensure the information found there is accurate.

HUMAN SOURCES: Because of the nature of their work, graphics reporters don't always consult human sources as much as they should. Of course, the average information graphic rarely contains quotes from sources like a news story should. However, this doesn't mean that a human source can't provide information that will be valuable to both the textual and visual elements of a graphic. For example, if your graphic is meant to explain how to do something or how something happened, who better to consult than an expert in that area? Experts often have their own reference materials that they are willing to share with you and can explain a process or event in greater detail than other types of sources. Additionally, experts can often review your work as you go and help refine a graphic by advising you on the accuracy of your depiction, as well as help define, in layman's terms, other reference materials that may be laden with jargon that the average person wouldn't understand. When consulting experts, check your expert's credentials to make sure she is qualified to address a specific topic; talk to your expert's colleagues or others in the field to determine whether he is respected among his peers; and try to find other sources that support what your expert says about a given topic to be sure the information offered is accurate.

Developing a Source List

Any seasoned reporter has a thorough contact/source list that grows with every story she writes. In fact, reporters often have cause to consult the same sources more than once for multiple stories. Graphics reporters face similar circumstances, and developing a list of commonly consulted sources that you know you can rely on is a great way to develop shortcuts to the answers to future questions. A graphics reporter's source list should include a variety of types of sources – print, electronic and human – as well as a number of sources related to the same topics. For example, graphics reporters must often create charts and graphs for business- or economics-oriented graphics, so Web sites like the one sponsored by the Bureau of

Labor Statistics (www.bls.gov) often contain useful economic calculators, equations and data for building those graphics. Develop a list of trustworthy government, military or educational Web sites, such as nasa.gov (National Aeronautics and Space Administration) or ama-assn.org (American Medical Association). Likewise, every graphics reporter should have the most recent almanac and world atlas on her desk, as well as a list of topic-specific encyclopedias and other reference books she might commonly consult. And, why not also develop a list of trusted expert sources on a variety of topics? Find a doctor, professor, mechanic, city official, economist, lawyer and scientist you can turn to when graphics packages would benefit from their expertise. Develop a relationship with these people so that you know they will return your calls and be willing to help when you need them.

Finally, keep a graphics notebook full of clips that inspire you. In it, you can include photos, graphic designs, other information graphics and illustrations you find interesting for one reason or another. Clips you keep for your graphics notebook can lead to new graphics ideas for you to pursue, add to your list of possible sources for future projects or provide a diverse group of examples of different illustration styles. Keep photographs of interesting architecture, landscapes and different types of people or methods of transportation to consult later as references for the illustrative portions of a graphic. Save graphics developed by other reporters that you think are well executed. And, research and keep different illustration styles for inspiration and to help develop your instincts regarding when it's appropriate to implement different styles, such as sketch, watercolor, cartoon, woodcut, etc. After awhile, your graphics notebook will be both a valued informational source book and a great place to go for new ideas.

The Written Components of an Information Graphic

The writing style for the text of an information graphic really depends on the tone and context for the graphic. Serious breaking news events or simple charts and graphs often call for a more seri-

ous, straightforward tone, while lighter feature graphics can sometimes be more informal in tone. Furthermore, different types of graphics will often have different levels of information. For example, a simple or small passive locator map that merely marks a location will rarely be accompanied by a headline or introductory text, also known as "chatter." It's simply not necessary. Charts and graphs generally contain a headline and chatter, but the chatter is generally one to two sentences and extremely direct. More detailed maps and diagrams often contain longer blocks of chatter, as well as additional callouts or labels to help provide more explanation and context for the graphic.

Regardless, all of the written components for an information graphic should be tightly written, direct, active and easy to understand. In most print publications, such as newspapers and magazines, space is a commodity, so the tighter the text, the better. Likewise, broadcast graphics are often subject to time limitations, so any voice-over explanation should also be tight and direct. However, even in situations where space isn't a big issue – as is the case with the Web – simple, direct, active language is often the most effective method for explaining your graphic. After all, your job is to simplify complicated information for a very large audience. Effective graphics are those that get to the point using clear, simple language.

In general, the most important thing for a graphics reporter to remember when writing chatter, callouts and explainers for a graphics is to *think storytelling*. Write a narrative with a beginning, middle and end. Headlines, explainers, copy blocks and callouts should help establish a proper flow, and readers should recognize that order. Likewise, you can't adequately explain something that you yourself don't understand. So, you should *always* make sure you clearly understand the data and related information before attempting to pass that understanding on to the audience. Once you have a clear understanding of the content, try to boil it down to a concise, simplified explanation.

It's also important that you let the data speak for itself. In other words, you know the old saying about assuming, right? Making assumptions or statements that the data can't support in a graphic can be deadly. Just because a particular poll results in a single outcome, doesn't mean those results can be applied to other situations.

WRITING TIPS

Understand the information

Don't assume

Don't make judgments

Don't predict

Be specific

Don't overwrite

Don't restate the data; summarize it

Identify trends and call out differences

Use complete data

When possible, use present tense

Use active voice

Write in third person

Eliminate duplicative information

Use correct terminology

Edit, edit, edit!

Anatomy of an information graphic

HEADLINE: Most information graphics should include some sort of headline. Graphics headlines could be written as a label or title like the one below. They can also be written more like a news headline, with a subject and verb, such as "Halloween candy threatens dental health." Regardless, always remember that a headline is meant to capsulize the main focus of the graphic in a few concise, descriptive words.

CHATTER: A good rule of thumb for writing introductory chatter is to first summarize or evaluate the information by providing context for the graphic. Then, provide a transition to the main body of the graphic. This can usually be done effectively in two to four sentences.

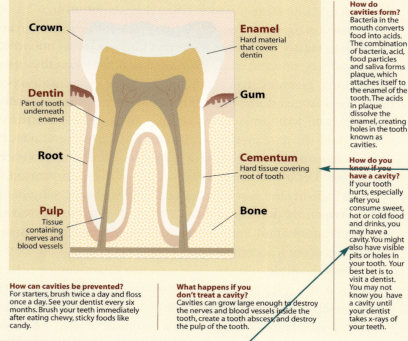

INSIDE THE TOOTH: Cavity prevention guidelines

With Halloween just around the corner, children might be thinking of candy but parents should keep an eye on dental health. The sugary content of Halloween sweets can cause cavities. Below is a diagram showing the parts of the tooth along with more information about cavities.

Crown

Enamel
Hard material that covers dentin

Dentin
Part of tooth underneath enamel

Gum

Root

Cementum
Hard tissue covering root of tooth

Pulp
Tissue containing nerves and blood vessels

Bone

How do cavities form?
Bacteria in the mouth converts food into acids. The combination of bacteria, acid, food particles and saliva forms plaque, which attaches itself to the enamel of the tooth. The acids in plaque dissolve the enamel, creating holes in the tooth known as cavities.

How do you know if you have a cavity?
If your tooth hurts, especially after you consume sweet, hot or cold food and drinks, you may have a cavity. You might also have visible pits or holes in your tooth. Your best bet is to visit a dentist. You may not know you have a cavity until your dentist takes x-rays of your teeth.

How can cavities be prevented?
For starters, brush twice a day and floss once a day. See your dentist every six months. Brush your teeth immediately after eating chewy, sticky foods like candy.

What happens if you don't treat a cavity?
Cavities can grow large enough to destroy the nerves and blood vessels inside the tooth, create a tooth abscess and destroy the pulp of the tooth.

Source: National Institutes of Health, American Dental Association, Loyola University Health System, Whyfiles.org, BBC, Kidshealth.org, University of Manitoba

by Katie Smith

CALLOUTS: When labels need additional explanation or definition, beyond the one-word description, they can be accompanied by a callout. A callout is generally an additional sentence or two that provides more specific information about the visual portion of the graphic it accompanies.

SOURCE LINE: A source line should accompany all credible graphics packages. Let the reader know where your information comes from. After all, it's not likely that you, the graphics reporter, are an expert in everything!

EXPLAINER: Supplemental chunks of text are often useful in graphics packages that require additional context.

BYLINE: A byline lets the reader know who is responsible for compiling the information at hand, adding to the credibility of the graphic.

Just because a stock price, for example, has risen consistently for the past ten years doesn't mean it will continue that trend. Just because a plane crashed doesn't mean everyone on board is dead. Avoid making predictions beyond what you know to be true at any given time. And even though it can be very easy to slip up and unintentionally draw your own conclusions about a situation, you must take care to only state the facts, report the news and let the audience draw their own conclusions. Additionally, make sure you are always using complete data. If numbers are missing or you don't have access to complete visual reference material for an illustration, rethink your graphic. Leaving out key information will likely leave the audience with more questions than they started with.

Developing an appropriate writing style for graphics can also be tough to master. Of course, it's always important that the writing be lively, interesting and fluid. However, like other forms of journalistic writing, graphics style should generally be clear, use easy-to-understand language and avoid jargon. Avoid vague or misleading language, and write in layman's terms. Furthermore, don't overwrite. Allow the data metaphor, the chart or illustration, to represent key information, and avoid unnecessary words and sentences. Be concise. Get to the point. There's no need to repeat yourself. If you said it clearly the first time around, you can avoid redundancy and consequently, develop a more efficient graphic. So, summarize important information, and work to evaluate the data in the context of the news event it accompanies.

When possible, use sentence structures that employ present tense and active voice. Admittedly, there are times when the tone of a graphic will be awkward if present tense is used. However, most of the time, present tense carries with it a quality of urgency and timeliness. Even when constructing a time line, present tense is generally a more effective, vibrant writing style. Likewise, sentences that make use of active verbs are generally more concise and interesting to read. When possible, avoid passive verbs, also known as "verbs of being," such as *is, am, are, was, were, has, have* or *had*. Put the subject first in the sentence, and make sure the subject is actually *doing* something. Finally, write in third person. There is rarely cause to use personal pronouns in an information graphic. Even features graphics should remain neutral in this regard.

It's also important to use terminology correctly where graphics are concerned. Graphics often show breakdowns, comparisons, trends, cutaways, perspectives, angles of view, amounts, numbers and locations. Make sure that you use these terms correctly to describe what your graphic really shows. For example, a breakdown implies that a "whole" exists and you are showing the amounts that make up that whole. A comparison, on the other hand, implies that you are calling out similarities or differences among and between a number of values. These terms *are not* interchangeable because they have two very different definitions.

Finally, be an editor. Eliminate unnecessary words. Scrutinize your writing. Use spell check! I always tell my students that I will never hold it against them if they aren't good spellers. However, I *will* be irritated if they don't run spell check! Check the data for accuracy. I always find it helpful to have someone else read my writing after I believe my work is complete. Bringing someone in who has a fresh point of view will often help you determine how the larger audience will actually respond to your work. If someone you trust takes one look at your graphic and says, "I don't get it," chances are you have some major revising to do!

Information Graphics & News Coverage

In news coverage, information graphics often serve as alternative storytelling devices. In other words, if a text-based story is considered the "traditional" approach to the presentation of news, then information graphics, regardless of their form (print, broadcast or online) or type (map, chart, diagram), provide journalists with a different mechanism for conveying information. And, because graphics are at once visually driven and textually driven, they are often extremely rich and informative devices for conveying news and information.

In most cases, other forms of storytelling accompany a graphic. For example, a newspaper or magazine graphic often accompanies a more traditional, text-driven story. Broadcast graphics are often combined with video footage and live reports provided by a news anchor or reporter. And online graphics often represent only one piece in a package of storytelling devices, such as audio, video, text and still images. However, it is equally important to note that infor-

mation graphics for print and online should almost always be designed and written to stand alone. Because graphics are so visual, your audience may often be attracted to and therefore consume a graphic first, even though there are other elements in the story package. Thus, a reader should never come away from a graphic with major unanswered questions. The reading or viewing experience should feel complete, and the audience should feel satisfied that they have engaged with a single, independent chunk of information.

This is not necessarily the case with broadcast graphics because the nature of storytelling for this medium is much more linear in nature. Thus, an information graphic is generally encountered at a specific, designated point in a news broadcast. However, as interactive television technology begins to emerge, this too may change. Interactive television is based on the notion that television watching will eventually become a much less passive activity, and viewers will have an opportunity to navigate TV news much the same way they do the Internet. Thus, as information technologies evolve, so too will information graphics, and an effective reporter should be ready to evolve as well.

Additionally, as I stated in Chapter One, information graphics can often take you where reporters and cameras cannot. Graphics can show a sequence of events with complete accuracy after they actually happened. And because reporters and cameras can't always be everywhere in the world all the time, graphics provide us with a great tool for explaining a news event for which we weren't actually present. However, putting the pieces back together *after* a news event occurs can often make a graphics reporter's job extremely difficult. Graphics reporters absolutely *must* work to become pseudo-experts for every graphic they construct. But, beware. Remember that when you are closely related to something, especially a creative endeavor, *you* know exactly what you're talking about. *You* get it. *You* know what you're trying to accomplish. However, for the audience these ideas may not always come across as clearly as you intended. Make sure your enhanced knowledge of the subject doesn't get in the way of your ability to explain it clearly to someone else.

Finally, learn to respect the power of information graphics in news coverage, and understand that a well-researched, well-written

information graphic can be just as important, if not more important, than other storytelling devices in a package. On the other hand, a graphic with loose, incomplete information that is too verbose, vague or passive can actually impede your audience's ability to make sense of the information at hand. If the graphic confuses or frustrates the audience, you're likely to do more harm than good, leave them with more questions than answers and essentially turn them away from your publication.

In the Eyes of an Expert
What role(s) does text serve in a graphic?

Text should provide the information and context that visuals cannot. By their nature, visuals can be ambiguous; well-written sentences are not.

Infographics – whether statistical, cartographic or diagrammatic – are meant to demonstrate data visually and holistically. So the visuals in an infographic should do as much explanatory "lifting" as possible, allowing words only to qualify, specify, summarize and organize.

Do different types of graphics differ in terms of the writing styles they call for?

Not really. Even though different types of infographics will have different amounts of text based on their functions, it is important to approach the writing of every infographic with Journalism 101 basics. That is, apply the inverted pyramid when writing and organizing the infographic. Implement a hierarchy of information.

An infographic's headline should summarize the main point of the presentation. Any introductory text or "chatter" should explain the most newsworthy information within the context of the visual story being told; i.e., is the what of the story most important? Is the how of the story most important?, etc. Subsequent callouts and data then support the introduction, explaining the how, what, when, where or why as a reader

MICHAEL PRICE

Presentation Editor, San Diego Union-Tribune

Michael Price taught for 10 years at Ball State University, Muncie, IN, where he developed its journalism graphics program and was one of the founding faculty members of the College of Communication, Information and Media. A former commercial graphic designer and art director, Price was the graphics editor of the Philadelphia Inquirer and a member of the Society for News Design's board of directors. He graduated from Ball State University and completed fellowships at the Poynter Institute for Media Studies and National Geographic magazine.

processes the infographic from start to finish. The most important information goes at the top, with supporting facts and secondary information that add perspective toward the bottom.

How is writing for an information graphic different from other types of journalistic writing?

I think it is more important to concentrate on mastering certain writing basics that are common to all infographics rather than worrying about different writing styles. Brevity and conciseness are key.

Writing fluently in active voice is a must, as well as understanding that present tense is a staple of most graphics. A headline, a step in a diagrammatic sequence, an entry in a time line, a sentence that describes activity on a map – they are all written in present tense even though they often describe activity that took place in the past. Why? Because we wish to convey a sense of immediacy with our reporting, and an infographic conjures the notion that the activity is taking place before the audience's eyes as it is described.

What is the most common challenge when researching and writing for information graphics, and how can it be overcome?

The greatest challenge is often editing. Often graphics reporters want to report most of the information they researched, not realizing it isn't necessary.

A large percentage of research is applied only to the journalist's knowing the material and understanding the subject. Only the pertinent facts and explanations that visuals can't provide are important. The kitchen sink of information isn't necessary in an information graphic. Many professionals suggest loosely adopting a 25/75 ratio; that is, a graphic would contain only 25 percent text and 75 percent visuals.

Another challenge is rectifying the data in an infographic with its accompanying story. Often news artists work independently from story reporters when covering subjects because of staff

organization or the need to maximize time by working on parallel tracks. Unfortunately this can produce discrepancies in information. Catching such discrepancies within an article and its accompanying graphic is achieved by sharing information early, communicating and continuity in editing. It is essential that all involved reporters, news artists and editors review all pieces of a story package to catch and solve potential conflicts.

What types of sources do you find yourself consulting again and again?

U.S. Census Bureau; *CIA Fact Book*; *The Times World Atlas* (or other comprehensive world atlas); *The Thomas Guide* (or other reputable, local street atlas); National Oceanic and Atmospheric and Administration/National Weather Service; the Bureau of Labor Statistics inflation adjuster (www.bls.gov); a dependable online percentage-change calculator (or homemade spreadsheet equivalent); *The Statistical Abstract*; howthingswork.com; my Rolodex; and librarians, librarians, librarians.

What's the most extensive research you have ever done for an information graphic?

When I was the graphics editor for *The Philadelphia Inquirer*, my staff created a presentation that helped readers understand the nature of a severe area drought. The full page presented a visual storyboard that included charts, maps and diagrams. The infographic calculated precipitation shortfalls versus norms, reservoir levels and detailed the underground water table. It also taught readers where their water supply actually came from: a unique system of reservoirs (located hundreds of miles away) that supplies the Pennsylvania side of the Delaware River, and an underground aquifer system that supplies the New Jersey side of the river. Each staff member was responsible for one subject area of the infographic, and it took about four months to produce, including research, writing, illustration, design and editing.

Please offer five tips for graphics reporters to consider when conducting research.

1. Communicate with all staff involved in the presentation,

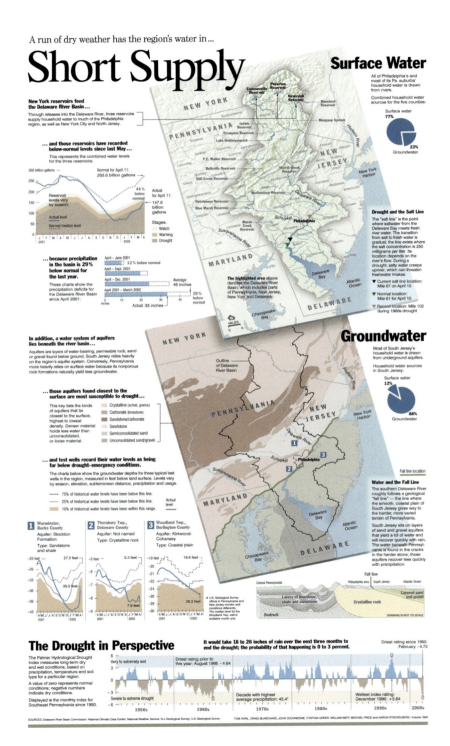

especially other reporters who are covering the same story.

2. Consult the most current, reputable sources of information.

3. Search for infographics that have been published on the same topic whenever applicable. Don't "steal" or plagiarize, but analyze the strengths and weaknesses of the example.

4. Verify your work. Check and recheck your facts, and compare them to additional sources when applicable to ensure accuracy.

5. When collecting facts, remember that the basis of many infographics is simply to answer the question: "Compared to what?"

Please offer five tips for graphics reporters to consider when composing the written components of an information graphic.

1. Apply the inverted pyramid when writing and organizing the infographic.

2. When you start, write a headline for your infographic – not a cutesy title or subject label but a subject/verb summary (probably five to 10 words) – of the visual story you are telling. That will help you keep your presentation focused.

3. Avoid jargon. Use words that any reader can understand. If technical terms must be used, make sure they are defined.

4. Have others read your work. Heed their suggestions and advice. Often the best improvements are offered by those reading an infographic for the first time, with no foreknowledge of its subject matter.

5. Study infographics in *The New York Times*, *Time* and *Newsweek*. Analyze how those publications write infographics. They do so often on very complicated subjects, with so few words; yet, they are complete. Strive for that kind of simplicity.

Chapter Three Exercise

Information graphics are often used to show how something works or how something happens. In particular, graphics commonly accompany medical and health-related stories. For this exercise you are to research the process by which blood flows through the human heart. The outcome will be a diagram that not only labels the parts of the heart, but also shows the movement of blood through the heart.

Once you have researched this process, work on writing a headline,

chatter, callouts and explainers for a print graphic. Then, think about how the text would change if the graphic were an interactive diagram presented on the Web. Finally, adapt the text into a script used to explain an animated broadcast graphic.

To effectively complete this assignment, you may need to create rough sketches of the print diagram, as well as simple storyboards for the online and broadcast pieces. This will help plan how many chunks of text or audio you'll need to effectively explain this process. If you have access to them, consult the appropriate stylebooks for your writing as well.

References
Hansen, Kathleen A. and Nora Paul. Behind the Message: Information Strategies for Communicators. Boston: Allyn & Bacon. 21 Jul. 2003.

CHAPTER
FOUR

Ethics & Graphics Reporting

In recent years, surveys of public opinion place journalism at the bottom of 15 groups in terms of public credibility – even below politicians! Thus, maintaining the highest journalistic and ethical standards for your publication's information graphics is not only important, but it's essential to the credibility and reliability of the product. The ethical and responsible journalist is one who constantly challenges and reviews his personal ethical standards, as well as those of the publication for which he works. According to Richard Keeble, author of *Ethics for Journalists*, ethical inquiry "…encourages journalists to examine their basic moral and political principles; their responsibilities and rights; their relationships to their employer and audience; their ultimate goals." And in a media age that boasts increased globalization, constant advances in technology and more media outlets and journalistic roles (i.e., reporters, photographers, editors, producers, graphics reporters, designers, etc.) than ever before, continued ethical inquiry on a number of levels must be every journalist's top priority.

In general, graphics reporters face many of the same basic everyday ethical challenges as photographers, editors and reporters who write. However, the context in which some of these challenges present themselves is often a bit different. Add to this the fact that while much has been written about the ethical responsibilities of journalists, few scholars, journalists and critics have addressed the more specialized considerations related to graphics reporting and design. Copyright laws are much sketchier where the graphic arts are concerned, and due to the specific illustration techniques used by graphics

reporters, including tracing base reference material for visual accuracy, a finer line exists between visual plagiarism and acceptable visual reporting methods. Additionally, an ethical and effective graphics reporter must understand her ethical responsibilities regarding citing sources, using Internet sources and working with numbers to ensure that the credibility and accuracy of the publication are upheld.

The Graphics Reporter's Code of Conduct

Although as a graphics reporter you may not find yourself in ethical dilemmas as regularly as other journalists, there are some common scenarios that pop up from time to time. The first of these is the tendency to be faced with incomplete data and the temptation to "fill in the blanks" in order to complete your graphic. When information is incomplete or seems to be misleading, you must make every effort to find the missing links through more research and fact-finding. Often, you can consult the original source(s) of the data and, by asking a few more questions, fill in the missing pieces of the puzzle. If this doesn't work, there are often ways to present the information you *do* have in a way that provides the reader with a bit more detail, while at the same time, makes it clear that there, in fact, *are* some missing numbers. For example, when you don't have all of the numbers for a bar, pie or fever chart, you could present the numbers you *do* have in the form of a "by the numbers" box that lists each figure and gives a simple explanation of what it represents. In this case, the worst thing you can do is try to pass off the numbers you do have as a complete set of data when they aren't. Finally, you may sometimes have to scrap the graphic until you can get the answers to your questions. Just remember that it's much worse to mislead or confuse the audience than it is to simply eliminate the graphic altogether.

Other important considerations are related to onsite reporting techniques. At times, you may be required to actually go out on assignment and gather information at the site of a news story or personally meet with sources. In these cases, you may run into three common dilemmas. The first relates to your responsibility to

always represent yourself as a journalist covering a news story. In this regard, you *must* comply with "no trespassing" signs or restrictions to private property access, as well as accurately identify yourself to sources or individuals you encounter along the way. In other words, don't lie about who you are in order to gain access to a site, and make sure you obtain permission before entering private property or when gathering source information. The second consideration relates to your rights and responsibilities as a journalist when it comes to interviewing sources. If sources say they are speaking off the record *before* you begin the interview, you *must* respect their wishes. If, on the other hand, you are clear with your source's that a formal interview is taking place, they tell you something and then later say it's off the record, you don't have to strike their statements from the record. Likewise, you may often want expert sources to review a graphic for accuracy to help make sure you have told a complicated story correctly. However, beware when sources tell you they will *only* give you the information you need if you are willing to let them have prior review of the piece before it is published. Sources should never dictate to you what you can or can't run as long as they were clear at the time of the interview that they were being interviewed on the record. Finally, a third consideration related to onsite reporting relates to access to certain documents that may be considered privileged. Be aware that in a post-9/11 world, gaining access to building blueprints and other types of sensitive information is more difficult. Provide yourself with enough time to get the information you need, and know that in the interests of security, you may not be able to gain access to information that could be considered privileged.

Certainly, you are likely to encounter other specific ethical dilemmas during your graphics reporting career, but regardless of what you face, you can always rely on three key concepts by which to measure your conduct: (1) your individual conscience; (2) your publication's policies; and (3) common sense and professionalism. Chances are, if you feel "funny" about some action you're considering taking, you shouldn't do it! If you're hoping to yourself that no one finds out, rethink your plan. If you are uncertain about the proper approach to take, talk with your colleagues and your boss. Find out what they would do or if your publication has a formal pol-

icy or statement regarding this or similar scenarios. Rely on your own sense of objectivity, balance, fair play, accuracy, credibility, neutrality, social/cultural responsibility and the general public interest. If you find yourself in an ethical conundrum, chances are you already know the answer. Sometimes, you just have to dig for it.

Visual Plagiarism & Copyright

Plagiarism is defined as the presentation of work, in any form, that is not the reporter's own or without acknowledgment of the sources from which the information originally came. Thus, if a reporter who writes, submits a story or any piece of a story that she didn't report and write yet claims it as her own, she has committed plagiarism. Likewise, if an artist copies a work that he didn't create, he is in violation of visual plagiarism. Plagiarism is theft. Period. And those who engage in plagiarism cannot only be held ethically responsible for their discretions, but they may be held legally responsible for violating federal copyright laws. Copyright laws are a collection of rights related to the reproduction, distribution, performance, etc., of original literary, musical, dramatic or artistic works, that protect the creator of such material(s) to the exclusive ownership. Thus, you may not simply scan an image from another publication, book, the Internet, etc., and rerun it in your publication without permission from the owner. Nor may you lift the text from an existing graphic or written work and use it in your graphic. Instead you must create your own illustration and adapt the textual information to fit. Now that you know what you *can't* do, let's talk about what you *can* do. Just like any other type of reporter, a graphics reporter's job is to locate credible sources for information and then conduct research and interviews to develop a cohesive, tightly edited graphic that effectively tells a news story. And, assuming you're not an expert in every field from science, to medicine, to technology, to architecture and so on, you'll likely need to consult outside sources for both the visual and textual information that will be included in your graphic. Thus, it is acceptable to draw both visual and textual information from reference books, such as encyclopedias and visual dictionaries; atlases and other reference maps; and architectural drawings, photographs and official or credible

Web sites. It will also often be necessary for you to sketch drawings and illustrations based on these references in order to ensure that your reproduction is accurate according to an official source. However, the key to maintaining ethics in visual reporting is to clearly give credit to those sources you do use.

Most source lines appear in the bottom left-hand corner of your graphic, outside the boundaries set for the graphics package itself. Most publications list all initial sources and omit sources that are used solely to confirm or verify the accuracy of initial sources. In any event, know your publication's policy for citing sources, and *do not* stray from it.

The Internet as a Source

Chapter Three, "Research & Writing for Information Graphics," goes into greater detail regarding the benefits and pitfalls of searching the Internet for sources of textual information for your graphics. And, basically, the same rules for ensuring that text found on the Internet is accurate and reputable apply to visual sources, as well. To review, you should always obtain the name of the individual, organization or group responsible for the site's publication so you can check up on them and find out if they are reputable; make sure the site includes a revision date so that you can determine whether the information published there is up-to-date; and find multiple sources that corroborate your primary source to ensure the information found there is accurate.

The latter of these tips is probably the most important when it comes to visual sources. Visual accuracy is a must when it comes to maps, diagrams and other types of news graphics. If you are creating an illustration of the human heart, for example, it must be exact. This is not an artistic representation of the heart, and shouldn't be over-simplified, leaving out important visual information. Therefore, you must find accurate and reputable sources for this graphic. Don't rely on a random illustration of the heart if you aren't certain it was created by a reliable source. Because virtually anyone can post information to the Web without having to adhere to any specific standards regarding the validity of their content, you should be safe and consult multiple visual resources to confirm the accuracy of the image.

Working with Numbers

Believe it or not, it's easy to make statistics lie. It's called massaging the facts, and people do it all the time. Struggling companies often report earnings in a variety of contexts to make their financial failures seem less magnified. Organizations report statistical data without clarifying the span of time over which the data was collected or the number of people polled in order to make the report seem more significant. People compare apples to oranges in an attempt to make issues or events seem more or less important than they really are. It happens every day in every sector of our world, and if graphics reporters aren't careful, they can easily fall prey to this deception and can even perpetuate it.

To avoid this, graphics reporters should develop a keen eye for spotting problems with statistics in order to avoid the embarrassment and possible liability of reporting incorrect information. Also, graphics reporters conducting their own research that involves numerical data should make every effort to gather information with grave attention to the details of accurate and ethical reporting. Chapter Eight will go into more detail regarding how to synthesize a set of numbers and convert them into a useful graphic.

Diversity in Information Graphics

It is human nature to be more comfortable approaching people who look like you. For this reason, journalists must constantly be mindful of their responsibility to consult all types of people in their reporting to ensure that the diversity of the population is adequately represented. Male *and* female perspectives must be represented. Likewise, different races, social classes and cultural groups must be represented. As journalists, we must always work to offer a variety of perspectives and avoid alienating individuals who represent a different way of thinking.

The same concepts can be applied to visual journalism, such as photography and graphics reporting. We have a responsibility to represent different types of people in our graphics and photographs as much as a writer should consult diverse sources for a written story. This is important on two levels. First, we must recognize the

fact that people are generally drawn to and more likely to trust reporting that represents people who *look* like them. We want to see ourselves and others we feel we can relate to in the pages of our newspapers, on our nightly news broadcasts and on the news and information Web sites we frequent. Therefore, when developing information graphics that include human figures, avoid always using the same skin tones or gender. Second, because we will have a tendency to consult real people or experts in a particular field for our graphics, we must seek diversity in our information gathering as well. Make sure that your list of commonly consulted sources includes some cultural and gender-oriented diversity, and review your graphics for these staples of good reporting as well.

In the Eyes of an Expert

What are some common ethical challenges graphics reporters encounter, and how should the responsible graphics reporter deal with each?

I appreciate that we are discussing this issue because throughout my career as a graphics journalist, I've encountered almost every ethical dilemma that a reporter (who writes) encounters. Here are a few:

For artists, (plagiarism) would be copying someone else's artwork or reworking a wire graphic and putting your name at the bottom of the graphic. Copying photographs or illustrating over someone else's photograph to make it look illustrated and taking credit for it would also qualify as plagiarism, and it's done quite often. The best advice I can give to artists on this matter is to sketch, and don't trace, unless it is your own photo. Use other references as inspiration, but don't copy someone else's artwork; and be careful about ripping off ideas. The temptation is so great at times, especially when you're on deadline and you're desperate for an idea or an image.

Always identify yourself as a journalist in the field. Let your sources know whom they are talking to. You are often seen as the bad guy when you're snooping around crash sites, crime scenes

JEFF GOERTZEN

**Senior Artist,
St. Petersburg Times**

Jeff Goertzen is a senior graphics journalist for the St. Petersburg Times and an international graphics consultant. He has worked with more than 60 newspapers around the world building graphics departments and training journalists, editors and graphics artists how to incorporate graphics in their daily news coverage. His clients include USA Today, El Mundo in Spain, Le Monde in Paris and New Straits Times in Malaysia. He has been a visiting faculty member for the Poynter Institute for Media Studies since 1987 and serves on the Society for News Design Board of Directors where he organizes graphics workshops around the world. His work as a graphics journalist has won dozens of awards both with the Society for News Design and the Malofiej. Jeff has a master's degree in journalism and fine arts from the California State University at Fresno.

or wherever there is controversy. Witnesses just don't want to talk with you. But our code of ethics, at least at the *St. Petersburg Times*, is to disclose your identity to your sources. It can be difficult at times, but then it's your job is to gain their trust. Get them to talk to you. That's part of the job.

Never accept gifts or any tokens of appreciation from sources. That has happened quite often, especially when doing a feature story or feature graphic. The word "feature" has a schmoozy connotation. It sounds fluffy and inviting, almost always good spirited. Sources sense that. But what happens if during the interview you stumble onto some rather controversial or questionable information? That free coffee you might have just accepted from your source can quickly turn bitter.

Don't develop personal friendships with sources. I'm not sure if this one is written in the journalist's code of ethics, but I try to keep the relationship strictly professional. Getting too friendly or too comfortable with your sources can cloud your objectivity as a reporter.

Can you offer some onsite reporting tips/techniques every graphics reporter should know?

1. Always take a digital camera with you, a reporter's note pad and a pen – never a pencil (they can break). AND DON'T FORGET YOUR PRESS CREDENTIALS!!!!!
2. The first thing I do when I arrive on the scene is look for the TV trucks and satellite towers. That's where I'll find the press.
3. The next thing I do is hook up with the reporter and photographer from my newspaper. I get caught up on the story and find out what information they have obtained. This gets me up-to-date and keeps me from asking the public relations officer questions that have been answered already. I then write down a list of questions I need to have answered to make the graphic.
4. Take as many reference photos you think are necessary. Then, take more, just to be sure.
5. Talk with witnesses, and write down their names and telephone numbers. That's always easy to forget.

6. Don't be afraid to horn in on TV interviews being conducted by TV reporters. Just do it! Everyone's there for the same information, and they will only broadcast what the witnesses say, not the questions they are being asked.

7. Learn as much as you can from watching other reporters at work. They have a ton of experience.

What was the most challenging onsite reporting situation you have encountered? How was it challenging, and how did you deal with it?

My interview with Tony Hawk was by far the most challenging. He was doing his Boom-Boom Huckjam Tour throughout the United States and was scheduled to reach the Tampa Bay area toward the end of the tour. I was to fly out to San Diego to interview him and research how they assemble and disassemble the track and his world-famous "vert ramp." I knew virtually nothing about extreme skateboarding, and I had very little time to brush up on the event before I had to meet up with Tony in San Diego.

I was told I would only have five, maybe 10 minutes with Tony. When he sat down at the table, it was hard to keep my cool and conduct a smooth interview. My mind almost went blank, and I could barely keep from stuttering. There's really nothing you can do to prepare for celebrity interviews. Trying to keep cool and focused in these sorts of situations is something you don't learn in school. It takes experience.

That was only half of the research. The other half was trying to get a full understanding how the enormous track and vert ramp is assembled and disassembled. Trying to be everywhere at once and not miss anything is an incredible challenge. Also, knowing where to go, who to talk to and where to find the sources while all the mayhem of the track assembly is taking place is nearly impossible.

Fortunately, in the few days I had to prepare for the interview, I had developed a lot of trust with the media relations director. She sensed my enthusiasm for the event and put me in touch with the proper sources so when I arrived, I wouldn't waste any time. I also had a list of questions ready for the various inter-

Goertzen taped his interview with Hawk. With only five to 10 minutes to interview the athlete, Goertzen was able to gather some of the information needed to explain how they assemble and disassemble the track and his world-famous "vert ramp."

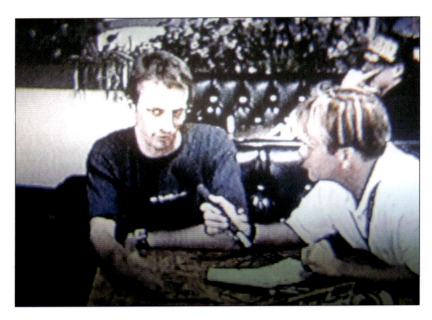

views. I took lots of photos and came back with more information than I would possibly need.

What's the most challenging ethical dilemma you have encountered as a graphics reporter? How was it challenging, and how did you deal with it?

Probably the Tony Hawk interview. The relationship I developed with the public information officer over the phone was definitely an advantage. I love communicating and conversing with people, especially sources. Charm has always worked in my favor. You want to build that trust, but you don't want to get too personal with your sources. You have to keep emotions (friendship) at a distance so you don't give the wrong impression. In this particular case, I was given many opportunities to accept free food and free tickets. Of course, I had to refuse them. Also, the graphic that we published in our paper, in essence, was good publicity for the Tony Hawk Tour. We published the graphic the day the event came to Tampa, and the whole crew in the Tour had seen the graphic. That evening, I attended the press pool at the Forum in Tampa, and Tony, himself, having seen the graphic, invited me up on the stage to shake my hand and take a few photos.

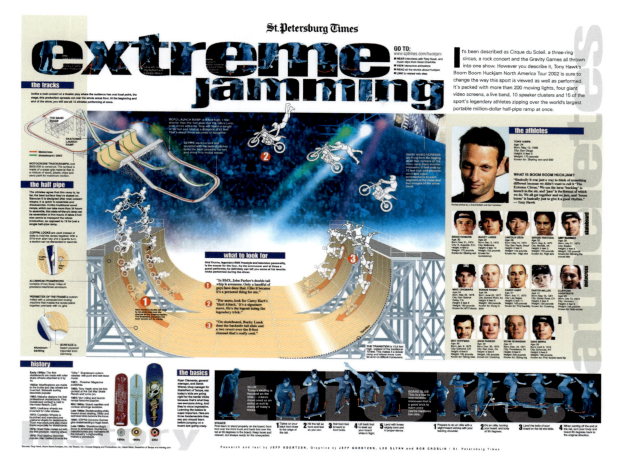

If you had to put your own "code of conduct" as a graphics reporter into words, what would it be?

The reporters in the newsroom (who write) are your role models. Follow all the same rules they follow. Work like they work; think like they think; act like they act. Learn from them. They are proactive on the phone and on the streets, constantly looking for stories. You do the same.

How do technology/software capabilities play into ethical responsibilities for graphics reporters?

Adobe Photoshop has definitely made it easier for us to cross the ethical line in the way we use digital imagery. There have been numerous cases where photojournalists have manipulated

their photographs to become something that isn't a true account of what occurred when the photo was taken. Designers in newspapers I've worked with in other countries have been known to scan photos from other magazines as quick fixes for feature page designs. There's no doubt that digital imagery and the software we use to manipulate them have been abused.

Does visual plagiarism exist in graphics reporting?

As I mentioned earlier, the misuse of visual images is a common problem in the print media. I've seen many cases where graphics artists copy graphics from other publications without giving proper credit to their sources. Plagiarism occurs quite often in the graphics industry. What's sad is the apparent double standard that seems to exist: If a reporter is caught lifting material from another story or inventing facts in a story, it makes headlines, and the reporter is fired. I've yet to see that happen with a graphics reporter. My only explanation and fear are that perhaps our profession is not held to the same standards as reporters, and it should be.

Are there pitfalls to using the Internet as a source?

Be careful with the Internet. I use it quite often as a source of preliminary research. I still prefer first-hand information. That is, information from one-on-one interviews. There is a lot of bad information out there in the Internet. Be careful where you get your sources. Always use two or three sources. Government Web sites are pretty reliable.

Chapter Four Exercise

Often, the best way to improve your reporting, writing and illustration skills is to analyze work created by someone else. Find ways to be inspired by their strengths and learn from their weaknesses. Put yourself in the mind of the audience, and analyze a graphic as they would.

For this exercise, you need to spend some time looking at information graphics from a number of sources. You'll have the best luck with print and online sources because they are greater in number and it will be easier to gain access to them for review than broadcast graphics.

Examine the graphics you find for the accuracy of their content.

Look for discrepancies between what is presented in the written story and what is shown in the graphic. Look for instances of misrepresented facts or misleading statistics. Once you have found three examples, write a one-page analysis of the graphic. Explain its deficiencies and how it could be improved. In order to do this effectively, you may also need to do some digging of your own. If you are suspicious about a graphic, conduct some of your own research and see if you can track down the sources that will help clarify the information. Then, cite those sources in your analysis.

Some great sources for finding graphics are your local newspaper and newspaper Web sites, as well as the local library for newspapers from cities and states from across the country. Another good place to look is the news page designer's Web site, newspagedesigner.com, which has a catalog of information graphics from all over the world. Finally, sun-sentinel.com/broadband/theedge/, MSNBC.com and nytimes.com are sites very committed to multimedia graphics reporting and can be excellent places to review online graphics.

References

Edelman, Murray and Don Dillman. "What Is a Scientific Sample Survey or Poll?" Jan. 2002. The AAPOR Standards Committee. 2 Jan. 2005. <www.aapor.org/default.asp?ID=27&page=news_and_issue/aapor_ newsletter_detail>.

Franklin Pierce Law Center. Ed. Thomas G. Field, Jr. Dec. 2002. Pierce Law, Concord, NH. 2 Jan. 2005 <http://www.piercelaw.edu/tfield/copyVis.htm>.

Intellectual Property Law Server. Ed. George A. Wowk. Dec. 2004. Parlee McLaws LLP. 2 Jan. 2005 < www.intelproplaw.com/copyright>.

Designing Information Graphics

Actually composing an information graphic – putting all of the pieces together in a rhythmic, orderly, interesting design – is equal in importance to writing the text and creating the main illustrations. In fact, the design of the graphic can have a direct impact on an audience's ability to follow the information that is presented in an efficient and logical manner. Design can also affect the level of meaning and understanding an audience will take away from the graphic. Thus, understanding how to compose/design an information graphic is paramount to a graphics reporter's ability to succeed.

Basic design principles have been studied and implemented since the days of the ancient Roman and Greek architects, sculptors and artists. Visual experimentation in the fine arts has led to principles that were later applied in the design fields. While every graphics reporter should feel a degree of creative freedom when working, there are certain concepts that are tried and true for ensuring your work is fundamentally sound.

The Seven Basic Design Principles

In communications design, there are seven basic design principles commonly observed by page designers, graphics reporters, illustrators and even photographers for composing their work. While each principle represents a different concept, each is strongly related to the others, and their incorporation into the design process is essential to developing strong visual presentations.

Symmetrical balance is a more deliberate, formal organization of elements. By organizing elements symmetrically, the reporter can place equal importance on more than one aspect of the graphic.

Graphic by Katie Smith.
Used with permission.

Protocol for four-way stop intersections

Proper four-way stop protocol could have prevented Monday's four-car accident at the intersection of Main and Elm streets. The diagrams below illustrate how the accident happened, and what drivers should have done.

What happened

Witnesses say Car A arrived at the intersection first. Seconds later, Car B and Car C arrived at exactly the same time, followed shortly by Car D. After stopping, all four cars drove straight through the intersection at the same time, resulting in a four-car collision.

What should have happened

Since Car A arrived at the intersection first, it should have proceeded first. When two cars arrive at the same time, the car on the right has the right-of way, so Car B should have gone before Car C. Since Car D arrived last, it should have proceeded last.

Artists, architects and others dedicated to visual pursuits use these design principles each in slightly different ways to measure the quality of their work. When an architect designs a building, for example, she must adhere to certain structural principles. If she doesn't, the building may be wobbly, at best, or it may collapse entirely, at worst. This is true for communications design as well.

I often advise students to first memorize these principles and engrave them in their brains so that each and every time they begin a graphic, these principles are among the key considerations throughout the process. It's also a good idea to list the seven principles on a piece of paper and post it to the edge of your computer screen. As you're working on a graphic, and certainly as you're going through final edits, run through the list of principles and make sure you have adhered to each of them in your graphic design. If one has been neglected, chances are the composition of your graphic could use some revising.

BALANCE: When weight is distributed evenly, the result is balance. Because elements in graphic design have visual weight, they need to be arranged so that a comfortable sense of equilibrium is achieved.

Generally, they are arranged in relation to an invisible vertical axis. Balance does not need to be precisely equal. Slight, but controlled, imbalance can add a great deal of visual interest to a design. In graphic design, we are concerned with two different types of balance, asymmetrical and symmetrical.

If a composition consists of two vertical halves that are unlike, the balance is considered to be asymmetrical or informal. Although the sections aren't identical, they should still have relatively equal weight and visual appeal to maintain a sense of balance. Asymmetrical balance is commonly used in the composition of information graphics, because it generates a sense of movement and helps guide the eye through the information in an extremely rhythmic manner.

Imagine a scene or an object folded in half right down the center. If the shapes on both sides appear identical, symmetrical balance is present. Symmetrical balance conveys a stability and uniformity. Nature is full of symmetry. The human body is designed symmetrically – two eyes, two arms, two legs, etc. In publications design, symmetrical balance is often applied when the message is more conservative or calls for a more subdued, classic look.

PROPORTION: If everything is "big," nothing is "big." Likewise, if everything is "small," nothing is "small." Large and small are relative

In this example, asymmetrical balance is used to enhance the degree of emphasis that is placed on the dominant illustration and create a more rhythmic presentation. Also inherent in this example is a sense of proportion. The visual elements are directly proportionate to one another, their level of importance, within the presentation and in relation to the overall space.

Graphic by Shawn Barkdull. Used with permission.

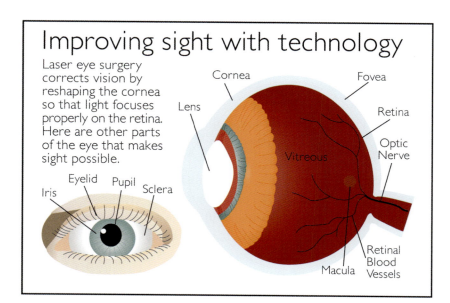

Improving sight with technology

Laser eye surgery corrects vision by reshaping the cornea so that light focuses properly on the retina. Here are other parts of the eye that makes sight possible.

Iris
Eyelid
Pupil
Sclera

Cornea
Lens
Fovea
Retina
Optic Nerve
Vitreous
Macula
Retinal Blood Vessels

terms. Each needs the other in order for either to exist. Thus, proportion refers to the size of one element in relation to the other elements in a graphic or the overall space devoted to the graphics package. In other words, it refers to how large or small an element is compared to its surroundings. Proportion can be achieved through size, shape and tone, and it can help establish importance through emphasis.

Proportion is important to information graphics because it helps create a sense of hierarchy and order among the elements. For example, if the headline or title for a graphic is too small, it could get lost among the other elements. Likewise, if it is too large, it could overpower more important visual elements. And, the headline should be proportionate to the total amount of space devoted to a graphic. A 54-point headline would be way too large for a graphic that occupies only two columns of a broadsheet newspaper page. However, if the graphic is large enough to fill an entire broadsheet page, the 54-point headline would be just right in relation to other elements on the page and the size of the page itself.

Proportion is also achieved by incorporating elements of varying sizes or shapes in a layout. This practice allows us to compare them to one another and make visual judgments about their relative sizes and shapes or proportion. Adhering to proportional size and shape relationships will result in a more interesting overall visual effect than if all elements are more or less the same size. Proportion is also useful in contributing to a sense of depth. A large, dominant item is immediately perceived as being closer, or in the foreground, whereas the smaller element is perceived as being farther away, or in the background. Thus, the main illustration in a graphics package should be considerably larger than any other element because it is likely the most important.

CONTRAST: The human eye notices distinct change more readily than when there is little or no difference among elements. By introducing various levels of visual contrast, a graphics reporter can emphasize important information, create visual hierarchy and help activate eye movement on a page. Every design should have some degree of contrast; however, the level of contrast you choose to incorporate is generally dependent upon the nature of the content.

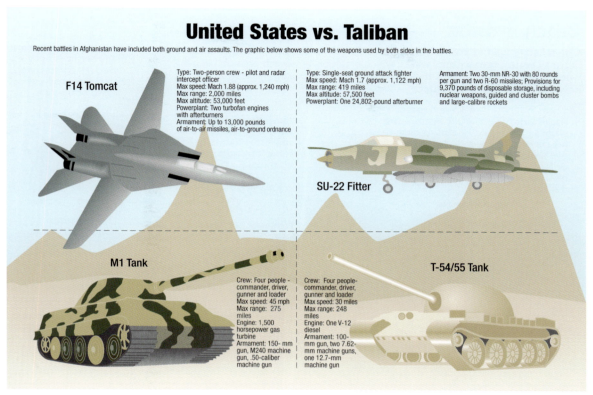

United States vs. Taliban

Recent battles in Afghanistan have included both ground and air assaults. The graphic below shows some of the weapons used by both sides in the battles.

F14 Tomcat

Type: Two-person crew - pilot and radar intercept officer
Max speed: Mach 1.88 (approx. 1,240 mph)
Max range: 2,000 miles
Max altitude: 53,000 feet
Powerplant: Two turbofan engines with afterburners
Armament: Up to 13,000 pounds of air-to-air missiles, air-to-ground ordnance

Type: Single-seat ground attack fighter
Max speed: Mach 1.7 (approx. 1,122 mph)
Max range: 419 miles
Max altitude: 57,500 feet
Powerplant: One 24,802-pound afterburner

Armament: Two 30-mm NR-30 with 80 rounds per gun and two R-60 missiles; Provisions for 9,370 pounds of disposable storage, including nuclear weapons, guided and cluster bombs and large-calibre rockets

SU-22 Fitter

M1 Tank

Crew: Four people - commander, driver, gunner and loader
Max speed: 45 mph
Max range: 275 miles
Engine: 1,500 horsepower gas turbine
Armament: 150- mm gun, M240 machine gun, .50-caliber machine gun

Crew: Four people- commander, driver, gunner and loader
Max speed: 30 miles
Max range: 248 miles
Engine: One V-12 diesel
Armament: 100-mm gun, two 7.62-mm machine guns, one 12.7-mm machine gun

T-54/55 Tank

Contrast can be created by using varying sizes and shapes of elements, implementing the use of color and through the use of a typographic palette that incorporates a number of different fonts.

Typographic contrast is very important to information graphics design. Through the use of varying fonts and type sizes, you can distinguish among different levels of information, from headlines and labels, to chatter and explainers. This contributes to both the visual appeal of a design and the ordering of items on a page.

Shape contrast breaks up the repetition in a graphic. By implementing the use of elements with different shapes, you can work to minimize harmony and add contrast and variety to the printed page.

HARMONY: While some degree of contrast is necessary for a graphic to be effective, so is some degree of harmony. Harmony refers to how well the individual elements on a page work together. Is the color scheme harmonious? Do the typefaces chosen work well together? Is the overall presentation effective for the relative con-

> The symmetry and unified type palette establish a great deal of harmony in this graphic. Contrast is introduced through differences in color and shape, as well as the typographic texture that exists in the bold and light combinations.
>
> *Graphic by Josh Engleman.*
> *Used with permission.*

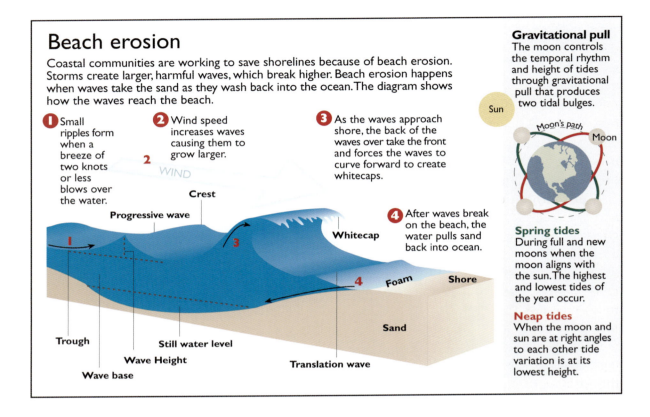

Beach erosion

Coastal communities are working to save shorelines because of beach erosion. Storms create larger, harmful waves, which break higher. Beach erosion happens when waves take the sand as they wash back into the ocean. The diagram shows how the waves reach the beach.

1 Small ripples form when a breeze of two knots or less blows over the water.

2 Wind speed increases waves causing them to grow larger.

3 As the waves approach shore, the back of the waves over take the front and forces the waves to curve forward to create whitecaps.

4 After waves break on the beach, the water pulls sand back into ocean.

WIND

Crest

Progressive wave

Whitecap

Foam Shore

Trough

Still water level

Sand

Wave Height

Wave base

Translation wave

Gravitational pull
The moon controls the temporal rhythm and height of tides through gravitational pull that produces two tidal bulges.

Sun

Moon's path

Moon

Spring tides
During full and new moons when the moon aligns with the sun. The highest and lowest tides of the year occur.

Neap tides
When the moon and sun are at right angles to each other tide variation is at its lowest height.

▲ **Several techniques are used in this display to create a sense of rhythm. The arrow is used to create a sense of implied motion. Numbers are used to represent a chronological ordering of events, and the general placement and sizing of elements in an asymmetrical display helps to rhythmically move the eye through the information.**

Graphic by Shawn Barkdull.
Used with permission.

tent? These are all questions a graphics reporter should ask when trying to determine how to introduce harmony to a design.

You can work toward typographic harmony by choosing typefaces that work well together for one reason or another. Likewise, harmony can be introduced through the predominant use of vertical or horizontal shapes within a graphic layout. For example, if the graphic is a vertical shape, the elements in the layout should repeat the same format to achieve harmony of shape in the design.

RHYTHM: Just as rhythm in music can move you to dance, sway or tap your foot, visual rhythm is the combination and arrangement of elements that moves your eyes through a graphic presentation. Visual rhythm can be achieved by repeating patterns that are similar in size, shape or color, by alternating elements that contrast one another in some way or by placing elements in a manner that creates progression, such as small to large or light to dark.

Graphics reporters must always be aware of the rhythm of a design. It is important to move a reader through and around the graphic so that nothing is overlooked or dismissed due to its ineffective placement. When considering the rhythm of a presentation, think about your audience's natural eye movement. In Western culture, we are taught to read left to right, top to bottom. For this reason, our eyes have been trained to move in this pattern when we view most complex objects. The natural path of the eye, then, moves us in the form of a z-pattern when we visually navigate a graphic design.

Thus, rhythm can be achieved in a variety of different ways. Asymmetrical balance is most commonly used in the design of graphics because it is the most effective way to move the eye around a graphic. Repetition in the placement of like elements or even the same element can also establish rhythm in a graphic. The similarity of the elements makes a visual connection for the eye and moves it from one to the next. Chronological, numerical or alphabetic placement of elements is also a simple way to create rhythm. This placement creates an obvious order for the eye to follow. Finally, integrating visual elements that are directional in nature often helps lead the eye in a specific direction. This could be something as simple as the use of an arrow in a design.

FOCUS: While there are several ways to create focus, each method results in creating a difference of some kind among elements in a graphic. Focal points are important for grabbing a reader's attention and establishing importance and visual hierarchy.

One of the most important rules of thumb for any graphic designer is that there must always be a dominant element, which is usually the main illustration. This refers to the one object within the design that is larger than the others. By introducing a dominant element, a good designer creates a focal point, or an area to which the eye is drawn most strongly. Once a dominant element is established, the addition of secondary and tertiary focal points is necessary. In information graphics, these are usually secondary illustrations and explanatory text blocks. Remember that the dominant element should be noticeably larger than the other elements within a graphic. In fact, the dominant element can be up to three times as large as any other element in a graphic presentation.

THE PERFECT SET

In volleyball, there are three essential moves, the pass, set and spike. After pass sends the ball to the setter, she lofts the ball into the air for the next move, the spike. Here are three basic steps to a perfect set.

Step One

Position yourself under the ball, shoulders facing the hitter. Steady your footing with your dominant foot forward. Hold your hands above your forehead creating a window, with your thumbs and index fingers touching. Spread the rest of your fingers out as if you were actually holding the volleyball.

Step Two

With your arms and legs slightly bent, contact the ball above your head. The ball should land in your fingers and should never touch the palms of your hands. The main points of contact should be your thumbs and index fingers, while the other fingers should touch slightly for control.

Step Three

Extend your arms and legs, pushing the ball with your fingers toward your target. Move in the direction of the set, shifting your weight toward the target. The ball should only contact your hands for a split second.

▲ **In this graphic, you can see the underlying grid the graphics reporter used to help organize and size the visual elements of the graphic. Note that each element, from text blocks to illustrations, locks to the grid.**

Graphic by Robin Anderson. Used with permission.

UNITY: In publications design, unity generally refers to the overall cohesiveness of the design of the entire publication. At first, unity may sound a lot like harmony. However, while harmony refers to how elements in a specific graphic or in a page design work together, unity refers to the cohesiveness of the entire product. Unity can best be achieved through the implementation of consistent typographic and/or color palettes and a uniform grid system.

After becoming familiar with a publication, a consumer should be able to immediately recognize graphics from that publication simply based on the consistent presentation of type and color. Thus, most publications will have already established these palettes, and you should always adhere to them when composing new graphics.

Working with a Grid

One of the best things you can do to help make sure your graphic layout is active, easy to navigate, logical and attractive is to work with a grid structure. While the average reader may not recognize your efforts in this regard, working with a grid will go a long way toward making sure the composition of your graphic supports all of the visual elements present in the graphic. In fact, the grid can be likened to the frame of a house. Without a frame made of equally spaced wooden beams, the structure would be weak, the house would be unbalanced and the homeowners would be subject to major structural problems down the road. Ceilings would cave in and walls would become cracked and deteriorate. Likewise, if a designer fails to incorporate a grid structure into the creation of an information graphic, she risks building a framework that is weak and unstable.

You may have already noticed that grids are most closely related to the basic design principles of balance and rhythm through place-ment and proportion through size relationships. By using a grid when you design graphics, you establish a mechanism for making sure the visual weight of your graphic is balanced and all elements within the design are well aligned. This is important because graph-ics that are top/bottom/left/right heavy, fail to adequately move the reader through all of the key elements. Instead, your audience is likely to get stuck in the heavy dominance of the area that holds excessive amounts of visual weight. A grid also helps ensure that the sizes of individual elements are both proportionate to one another and to the overall canvass of the graphic. This is achieved by mak-ing sure that every element is sized in relation to the grid, with each one locking to the grid on the left and right. This is important because disproportion offends the visual appeal of the graphic and causes elements that are too large to drown out and overpower those which are too small.

The grid you choose for your graphic may be based on a variety of things. If you are designing for a newspaper, magazine or other type of print publication, your grid will likely be based on the columnar (vertical) grid already established for that publication. Newspapers generally use six-column grids for their editorial con-

tent. Thus, the overall size of your graphic will likely be between one and six standard broadsheet or tabloid columns in width. Doubling that grid – turning a six-column grid into a twelve-column grid – can be extremely helpful for designing information graphics because you will often be dealing with many small blocks of explanatory text or smaller, secondary illustrations. Then, to make your grid even more precise, add horizontal lines that create exact squares when combined with your vertical grid lines. By doubling the grid and adding a horizontal baseline, you establish for yourself a much more detailed grid to work with and a nice guide for the placement of all of those smaller elements.

If you are developing graphics for the Web, you will likely have a pre-established amount of space to work with as well. If your editor hasn't already established a grid, it's in your best interests to do so. And, while broadcast graphics don't generally contain much text, there may be a number of illustrative pieces for which you will need to establish proportions and balance. In both cases, you may simply choose a logical number of vertical and horizontal columns – proportionate to the overall size of the media format – that allow you to place textual and visual elements in a proportionate and balanced arrangement.

Color & Type Palettes

Using established color and typographic palettes for your information graphics is imperative when attempting to establish unity for your publication and harmony for your individual graphics. Not only will you create a sense of visual recognition that will become a part of your publication's visual identity, but you will also ensure that similar elements within a single graphics package are designed in a similar fashion. This will eliminate confusion and disorder for your audience. Chances are, the publication you work for will have established these palettes a long time ago. However, should you ever find yourself participating in a redesign or the creation of a new product, there are several important considerations to be mindful of when developing new color and type palettes.

COLOR PALETTES: Developing a well-rounded color palette that covers

COLOR CHECKLIST

Strive for visual accuracy: Your first and primary objective should be to accurately reflect the visual appearance of your subject matter by choosing colors that are as close to reality as possible.

Establish a consistent choice of colors: Make sure you have an adequate number of greens, blues, browns and flesh tones in your palette. Then round it out with a few neutral, pastel tints.

Text is best in black: Avoid color in chatter and explainers. It causes type to be difficult to read in small sizes.

Avoid creating false relationships: By using the same color for elements within your graphic, you will automatically create a visual connection between them. Be careful that the associations that are caused by color combinations aren't unnatural.

all the necessary bases is important. If you don't, members of the graphics staff may be inclined to arbitrarily mix new colors later because the palette doesn't contain one they need. Before you know it, there will be stray colors in a variety of shades floating around the publication, defeating the original purpose for establishing a palette at all.

There are a few colors that are essential for every color palette. For example, graphics often depict images of nature or human beings. Thus, your graphics palette should contain several shades of green for trees and grass, browns and tans for earth and ground and blues for water and sky. You should also include a wide range of flesh tones to represent individuals with very light skin to very dark skin. This will ensure that you never lack a skin tone you may eventually need, as well as account for racial and ethnic diversity among the human figures illustrated in your graphics. A few shades of red, orange, yellow and violet from deeper tones to brighter tones are also necessary to represent the natural colors of the world in which we live. Finally, complete the palette with a number of pastel tints in neutral shades like peach and tan to be used when background shades are necessary. Darker hues like red, green or blue generally make poor background shades because they are too dark and intense to recede into the background of your graphic. Thus, they often overpower the content they are meant to highlight.

If you're developing graphics for print, beware that one of the biggest mistakes you can make when developing a color palette is to rely on only your computer screen for determining the appearance of certain mixes. Depending on the type of paper on which you are printing and the presses on which your publication is produced, the colors you mix on screen may look very different in print. Therefore, when you have chosen a set of colors for your palette, run a press test to make sure the colors will print the way you intended. If they do not, you may need to adjust the color mixes until they are accurate. Then, don't ever worry if they look strange on the screen. If you have tested them in print, that's all you need to worry about. Finally, remember that when you are creating graphics for the Web and broadcast, you are working with the additive color palette, RGB (red, green, blue). Color that is printed, on the other hand, is subtractive, CMYK (cyan, magenta, yellow and black). When developing a color palette for print, you can mix various shades of these four colors to

TYPE CHECKLIST

Choose a sans serif: Most graphics type palettes make use of a single sans serif font that comes in a number of weights and widths. Sans serifs are considered to be most readable in small sizes when combined with complex illustrations.

Develop an inventory of styles: Make a list of all of the possible typographic elements you may need to create an information graphic – headlines, chatter, labels, etc.

Create prototypes for different kinds of graphics: Test different weights and sizes in graphics prototypes to determine the most readable and space-efficient styles for different typographic elements.

Develop a hierarchy among elements: Use different sizes and weights to distinguish among different styles, such as headlines, explainers and labels. The difference doesn't necessarily have to be extreme, but is necessary to provide adequate contrast among typographic elements in a graphic.

Stick to it: Once you have established a type palette, don't stray from it. This will only interfere with the harmony of individual graphics and the unity of the entire publication.

produce every color in the rainbow. When developing color for the Web, you must choose from a limited number of pre-established Web-safe colors.

TYPE PALETTES: Establishing a type palette is much like establishing a color palette. However, for information graphics, you'll be dealing with a lot fewer typefaces than you were colors. In fact, a good graphics type palette may actually only make use of one font, and different weights and sizes of the font are then used for hierarchy and contrast. Furthermore, most graphics type palettes make use of only sans serif faces to eliminate any unnecessary clutter in presentation. Because sans serif faces generally have little or no differentiation in stroke thickness and because they are generally pretty clean and streamlined, they tend to read more clearly when combined with complex illustrations. Serif fonts, on the other hand, tend to be much more detailed, with differences in stroke thickness and small "feet" on the ends of the letterforms. Therefore, when combined with illustrations that may contain complex lines and use of color, they tend to be less readable and can potentially clutter a graphic unnecessarily.

So, your first step when creating a typographic palette for information graphics is to choose the typeface, preferably a sans serif, that will be the main font in the palette. You may have occasion to choose one additional font if you are concerned with adding a bit more contrast to the palette. But, I wouldn't advise more than two fonts for your type palette. Too many fonts will only interfere with the overall unity and harmony of your palette. If you are working for a larger publication that presents other types of information in textual formats, such as a newspaper, magazine or Web site, chances are your type palette will need to align with the type palette for the entire publication. For example, if a sans serif has been chosen for fact boxes, story labels or headlines, you will likely want to use the same font in its various weights for the graphics palette. This will help maintain a sense of unity with the rest of the publication.

If you are in charge of choosing the typeface, make sure you choose one that comes in a variety of weights. Recently, type foundries like Font Bureau & Frere Jones have developed fonts with a number of extended, compressed and condensed weights to pro-

SAMPLE TYPE PALETTE

Develop a type palette that you consistently use for every information graphic you publish. Doing so will create a strong sense of unity among the graphics you run on a regular basis. This sample type palette uses the font Richmond and its various weights for all typographic elements used for information graphics.

Headlines: 24- to 30-point Richmond Black condensed

Chatter: 10-point Richmond Medium

Explainers/callouts: 9-point Richmond Light

Diagram labels/state & country labels: 10-point Richmond Bold, all caps

Roads & streets: 8-point Richmond Light

Cities & towns: 9-point Richmond Medium

Bodies of water: 8-point Richmond Light Italic

Source lines/bylines: 6-point Richmond Light

vide more options for a more detailed type palette. In the end, you may not use every weight or width available in a given font, but having a number of options will be helpful when developing a rich, comprehensive palette. Once the primary graphics font has been chosen, you can begin testing the readability and efficiency of different weights and sizes.

Start by developing an inventory of all of the different typographic elements you will make use of in the various kinds of graphics you'll produce. For example, all graphics will likely contain headlines, chatter, explanatory callouts, labels, source lines and bylines. Maps will contain street, city and country labels, as well as labels for political boundaries and bodies of water. Finally, large, complex diagrams may also contain additional explainer boxes, bold lead-in text or labeling devices. Once you have developed a comprehensive type style inventory, you can start creating prototypes that test various type styles in a variety of weights and sizes to find the combination that works best for each element. Establish a fair amount of contrast among the styles for different elements by using different sizes and weights. This will ensure that there is some hierarchy and visual rhythm built into your palette. As a rule, headlines for smaller graphics should generally be between 18 and 30 point. Add to that a size and style for a larger, more complex graphics package, and you should have plenty of headline options. Labeling devices are generally bolder and are between 10 and 14 point, depending on their intended use, and chatter and explanatory callouts generally range between eight and 10 point, depending on what is most readable in a specific weight and width. It's a good idea to test a number of style options in a number of different types of graphics – maps, charts, diagrams, etc. – before settling on the styles that will comprise the final type palette.

Finally, perhaps the most important thing to remember is that once a type palette has been established, you must stick to it. I have known designers and graphics reporters who will occasionally squeeze or resize type to make it fit in tight situations, and believe me, it's not a good idea. The minute you start manipulating type styles beyond how they were originally intended – even if you think the modifications are "barely noticeable" to the audience – you put the integrity of the design at risk. You disturb the unity of the pub-

RON REASON

Design Consultant

With 20 years experience in news design and editing, Ron Reason helps newspapers and magazines become more creative, smart, relevant, appealing and easy to use. He has redesigned The Dallas Morning News, Orlando Sentinel, and Boston Herald, among others. For Garcia Media, he directed the redesigns of The San Francisco Examiner, The Harvard Crimson, Staten Island Advance and Crain's Chicago Business, and assisted with The Wall Street Journal and Gulf News. He has also provided training for newspapers around the world. Ron honed his skills at the Dow Jones Newspaper Fund editing workshop and got his real-world start at the St. Petersburg Times, where he edited and designed for 10 years. He then joined the faculty at the Poynter Institute and served as Director of Visual Journalism from 1995 to 1999. You can find lots of tips, case studies and commentary on design at his Web site: www.ronreason.com.

lication's overall visual appeal, and you defeat the purpose for establishing a consistent style in the first place.

In the Eyes of an Expert

What design principles cross over from page design to designing graphics?

Perhaps even more so than good page design in general, information graphics absolutely rely on cleanliness and the use of no frills. For example, a feature page about New Year's Eve doesn't inherently suffer from gratuitous curlicues, arrows, starbursts or other doo-dads that might suggest a party of fireworks. But a graphic cannot afford to incorporate elements like that, since the audience particularly looks for meaning in every visual element included.

The placement, sizing and editing of text ("information architecture") is also extremely important in infographics. Whether a tab chart, fever line or a locator map, the audience instantly zooms in on the small text to derive meaning in relation to the visuals.

What are the most important design concepts a graphics reporter should be aware of?

The real estate devoted to a graphic must be extremely economical, so editing has to be as tight, clear and to the point as possible. Typically, a headline of two to five words, and introductory text of one to two sentences, must set the stage very quickly.

Colors also must be used critically. More than in a page design, readers make associations between colors; the repeated use of a color (in a bar chart or pie graph) will definitely create a connection. If only black and white is available, most newspapers cannot print more than four to five shades of gray very distinctly, so that obviously affects the kind of information that can be presented.

Finally, the graphics reporter or editor should be aware of what other elements are going with a story, i.e., photos, illustrations, sidebars, etc. Particularly in the case of headlines on main sto-

ries and sidebars, the graphics text has to be coordinated so it complements, and doesn't repeat, the other headlines.

What can graphics reporters learn from designers?

Editing. Good designers often leave good text and visuals on the cutting room floor. Graphics reporters probably have to do this even more. Knowing what to leave in, what to leave out and what to emphasize is paramount.

How important is a good design to creating an effective graphic?

The more complex a graphic becomes – the more visual and text elements to be thrown in together – the more important good design becomes. The arrangement and sizing of elements become critical to the understanding of the information.

What are some of the greatest challenges when designing information graphics?

Fitting the information into the space allotted. Distilling the information – visuals and text – so that the "average person" can understand it, without talking down to the more knowledgeable reader.

Please offer five tips for composing/designing information graphics.

1. Have a set color palette that repeats or at least complements the color palette of the rest of the newspaper.
2. Never use funky fonts.
3. Use a set palette for type, i.e., headline, introductory text and small identifiers within the graphic should always be consistent.
4. Follow consistent standards for boxes, shadows, spacing, credit placement and so on.
5. Always have as many people involved with the reporting and editing of the story – and maybe one or two who aren't – look over the graphic several times before publication.

Would you recommend that graphics reporters design on a grid?

The graphics themselves typically should be on common grid measures – one column, two, three and so on. This greatly eases production later in the deadline process. Within a graphic, I'm

usually less concerned that a strict grid is followed, but as a rule, a designer might break a graphic into a three-, four- or five-column mini-grid if it seems to help the placement of elements.

What's your philosophy as a designer?

Let the information – visuals and text – speak for itself, clearly and intelligently. Never try to make the design elements themselves (fonts, colors, shadows, rules) cry out for attention.

Chapter Five Exercise

Below is a set of elements used to create an information graphic that diagrams how secondhand smoke affects the respiratory system. You are provided with a main illustration, an inset and several blocks of text. Using all of the pieces, develop a layout for the graphic in the illustration program of your choice (i.e., Macromedia FreeHand or Adobe Illustrator). In the end, your graphic may be horizontal or vertical, and you may choose any size you feel is necessary to display the information effectively. Feel free to set the type for the chatter and explainers in any width or configuration. Adhere to the styles from the type palette that is provided. (NOTE: The diagram elements can also be found in electronic form on the accompanying CD-ROM.)

Headline: Secondhand smoke & the respiratory system

Chatter: Secondhand smoke contains approximately 3,000 harmful chemicals. These chemicals primarily affect the respiratory system, causing numerous types of illnesses or diseases, such as lung cancer, asthma, bronchitis and heart disease, to name a few. The steps below show how these chemicals invade the respiratory system.

1: NASAL CAVITY Chemicals in the air enter the body here, where it is moistened, warmed and filtered.

2: PHARYNX The pharynx, or throat, is located where the passages from the nose and mouth join.

3: TRACHEA Otherwise known as the windpipe, the trachea is the main tunnel leading toward the lungs.

4: BRONCHI From the trachea, the air is split into two tubes, called the bronchi.

5: LUNGS Located behind the rib cage, the bronchial tubes split into tiny tubes transferring the air to sacs called alveoli.

(Inset) ALVEOLI The bronchial tubes split into tiny tubes, transferring the air to sacs called alveoli. These sacs provide nourishment to the bloodstream. When these sacs are filled with harmful substances, they spread through the rest of the body, increasing the risk for disease.

By: Kate DeHaven
Source: www.cin.org

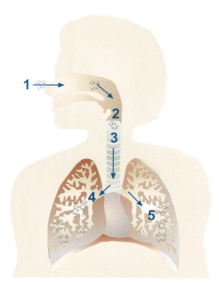

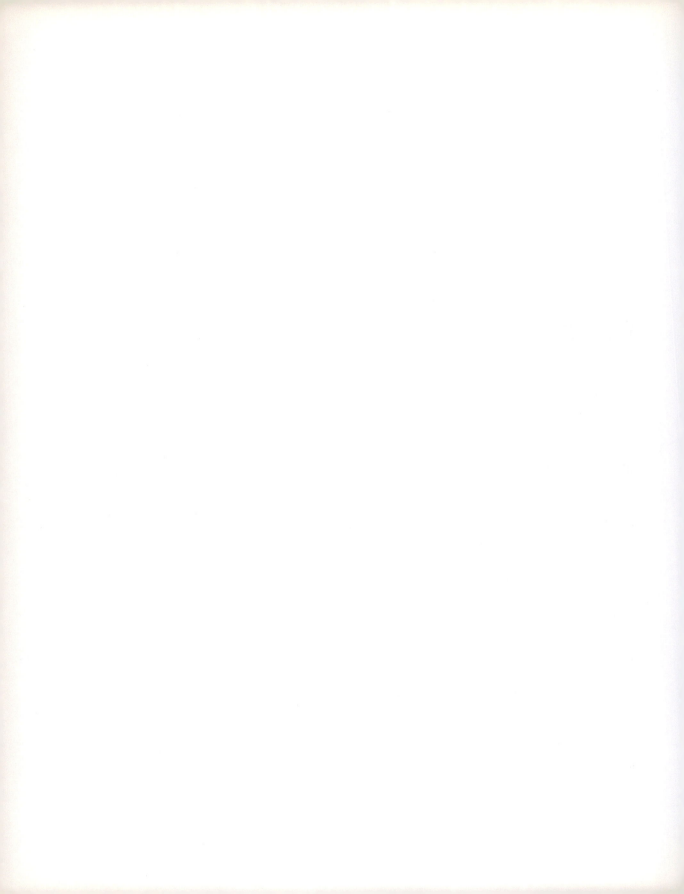

Cartography for Journalists

Maps are, perhaps, the most common types of information graphics. In addition to serving a variety of purposes in communications design, such as forecasting the weather, locating the scene of a news event or plotting statistical information geographically, maps are also used by the government, private and public companies and community organizations. Road maps provide us with directions for how to get to where we're going. Land-use maps are used to outline a city's zoning parameters. Topographic maps show the physical features (i.e., water, mountains, valleys, etc.) of land. Statistical maps associate numerical data with specified areas of land. In fact, for every known location in the world, any number of maps may exist that provide a variety of information from a simple x-marks-the-spot location to a more detailed explanation of a specific location's various characteristics.

Thus, map-making, or cartography, mixes geography with many other fields, including mathematics or meteorology, and a cartographer's job often includes a great deal of research and data analysis, as well as illustration. Likewise, a graphics reporter who is faced with the task of creating a map-based graphic must be aware of a number of concepts related to all of these areas to effectively do her job. Newspapers, magazines, online publications and broadcast media frequently use maps as a way to apply news and information to cartographic illustration. Understanding what kinds of maps are possible for illustrating a given story requires thorough knowledge of the geographic nature of map-making and knowledge of the illustrative hierarchy prescribed by cartography.

However, it is also important to understand that while cartographers and information graphics reporters may engage in many of the same practices, there are some differences in the way each approaches map design. Cartographers, who are often employed by agencies that are concerned with the most thorough, detailed maps possible, are often primarily concerned with maps that include the highest degree of visual detail related to the topic at hand. For example, a cartographer's version of a road map would include *all* highways, major and minor, as well as all bodies of water and major landmarks. A graphic journalist, on the other hand, is equally devoted to accuracy but perhaps less concerned with locating all of these things. Because a graphic journalist is always relating the map to a specific news event, he will often edit out less important visual information that is not essential to the telling of that particular story. This less essential information is called "map fat." In fact, graphic journalists should always remember that the average person isn't generally well versed in geography. So, in an effort to simplify complex information, a graphics reporter will often remove map fat from the base map to ensure that the elements most relevant to the story remain salient and the map remains uncluttered.

So, most communications graphics only include the amount of detail necessary to provide context for the news at hand. For example, a simple locator map will likely include major highways, roads and streets, but may not necessarily mark every street in a nearby housing addition if their names and locations aren't intrinsic to the story. Or a topographic map used to explain how a volcano erupts or how a wave forms may include a great deal of illustrative detail, while leaving out latitude and longitude designations. Likewise, a map of a country may include labels for the locations of major cities or political borders, but may not locate *every* city, which keeps the map from becoming too cluttered. Again, the goal should be to provide as much *necessary* information, in the smallest amount of space, in the least visually and textually complicated fashion.

Functions of Maps

While a graphics reporter's basic goals for map design are the same – to accurately depict a landmass or location in the context of

a news story – the function of a map is determined by the nature of the story, and it is imperative that a graphics reporter understand those various functions. A thorough knowledge of the different functions of maps will ensure that a reporter chooses the right display for a specific set of data or information. For example, a graphics reporter's approach to a map meant to show how many bushels of corn are produced in each county in Indiana each year is different than the approach to a map geared to show the location and progression of an earthquake in Southern California. Like diagrams, maps are often categorized as *passive* or *active*. A passive map generally shows nothing more than a location. It's an x-marks-the-spot visual description of an event. An active map, on the other hand, displays the progression of an event through movement, chronology and direction. For example, an active map of a car accident would not only show where the crash occurred, but the chain of events that led to the crash as well. All maps have some passive qualities, in that they all illustrate a specific geographic location. However, a map is only active if it shows or implies movement. In print publications, movement or visual rhythm is most often illustrated with arrows, lines and numerical or alphabetical ordering. Online and broadcast news graphics benefit from the potential for animation, allowing the graphics reporter to provide an even more realistic depiction of an event. Regardless, passive *and* active maps each have their place in visual storytelling.

Kinds of Maps

There are different kinds of maps available to graphics reporters. The most common of these are *surface* (*locator*) *maps, geological maps* and *statistical maps.* Each type serves a different purpose in storytelling, and a graphics reporter must understand the function as well as the illustrative characteristics of each type.

LOCATOR MAPS are the most common types of maps used in print journalism. So often, the level of understanding of a news story's context or significance is enhanced when an audience is provided with specific information regarding

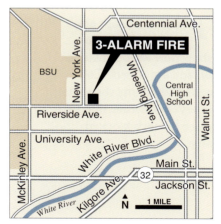

Locator maps are generally small and don't necessarily need a headline or chatter. Their purpose is to give context to a story by showing the location of a news event.

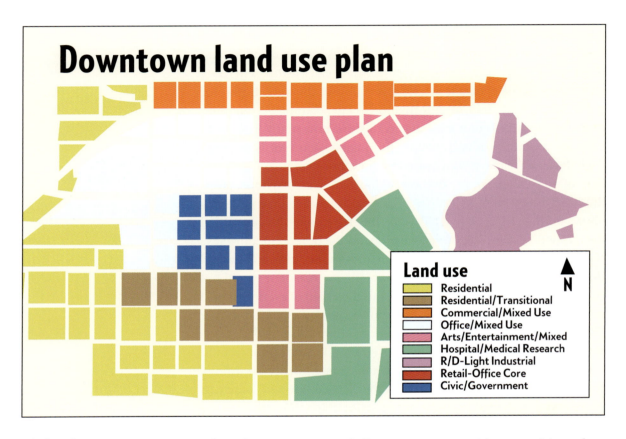

Downtown land use plan

Land use

N

- Residential
- Residential/Transitional
- Commercial/Mixed Use
- Office/Mixed Use
- Arts/Entertainment/Mixed
- Hospital/Medical Research
- R/D-Light Industrial
- Retail-Office Core
- Civic/Government

▲ **Land-use maps are commonly used to show how various patches of land are zoned. Color-coded segments show the types of activities that take place on each block or area.**

where the event occurred. Locator maps provide recognition when a story occurs on a local or state level and a greater degree of context when a story occurs on a broader, international scale. Regardless of whether they show city streets or focus on a single country, they are usually relatively small, as it generally doesn't take much space to pinpoint a specific location. Locator maps should be clean and simple so that the audience can consume them at a glance, and they should include adequate visual detail. In other words, label streets, highways, landmarks or cities that are either in the immediate vicinity of the news focus or are major, widely recognized areas to provide clear context for the primary location. If you are working for a publication in the United States, it is generally acceptable to isolate a single state without showing its bordering states (if they aren't intrinsic to the story) because you can assume that most readers at least know in what part of the country most states exist. However, when a locator map focuses specifically on a

country outside the United States, avoid isolating the country. You can't assume your readers know where various countries are in the world without seeing their neighboring countries. Locator maps may also include insets that show either a zoomed out or zoomed in view of the area to either provide greater context or more detail. Insets are discussed in greater detail in the next section.

GEOLOGICAL MAPS are used to show the Earth's formations, such as fault lines, surface characteristics of a landmass or mountains, valleys and bodies of water. The two most common types of geological maps are *land-use maps* and *topographic maps.* Land-use maps show how communities and individuals use land, as well as how chunks of land are zoned. For example, counties often use land-use maps to show what portions of a city are designated for schools, residential areas, industrial areas, parks and playgrounds, cemeteries or other public, private or institutional areas. Topographic maps show the physical features and surface characteristics of a landmass, or the "lay of the land." Topographic maps may show mountains, valleys or ocean floors, for example, and can be very helpful in

▼ **Topographic maps show the physical features and surface characteristics of a landmass, or the "lay of the land." These types of maps can offer important information about the geological makeup of a landmass.**

Graphic by Josh Engleman. Used with permission.

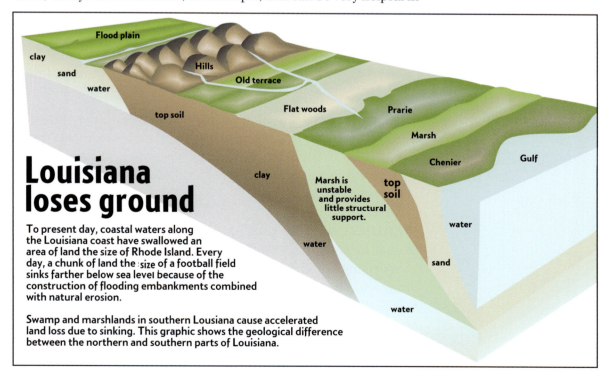

Louisiana loses ground

To present day, coastal waters along the Louisiana coast have swallowed an area of land the size of Rhode Island. Every day, a chunk of land the size of a football field sinks farther below sea level because of the construction of flooding embankments combined with natural erosion.

Swamp and marshlands in southern Lousiana cause accelerated land loss due to sinking. This graphic shows the geological difference between the northern and southern parts of Louisiana.

Choropleth maps categorize data according to sets of values. Each set is then color-coded, allowing the audience to associate blocks of color with a predetermined value at a glance.

*Graphic by Jeremy Brumbaugh.
Used with permission.*

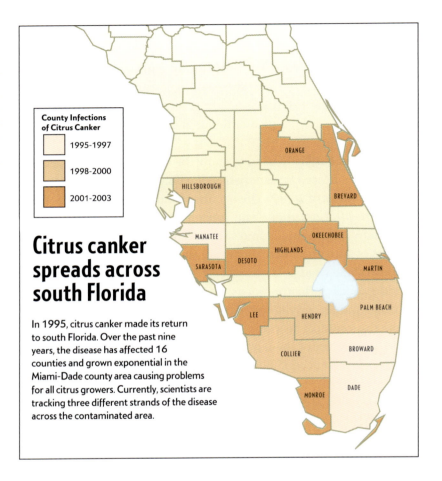

**County Infections
of Citrus Canker**

1995-1997

1998-2000

2001-2003

Citrus canker spreads across south Florida

In 1995, citrus canker made its return to south Florida. Over the past nine years, the disease has affected 16 counties and grown exponential in the Miami-Dade county area causing problems for all citrus growers. Currently, scientists are tracking three different strands of the disease across the contaminated area.

displaying important geological information in a news presentation. Sometimes, topographic maps are illustrated to appear three-dimensional. When this is the case, a topographic map is also called a *relief map,* and it allows a graphic artist to show topographic characteristics to scale.

STATISTICAL MAPS are used to correlate numerical data with geographic locations. In other words, you can show the concentration of agricultural production, numbers of voters, democrats vs. republicans, etc., in a specific area of land by color-coding or using symbols to denote quantities or numerical values. Like any other type of statistical data display, statistical maps can require a great deal of time and attention from the graphics reporter. You must take care to understand the data, be sure you have a complete set of data, and

understand the best type of display for conveying the information at hand. Three common types of statistical maps are *choropleth, isolene* and *dot distribution.*

To create a choropleth map you must first categorize the data according to sets of values. For example, if you are attempting to show the approximate number of Hispanic residents currently living in the United States, broken down by state, you can create numerical ranges for each category such as 0-10,000, 10,000-20,000 and so on. The value ranges in each category should be equal amounts, and you should generally limit the number of value ranges to a number that is proportionate to the amount of information you are showing. In other words, too few categories result in a statistically less-detailed map, and too many categories result in a map that fails to show significant patterns. After your categories have been established, assign different colors to each value set, and colorize each state accordingly. When choosing colors for your choropleth, make sure you choose colors or shades of gray that are easily discernable. If your colors are too similar tonally, your audience will have a harder time distinguishing among them. By using this

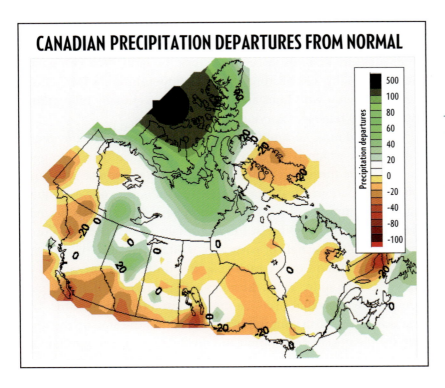

CANADIAN PRECIPITATION DEPARTURES FROM NORMAL

Weather maps are the most common types of isolene maps. Like choropleth maps, isolenes shows similarities in bands or blocks of value in a color-coded fashion. This map simplifies the information at hand by associating precipitation levels with degrees of color.

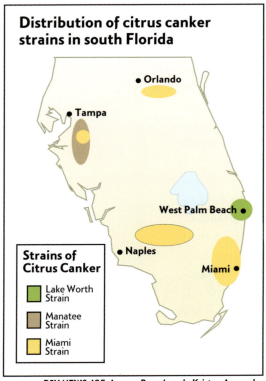

Distribution of citrus canker strains in south Florida

Orlando

Tampa

West Palm Beach

Naples

Miami

Strains of Citrus Canker

Lake Worth Strain

Manatee Strain

Miami Strain

BSU NEWS 485: Jeremy Brumbaugh, Kristen Angarola, Sara Heimann, Kathryn Biek, Scott Rogers

Dot distribution maps associate statistical information with blocks of color. Larger or greater numbers of dots equate to greater numbers.

Graphic by Jeremy Brumbaugh. Used with permission.

approach, your audience can clearly see, at a glance, which states have the lowest to highest concentrations of Hispanic residents.

An isolene map is one that displays data in relation to land by correlating points of similar value. In other words, this type of map shows similarities in bands or blocks of value, which, like choropleths, are colored to match specific value sets. The major difference between choropleth and isolene maps is that although choropleth maps link numerical information to specific units of land (like states, for example), an isolene map links points of similar values to one another along a specific patch of land. The most common type of isolene map used in communications design is the weather map. In fact, nearly every newspaper in the world runs a weather map of some kind every day, and nearly every nightly newscast devotes a period of time to forecasting the weather during the coming days. The maps we see in those types of presentations show bands of color that represent temperatures, amounts of precipitation and other pressure systems sweeping across the land. You can create these bands by connecting similar temperature patterns from region to region with lines and shapes and eventually filling them with color to represent varying weather patterns.

The third most common type of statistical map is the dot distribution map, which is used to combine numerical data with geographic areas through a series of dots meant to represent various value sets. Dots are most often related to a ratio, with one dot equaling a larger number of items. For example, a dot distribution map showing corn production in Indiana might assert that one dot is equal to 10,000 bushels of corn. So, if 50,000 bushels of corn are produced in Allen County each year, five dots should be placed in this area of the state. Thus, the areas with the most intense dot pattern are the areas that produce the greatest amounts of corn. The best way to establish your initial ratio is to find the area on the map with the greatest concentration and divide it by a given number. An

effective dot distribution map is one that clearly shows a significant concentration or pattern of dots across the land mass. If your ratio is too low, sparse areas will be covered with many dots, making it appear more concentrated than it really is. Likewise, a ratio that is too high will make a more densely populated area appear to be much more sparse than it really is. Because this type of map is meant to convey information at a glance, your audience may be misled if the ratios aren't just right.

The Physical Components of a Map

All maps that are intended to convey information related to news should be constructed with some of the same basic components in mind. In fact, without certain distinguishing elements, a map could become quite misleading and even display incorrect information altogether. Make sure that you assess each map you create, and determine whether the following elements are necessary for the type of information you are showing.

SCALES: A map without a scale is not a map at all, but merely an illustration. Scales are used to represent distance, and the map itself should be illustrated in proportion to that scale. Scales help ensure that distances from one element to another are accurate and that the map as a whole is relative to the actual mass of land it represents. When a scale is not used in a map meant to convey news and information, elements can be dramatically distorted. Streets can seem longer or shorter than they really are. Buildings or other landmarks can seem closer together or farther apart than they really are. Cities can become misplaced and states or countries can be disproportionate to one another or to their actual size, hindering the audience's ability to get a true picture of the story. For example, if you are using a map to show the path of a police chase from the point of the robbery to the point of the final apprehension, illustrating the correct distance can be crucial in helping the audience understand how long the chase took and what expanse of land it covered. Scales should generally be anchored in one of the lower corners of the map, away from the main point of interest. Also, it is acceptable to overlap simple illustrated elements such as roads, but avoid over-

TRANSFERRING A SCALE

In order to ensure that your map remains proportionate regardless of how small or large you make it, you must transfer the scale from your original reference material, such as a road map or atlas, to the map you are illustrating. The best way to do this is to scan the scale and the reference map together. Then, you can shrink or enlarge them to fit the size and shape of your map. If the scale of the reference map is too far away from the area you are cropping in on, you can scan the scale and the map separately as long as you make sure they are scanned at the same percentage. Then, you can later combine the two scans, illustrate your scale and move it onto the area of the map you are focusing on.

This inset (circled in red) shows a zoomed-out view of the landmass to show where Iraq is in the context of surrounding countries and continents. Insets can also be reversed to show a zoomed-in view of an area. Insets should be small and simple.

Graphic by Shawn Barkdull. Used with permission.

MAP SYMBOLS

Scale:

500 miles

Compass Direction:

N

Legend/Key:

County Infections of Citrus Canker

1995-1997

1998-2000

2001-2003

Pointer Box:

Explainer text should be set inside pointer box. Leave space for margins.

CAR BOMBS KILL IRAQI GUARDS, CITIZENS

Suicide bombings in Iraq have been a high threat to U.S. soldiers and Iraqi citizens. Below shows the locations of the deadliest attacks this year.

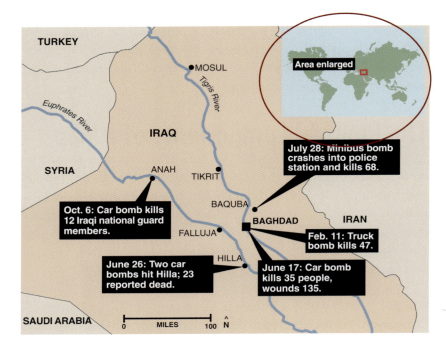

TURKEY

MOSUL

Tigris River

Euphrates River

IRAQ

SYRIA

ANAH

TIKRIT

BAQUBA

BAGHDAD

IRAN

July 28: Minibus bomb crashes into police station and kills 68.

Oct. 6: Car bomb kills 12 Iraqi national guard members.

FALLUJA

Feb. 11: Truck bomb kills 47.

HILLA

June 26: Two car bombs hit Hilla; 23 reported dead.

June 17: Car bomb kills 35 people, wounds 135.

SAUDI ARABIA

0 MILES 100 N

Area enlarged

lapping the scale with text. Instead, find a way to drop the scale in a less detailed area of the map. Finally, although you may encounter reference maps that measure distances in kilometers, if you are creating a map for a primarily American audience, you should convert kilometers to miles because that is the standard measurement used in the states. Metric conversion charts can be found online or in the *Associated Press Stylebook*. Kilometers may be used for maps created for audiences outside the states.

COMPASS DIRECTION: Ideally, an effective, accurate map should also include a north compass direction, and most maps should be drawn with north facing up to eliminate any possible confusion on the part of the audience as to the orientation of the map. The most common way of designating the compass direction is to simply place the letter "N" along with an arrow that points north in one of the bottom corners of the map. Like the scale, the compass direction shouldn't

overlap text, and shouldn't interfere with the point of news interest in the map. Some publications may choose to deviate from consistent use of the "N" symbol in maps by establishing a rule that *all* maps are drawn with true north facing upward because the average reader is likely to assume "N" is up anyway. Then, if there is a rare occasion to deviate from this rule because the content calls for a different angle, for example, then the "N" symbol is added with an arrow pointing the reader in the appropriate direction. Three-dimensional maps or maps that are turned a specific direction due to special circumstances in the content are rare, but are indeed sometimes necessary. For example, if your map includes a building that has suffered some sort of damage as a result of a tornado or earthquake, and the bulk of the damage is on the north side of the building, you may choose to turn the building around to show that area of interest more closely. In that case, north wouldn't be facing up, and the audience should be made aware of this alteration so as not to create confusion. Like the scale, the compass direction should be clean, simple and out of the way. Avoid adding illustrative flair to devices that are used as mere secondary reference points in a graphic.

LEGENDS OR KEYS: Depending on the purpose and focus of a map, it may also include a key or legend meant to simplify the information it displays. A legend is a list of definitions for symbols, colors or shapes used in a map to represent numerical values, objects or landmarks, and they are most often used when there isn't enough space in the map itself to display all of the story's key information. Letters, numbers, iconic symbols or blocks of color are commonly used as visual devices for a legend and allow a graphics reporter to show significant information in a small amount of space. Legends should always be present in statistical maps, such as choropleth, isolene and dot distribution maps, because they are the only effective way to inform the reader of the values each pattern of color or dot pattern represents. Additionally, any symbol, number or letter you intend to use in a map presentation that has no obvious meaning should be defined in a legend. However, not all maps require a legend. But when they do, legends should be small, simple and clean, and like scales and compass directions, they are generally displayed in a separate box or are placed somewhere below or to the

MAP REFERENCES

There are a lot of helpful and reliable references for developing maps of all kinds. Every graphics reporter should have a source list for maps on hand.

Any up-to-date world atlas: Several good world atlases exist. National Geographic and Rand McNally, for example, frequently release new versions of their atlases that include full-color political maps for each continent, maps with topographic detail, individual maps for the United States and Canadian provinces, an index of thousands of place names and country-by-country geographical data.

An up-to-date country atlas: All graphics reporters should have an atlas that accurately reflects the country in which they live. These will show state/province/etc., and borders and topographic detail as well as index thousands of place names.

Several detailed maps of your city, county and state: These can generally be obtained from your local chamber of commerce or city hall. Look for maps that show detail of the city's zoning boundaries, neighborhoods, roads, streets and highways, county lines, etc.

side of the map so that they are easy to read and don't interfere with the illustrated information found in the map itself.

REFERENCE POINTS: Effective maps should also include reference points that most of the intended audience would be familiar with to create recognition and context for the illustration. Reference points include state highways, main streets, state capitals, neighboring towns or cities, parks, rivers, churches, schools, railroads or business districts. These familiar focal points help readers get a sense of how close or far something is as well as where something happened in relation to streets, neighborhoods or cities with which they are more familiar. Of course, you must use your best judgment regarding how many reference points to place in a map. Too many can clutter your map and too few can result in not showing enough reference points for your map to be meaningful to most of your audience.

POINTER BOXES: Maps that are intended to accompany a news or feature story should have a central area of interest. This point on your map is generally the area(s) where the main event occurred. You can effectively highlight these areas by using pointer boxes to call out key locations or information in the map. The visual style for pointer boxes generally varies among publications and types of graphics. However, most are generally white with black type or black with white type. The key to designing an effective pointer box is making sure it stands out clearly among the other elements in the graphic, calling direct and immediate attention to the area it signifies. Text inside a pointer box should have adequate space surrounding it. You shouldn't run text right to the edges of the box, as this tight placement will cause visual tension. The type inside a pointer box should be limited to one to three words and should also be a couple of points larger than the other textual elements of the graphic, because elements highlighted by the pointer box should be of extreme interest and news focus. The type in a pointer box is generally either bold or all caps to create a visual hierarchy in comparison to other textual elements. The pointer box should be rectangular, and the arrow attached to it should stem from the middle of the box, either on one side or from the bottom. Avoid overlapping key illustrative and other textual information with a pointer box.

INSETS: Sometimes it's necessary to show a zoomed-in view or a zoomed-out view of the area of news value in order to offer more context regarding location for your audience. For example, if you are locating a news event that occurred in Dubai, a city in the United Arab Emirates (UAE), you might also want to show where the UAE is in relation to other Middle Eastern countries. If you try to show Dubai, UAE *and* the countries that surround it, you may not be able to illustrate the amount of detail necessary to adequately report on the news event. In other words, the crop on the map may seem too zoomed out. In this case, it would be more effective for the main portion of your map to focus on Dubai. Then, create an inset that shows a more zoomed-out view of the UAE in relation to its sur-rounding countries. Likewise, if the area of primary interest is the zoomed-out view, but showing a tighter crop would also offer a bit more context for your map, you can create an inset that is more detailed to accompany your main map. Not all maps need insets, but when they do, insets can be a great way to efficiently and accu-rately provide the audience with additional context.

In general, insets should be small, usually about one inch wide or smaller in a two-inch-wide map, for example. Of course, the larger the map, the larger the inset. However, the inset should always be much smaller proportionately than the main map in order keep a strong visual hierarchy between the two. An inset that shows a zoomed-out view should also include minimal detail and should be illustrated in the same style as the primary map it accompanies. In other words, use the same color palette and typography so that there is visual unity between the two. Finally, the inset can break the frame of the larger map; however, don't cover up important details with the inset. Like scales, compass directions and legends, insets should be placed within the dead space or sparse, less important areas of the main map.

HEADLINES, LABELS, CALLOUTS AND EXPLAINERS: Most information graphics, maps included, have headlines, introductory explainers (a.k.a. chatter), labels and callouts. While the amount of text in var-ious types of information graphics may vary, the textual compo-nents are generally what transform simple illustrations into com-plex information graphics. The more basic and straightforward a

MAP REFERENCES

usgs.gov: The U.S. geologi-cal survey is a federal source for science about the Earth, its natural and living resources, natural hazards and the environ-ment.

geodata.gov: Part of the Geospatial One-Stop E-Gov initiative, geodata.gov provides access to many U.S. maps, including administrative and politi-cal maps, agriculture and farming maps and atmo-sphere and climatic maps.

MAP-MAKING TIPS

Find a good reference: Without a strong base map, you can't ensure that your reproduction will be accurate. Every good graphics reporter has a list of handy map references, including a world atlas and a detailed map of the city in which he or she works.

Edit the fat: Before getting started, pinpoint the central area of news value on your base map. Then determine which surrounding streets, cities, boundaries, landmarks, bodies of water, etc., provide important context for your map and which ones are unnecessary to understanding the news event. Get rid of those that are less important.

Adhere to a type and color palette: Most publications will have previously established color and type palettes to be used for information graphics. It's important that you strictly follow those guidelines to maintain hierarchy, order and consistency.

Determine what type of map should be used: Is it active? If so, make sure you show that action. Is it passive? If so, make sure the focal point is placed in a central position on the map. Is it statistical or geographic? Choosing the right type of map will definitely impact

map, the less text it will likely require. For example, simple, small locator maps sometimes don't include a headline or much chatter. Rather, they include labels for streets and other key locations, as well as callouts in pointer boxes to highlight the news focus. More detailed maps, on the other hand, often include headlines that clearly summarize the main point of the map, chatter that expands on the headline and transitions to the illustrative portions of the graphic and additional callouts, labels and explainers that support the visual information. Chatter and explainers should be tightly edited, concise and written in active voice.

SOURCE LINES AND BYLINES: Be sure to cite the main textual and visual sources for any information graphic. It's important for the audience to know where your information came from because it lends credibility to your graphic and reliability to your product or publication. Likewise, most maps include a byline that gives credit to the graphics reporter. Source lines generally appear just outside the graphic along the bottom left-hand edge and bylines along the bottom, right-hand edge.

Map Construction

Don't worry. No one is expecting you to illustrate a neighborhood, city, state or country by memory. In fact, as a journalist, you would be making a big mistake by doing so. Like any other reporter, a graphics reporter seeks expert sources and official documents to help tell accurate stories. Thus, when creating a map, your first step should be to find good, reliable reference material. Make sure your map reference is current and roads and boundaries are easily understood and adequately marked. State and world atlases, phone books that include simple area maps, county maps and road maps are all great sources for reference. Once a good base map has been located, you can focus on the area of news value.

If you're creating a map for print, you'll likely be illustrating and designing to fill a predetermined amount of space. And even graphics for the Web and broadcast will likely need to fit certain image size requirements. Make sure the space allotted for the map is adequate, and then determine how much of the area from your base map

needs to be shown. For example, when creating a simple locator map that is meant to focus on a very small area, such as a neighborhood, the entire city or county in which the neighborhood exists doesn't need to be shown. However, in order for the audience to quickly understand where the area of news interest is, make sure at least one commonly recognized landmark, such as a park, body of water or major road or highway is visible. Once you've found the closest landmark, crop in on the area of interest, using your predetermined size window as a guide.

The easiest way to make sure the map you produce is accurate is to scan the reference map and import it into the software program document in which you intend to illustrate your version. Remember to scan the map with the scale that accompanies it and with north facing up. This way, if you need to shrink or enlarge the area you are using as reference, you ensure that it remains proportionate to actual distances and maintains accurate directional orientation.

Before illustrating roads and other landmarks in your map, you must also make some choices about which landmarks are necessary, eliminating those that aren't. This is where your job differs a bit from that of a true cartographer. A cartographer would be concerned with illustrating every significant landmark or road in a particular area, but a graphics reporter is much more concerned with illustrating those locations that are necessary for effectively telling a news story. In fact, although a cartographer would likely want to illustrate every street in a neighborhood, for example, a graphics reporter may actually leave some roads out of the map in order to keep it from becoming too cluttered. However, be careful that you don't edit out too many roads or reference points. Too few will result in a sparse map, potentially skewing a reader's perception of the actual makeup of the area. There's no formula for choosing just the right amount of visual information for a map. You'll have to rely on your journalistic skills and use your best judgment. After your reference map is scanned and scaled accordingly and you have chosen the roads and other landmarks you will need to show, you can simply trace the roads, landmarks, bodies of water, etc., that surround the area of news value.

The size of your map really depends on the amount of surrounding detail necessary to provide appropriate context for the

MAP-MAKING TIPS

its ability to tell the story and help the audience understand the news.

Make sure you include necessary elements: Run through a checklist in your mind that includes the scale, compass direction, legend, inset and source line. Your map should always include a scale and a source line and almost always a compass direction. Determine whether you'll also need a legend or inset, and plan accordingly.

news event you intend to locate. If you focus too closely on the area of news value, you may not be able to provide enough reference points for the average reader to quickly determine the location of the event. If you zoom out too much, you risk cluttering the map with too much unnecessary information, overshadowing the visual impact of the most important area. Again, use your best judgment to determine just how closely to focus in on your area of interest. Finally, make sure that the area of news value is placed near the center or visual center (slightly above and to the left of true center) of the map. The visual center will likely be the natural entry point for most readers, so placing the area of news value too low, too high or too close to the edges of the map will create visual tension and draw the eye away from the most important part of the map.

Color Use in Maps

Color can be an extremely useful tool for creating both illustrative and statistical detail in maps. If your map will benefit from full-color reproduction, shades of tan, blue and green can be quite helpful in distinguishing land from water and highlighting other key reference points. Likewise, color can be extremely useful in statistical maps when you have a large number of statistical values to represent. For example, different colors can be assigned to different numerical values in choropleth maps, patterns in isolene maps or dot sizes in dot distribution maps. The more color you have available to you, the more distinct these types of maps can be, making them easier to read at a glance. When creating a color palette for maps, make sure you have an adequate number of shades of the colors of nature – brown, blue and green. Then, fill in your palette with a few other hues, such as red, yellow and orange, to ensure you have an adequate number of supplementary colors for landmarks, buildings or statistical values.

While it's a nice luxury, full color isn't necessarily essential to creating an effective map. If you only have the ability to print in black and white, you can still develop a palette that includes a number of shades of gray to differentiate among elements in your map. However, when working in black and white, your most significant consideration should be determining the appropriate number of

shades you will include in the graphic. It has been proven that the eye can generally only distinguish six shades of gray at once, and grays should generally vary by 20 percent each for the eye to clearly detect a difference in tone. Thus, when developing any type of black and white graphic, you should adhere to a palette that includes white, 20 percent black, 40 percent black, 60 percent black, 80 percent black and 100 percent black. This way, you can be relatively certain that strong contrast among elements will be clear.

Newspaper graphics reporters should be even more careful with color and shades of gray when developing graphics because newsprint is usually very porous, causing the ink to print darker than it may first look on screen. So, it is generally a good idea for newspaper graphics reporters to test colors and shades of gray on the paper's actual presses to ensure that what is designed on the computer screen prints well on paper. Graphics reporters for magazines, online and broadcast generally have less to worry about when matching what they are designing to what the audience will see, because colors are generally truer in these mediums.

Type in Maps

As with most other types of information graphics, sans serif typefaces are generally more effective than serifs. Maps in particular tend to be more detailed illustratively, and with numerous lines representing borders, roads and bodies of water, the typeface you choose should be less detailed and cleaner to avoid excess clutter. Sans serif typefaces read clearly at smaller sizes, take up less space and are less likely to interfere with the illustrative detail of your map. Typographic contrast can be introduced by using oblique (italic), bold or all caps in addition to the regular weight of the face.

An effective type palette will include a bit of differentiation among the type styles used to label various common map elements, such as roads and streets, cities and towns, country or state names and bodies of water. Additionally, you may choose yet another style/size for any text that might appear in a pointer box. Finally, round out your typographic palette by including the font, Carta. Carta is a symbol font that includes shapes common to map-making, including state road and highway signs. By using Carta, the graphics

reporter eliminates the need to actually draw those symbols.

The placement of road and city labels can also influence the overall clarity of a map's design. Place text in a uniform manner above the road it marks, and align street names both horizontally and vertically. This will make text that signifies similar types of elements easier to follow and easier to read. On the other hand, if street names are placed randomly on the map, they will become more difficult to find and follow as the eye navigates the visual content. Likewise, state or country labels should be placed as close to the center of the land mass they signify as possible. This makes them easy to find and easy to read. And, when positioning state road or highway symbols on the map, consider the nature and curves of the roads. When two roads intersect, for example, don't place the road symbol or name in the middle of the intersection, as it will be difficult to determine which road the symbol or text actually belongs to. Finally, avoid placing a road symbol on a breaking point in a curve, and when a road is segmented by an abrupt dip, avoid placing a road symbol on that particular point on the road.

Maps in the News

In recent years, map use in news coverage has evolved from its most common forms, weather maps and simple, passive locators, to much more intricate, detailed and content-driven reporting tools. Geological maps are often used to explain natural phenomena about the world in which we live. Additionally, maps combined with diagrammatical information are frequently used by news media to show how police chases, plane and car crashes or devastating earthquakes and tornadoes unfold, providing audiences with context for the news stories that affect their lives every day. And, every time there's an election, a census report or a major environmental issue, newspapers, Web sites and broadcast stations across the country use statistical maps to geographically plot data so it's easy to understand at a glance.

Perhaps one of the greatest recent technological advances to provide journalists with a new method for enhancing their reporting strategies where maps are concerned is the creation of geographic information system (GIS) software that more efficiently

combines statistical data with geographic mapping. According to *Mapping the News*, by David Herzog, GIS software was used to plot the path of Hurricane Andrew, map election results, pinpoint the locations of environmental hazards, chronicle demographic changes and report census data. News organizations such as the *Miami Herald*, the *Washington Post*, and the *Chicago Tribune* are among those that have adopted GIS software as a method of reporting a number of stories with significant implications for their audiences. Additionally, transportation planners, geologists, telecommunications agencies and police departments have begun to use GIS to craft management plans for their organizations.

Herzog writes, "Broadly defined, a geographic information system is a system of hardware and software used for the storage, retrieval, mapping and analysis of geographic data." Thus, GIS combines database technology with mapping software and allows reporters a chance to enter all kinds of statistical data into the program and instantly combine it with corresponding geographic locations. For example, in 1992, reporters at the *Miami Herald* used GIS to plot the path of Hurricane Andrew in conjunction with specific statistics related to local properties and storm damage information supplied by the local Red Cross. The data they collected led them to the discovery that "shoddy construction and lax inspections exposed thousands of houses to risk" and in 1993, they were awarded a Pulitzer Prize for their outstanding hurricane coverage and investigative reports. Likewise, the *San Diego Union-Tribune* used GIS to analyze the Census 2000 data and develop an extremely interesting and insightful report on how the population and demographics of neighborhoods had changed since 1990. In the end, the package that ran in the newspaper combined statistical data with detailed maps that efficiently reported Census 2000 and its implications for San Diego County, showed which areas of the county had the most racial diversity and explained how increasing numbers of Hispanics were buying homes in San Diego County.

In general, maps have become an extremely effective way for journalists to tell visual stories in news coverage, as well as lend a great deal of reporting power to stories that range from very simple to highly complex. Understanding the basics of cartography, geography and even simple mathematical equations is an important

skill for a graphics reporter to have. In fact, many aspiring graphics reporters supplement their journalism and graphic arts coursework with additional courses in economics, geography or statistics to help bone up for the more intense demands of reporting and analyzing data for all kinds of information graphics. Regardless, make sure you familiarize yourself with these concepts as well as related software programs to make your life and your job much easier.

In the Eyes of an Expert

What are the most effective uses of maps in news coverage?

Maps are practically unlimited. From small locater maps to full-page presentations, the key is that they are content driven, not just decorative.

What are some of the more common mistakes graphics reporters make when developing maps for news coverage?

Using 3D maps for visual effects rather than a method for clarifying the topic. Geographical mistakes, typos and no scale for distance are also common.

How does journalistic cartography differ from other types of graphics reporting?

There is no difference. Everything needs to be truthful and accurate.

What is the most common challenge when developing maps for news coverage?

Having the proper amount of space – not too much or too little – to add all the necessary points of interest and frame of reference.

What was it like to develop the weather map for USA Today*? How/why did it come to be?*

I created the first two prototypes. The weather page was on the back on one of them, and it was in the inside in black and white on the other one. We wanted to find out what advertising agencies would say about that. They all felt that it definitely should be on the back page in full color, so it was.

GEORGE RORICK

The Poynter Institute for Media Studies & USA Today

A founding member of USA Today, George Rorick is best known for the innovative weather maps that included state-by-state weather briefings. Additionally, Rorick was the architect of six graphics services for print and broadcast, including Knight Ridder Tribune "Faces in the News" and "News in Motion." Rorick retired from the faculty at the Poynter Institute for Media Studies in 2004 after 42 years in news.

I hadn't seen any models of full-page newspaper weather pages to work from. We would, of course, have a map of the United States. We talked about the five-day forecast. We had a lot of discussion on what cities to use in the forecast, because it was going to be a national newspaper. A huge obstacle was the limitations of the technology of the time. I was scared to death until I saw the first prototypes. You didn't know if it was going to work until you saw the page. We didn't have computers to make sure the colors would come out the way we expected. One time Al Neuharth asked me: "Is this gonna work?" And I said "yes." But really, to be honest, I wasn't positive.

I think we did 15 prototypes total with tremendous differences. On the final prototype the map is more dynamic. It has a different shape, a different style. It's more what I'd call a designer map, an icon, a symbolic map. I didn't design a map that you would use to go from New York to San Francisco. It was more of just a symbolic map of the United States. It's a very quick read map. A very graphic map.

I remember all the attention that the weather page drew. It almost got to be embarrassing. After we started publishing, the TV stations would come in with their cameras and we would be live on television, and they'd want to talk to the weather guy. And then we would get letters. I would get more mail and responses from readers than almost anybody would in the beginning. People would come and ask me for my autograph. We got letters from people saying, "You don't have my city on the map. Can I get my city on the map?" There was a congressman at the time lobbying to get Alaska on the map in proportion to the United States.

Once I finished the design and established a way to automate the weather bands plus the standing features, it was easy to do on a daily basis. Remember, that page had been published for several years, 1981-1989, before it was a computer-generated page as it is today. I enjoyed doing the daily weather feature the most. For me, the weather graphic was the big challenge. There

were no graphics that the average person could understand that were being published for the general public at that time. I was sure there would be an audience for that, and I was correct.

If you had to summarize your philosophy of visual storytelling in one or two sentences, what would they be?

My definition of an informational graphic: a visual presentation of facts and visuals based on authenticity, truth and believability.

A successful graphic artist must have excellent graphic skills in addition to having the ability to research, write text for graphics and the desire to follow local and international news events. In other words, today's visual journalist is expected to cover the news and report the news the same as a reporter is expected to do, with the exception being that the reporter reports with text, and a visual journalist reports with visuals and some text as needed.

Offer five tips for graphics reporters to consider when developing maps for news coverage.

1. Credibility should be your first concern.
2. Do your research; credit your source.
3. Do not take maps for granted. People love maps.
4. Develop a coherent style, and be consistent.
5. Create a map checklist, and use it.

Chapter Six Exercises

EXERCISE NO. ONE: SIMPLE LOCATOR MAPS

Recreate the map shown on the next page as best you can. Use either Macromedia FreeHand or Adobe Illustrator to illustrate the map, and refer to the style palette below for specifications on type size, shading and line widths.

STYLE PALETTE
Box size: 12.5p x 14p
Background shade: 4C, 7M, 17Y
River line: 3-point, 50C, 23M, 5Y, 12K
River type: 6-point, Times italic (attach to path)

Campus shade: 10C, 15M, 30Y
2-lane streets: 1-point, white on 2-point, 70% K
4-lane streets: 2-point, white on 3-point, 70% K
Street labels: 8-point. Helvetica, u&lc
Road numbers: 7-point Helvetica, 3-point black circle
Reference point labels: 6-point Helvetica u&lc
Pointer box text: 9.6-point Helvetica Bold, all caps
Compass: 8-point Helvetica Bold, all caps

Next, use the same style palette to create a locator map for a warehouse explosion. Access the base map that is shown at right from the CD-ROM (CH6 BASE MAP.jpg) that accompanies your text. Import it into your illustration program and size and illustrate it accordingly. Remember to edit out unnecessary streets and landmarks and include a scale and compass direction.

EXERCISE NO. TWO: ACTIVE MAPS

Read the text about the fake scenario on the next page, and develop an active map that illustrates the news event. Use the information provided to write chatter and a headline for the graphic and to determine what types of visual reference materials are necessary. The scenario of known information at the time of publication is provided. Your final map should be in color and should be six inches wide. The depth of the graphic is up to you. Develop your own style and typographic and color

palettes for this project.

Yesterday, while traveling to promote business investment in Western Europe, Indiana Governor Joe Schmoe and his aides — traveling from Stuttgart, Germany, to London, England were aboard a Boeing 737 that crashed in the Ardennes Mountains of Belgium.

- British Airways Flight 200 was headed for Heathrow Airport near London.
- Jet crashed in Ardennes Mountains.
- Crash site was on side of 2,300-foot mountain about 20 miles from Bastogne, Belgium.
- Noon, Wednesday (5 a.m. EST), Schmoe had lunch with German business leaders in Stuttgart.
- At about 2 p.m., Schmoe's plane left Stuttgart for flight to Heathrow.
- 2:52 p.m., Plane disappears from radar screens.
- 7 p.m., U.S. ambassador to Belgium informs U.S. officials that plane is missing.
- 7:22 p.m., Nightfall in Belgium hampers rescue efforts.
- Reported possible cause for crash was a weather report consisting of rain, strong winds from the south and visibility of no more than 100 yards.
- U.S. Navy helicopters dispatched from the USS Conolly as well as NATO rescue teams were dispatched to the area.
- On board: 27 passengers, 6 crew members; flight list has not yet been released.
- No survivors have been found.

References
Herzog, David. Mapping the News. Redlands, CA: ESRI P, 2003.

CHAPTER
SEVEN

Charts, Tables & Text-Based Graphics

Abstract graphs and charts, along with the beginnings of statistical theory and the systematic collection of empirical data, were introduced to mathematics during the Eighteenth Century. And as the collection of economic, political and census data became more common, visual forms of presentation that allowed the data to "speak to the eyes" also became more prevalent. First conceptualized in the late 1700s by William Playfair, a Scottish architect, pie charts and bar charts use geometric shapes to metaphorically represent statistical concepts. Pie charts, for example, use sections of circles to represent parts of a whole amount. Bar charts, on the other hand, use rectangular shapes to represent how whole amounts may compare to one another. These simple shapes act as illustrations of visual data metaphors. And because the brain tends to better remember information that is in some way related to visual symbolism or imagery, individuals often come to understand statistical information more quickly and easily when presented in this way.

In fact, some of the most space-efficient, effective information graphics are simple charts. Tab charts, pie charts, bar charts and fever (or line) charts are often capable of presenting a great deal of serious statistical data in a relatively small amount of space, providing the audience with a great deal of evaluative information. Although these types of information graphics may seem relatively simple at first glance, don't underestimate their power or complexity. Not only do they have the potential to act as visual points of entry when combined with a story package and communicate important messages often central to the

CONFLICT IN IRAQ

War and political turmoil have plaged Iraq for nearly 25 years. This timeline highlights some key events in the history of conflict in Iraq.

1979

Iraqi leader Saddam Hussein succeedes Al-Bakr as president.

1980-1988

A ceasefire is declared with Iran after a long, eight-year war that killed 150,000 Iraqi soldiers.

1990

Iraq invades Kuwait. United Nations demands Iraq withdrawal by Jan. 15, 1991.

SEPTEMBER 2004: 1,000 DEAD IN U.S.-LED

War between the United States and Iraq officially ended in March 2003. However, conflict continues even today. Below is a timeline of U.S. casualties and key events since the official end to the war.

May 1, 2003
President Bush declares an end to war in Iraq.

July 14, 2003
First meeting of Iraqi interim council.

August 22, 2003
Ali Majid, "Chemical Ali," is captured and questioned about WMD.

January 5, 2004
U.S. soldiers sent home for beating prisoners of war.

2003	MAY	JUNE	JULY	AUGUST	SEPTEMBER	OCTOBER	NOVEMBER	DECEMBER	2004	JANUARY	FEBRUARY

May 28, 2003
Large increase of resistance to U.S. occupation. Saddam Hussein

July 22, 2003
U.S. troops kill Uday and Qusay Hussein.

August 29, 2003
Explosion in Najaf kills 90, including Shi'ite leader Ayatollah Mohammed Bakir al-Hakim.

October 27, 2003
Suicide bomber kills 35, injures 224 outside Red Cross headquarters.

January 17, 2004
Bomb takes U.S. death toll in Iraq war to 500.

▲ In this example, the time line is actually displayed in conjunction with a data metaphor. The time continuum helps organize the content linearly and conceptually.

Graphic by Miranda Mulligan.
Used with permission.

audience's understanding of a story, but they can be extremely tricky to execute as well. Graphics reporters must understand that the nature of the information at hand will dictate which type of graphic should be used to properly display the data. Likewise, what attracts the eye may not necessarily engage the brain, and to be effective, these types of graphics *must* be used to present clear and precise information accurately and consistently.

One of the most important things that Chapter Eight will teach

1991
Iraq didn't leave Kuwait. A coalition of 39 countries entered Iraq. The Iraqi army was defeated.

1998
Iraq refuses to cooperate with U.N. to seize weapons of mass destruction. Series of air-raids are launched.

2002
The U.S. and Britian make plans to destroy Iraq's weapons of mass destruction and remove Hussein from power.

Photos and a simple typographic hierarchy can help make text-heavy time lines more visually appealing. These types of time lines can either be displayed horizontally or vertically, depending upon the space available for the graphic.

Graphic by Erica Riggle. Used with permission.

COALITION IN IRAQ

Time line content may also be adapted for the Web and presented in a non-linear format as well. Dates, images or categories of information can be made "clickable," allowing the audience to navigate the time line in any order.

March 1, 2004
Interim government and U.S. approve Iraqi interim constitution.

June 24, 2004
Terror attacks throughout Iraq kill 100.

MARCH	APRIL	MAY	JUNE	JULY	AUGUST	SEPTEMBER

March 2, 2004
Terror attacks in Karbala and Baghdad kill 117 Americans and 271 Iraqis.

April 2004
Insurgency by radicals, including Moqtada Sadr and his Mehdi Army.

June 28, 2004
Iraqi Prime Minister Iyad Allawi assumes power in sovereign Iraq.

September 7, 2004
U.S. death toll in Iraq war reaches 1,000.

us is that statistics can often mislead rather than inform. Charts and tables, therefore, should accurately reflect the numbers they portray. This concept will be addressed in greater detail in the following chapter, but it is also an important concept to be aware of as we explore the different types of tables and charts in this chapter. Time lines, tables and various types of charts all have different strengths, weaknesses and purposes, and the sections that follow will provide you with some clear-cut guidelines for how and when to apply them.

Text-Based Graphics

Although most information graphics contain some type of illustration or data metaphor (chart), there are also ways to present information that is primarily text-driven in a more graphic format. Time lines and tables represent two commonly used text-based graphics that can provide readers with a great deal of important information in formats that are more visual and more conducive to at-a-glance reading. Although tables and time lines aren't exactly the most "graphic" pieces, they are alternative storytelling forms that provide opportunities for a more visually pleasing, visually organized format for data than the traditional one-paragraph-at-a-time story form.

In an increasingly visual age, designers and graphics reporters are often taught to cater to time-starved audiences by providing story packages that contain a number of different story forms. Of course, broadcast journalists have been catering to these types of readers for a long time. But even as television technologies evolve and information graphics as well as interactive television formats develop, information layering becomes more and more prominent in broadcast as well. Regarding print media and the Web, the idea is that by providing the shorter "quick reads," fact boxes, information graphics and other less traditional story forms, you provide the audience with an opportunity to scan the content quickly. Likewise, you may even have a better chance of keeping the audience engaged through a more visually rhythmic presentation. Thus, by developing a more hierarchical typographic format, as well as a more graphic style for the presentation of time lines, tables and other kinds of text-based graphics, you can hopefully create a more visually engaging package with relatively text-heavy pieces.

Any time you encounter content that addresses an ongoing story, a historic event or a set of circumstances precipitated by another, a time line may be an effective way to help provide more context for the primary story. In print formats, time lines should generally be comprised of 10 to 20 entries, each with a specific date attached. Entries are generally no more than one or two sentences and should be written in active voice present tense, even if the events of each entry happened years ago. Present tense is an effec-

Candidates address key issues

Presidential candidates George W. Bush and John Kerry differ on several hot topics leading into the upcoming elections. Below is a quick comparison of their stances on a few of these issues.

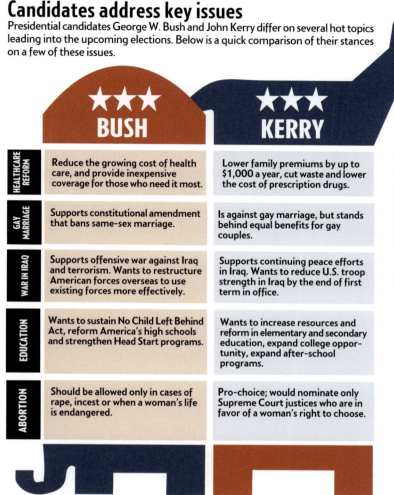

	BUSH ★★★	KERRY ★★★
HEALTHCARE REFORM	Reduce the growing cost of health care, and provide inexpensive coverage for those who need it most.	Lower family premiums by up to $1,000 a year, cut waste and lower the cost of prescription drugs.
GAY MARRIAGE	Supports constitutional amendment that bans same-sex marriage.	Is against gay marriage, but stands behind equal benefits for gay couples.
WAR IN IRAQ	Supports offensive war against Iraq and terrorism. Wants to restructure American forces overseas to use existing forces more effectively.	Supports continuing peace efforts in Iraq. Wants to reduce U.S. troop strength in Iraq by the end of first term in office.
EDUCATION	Wants to sustain No Child Left Behind Act, reform America's high schools and strengthen Head Start programs.	Wants to increase resources and reform in elementary and secondary education, expand college opportunity, expand after-school programs.
ABORTION	Should be allowed only in cases of rape, incest or when a woman's life is endangered.	Pro-choice; would nominate only Supreme Court justices who are in favor of a woman's right to choose.

Tables are best used when the numbers or figures themselves are as important or even more important than a comparison or breakdown of the differences between them.

Graphic by Broc Borntrager. Used with permission.

tive way to apply a more engaging and timely tone to any kind of information graphic.

Furthermore, the basic design for your time line can take a number of forms. When there are large gaps in the amount of time between each entry, you may choose to present entries in a horizontal or vertical format, using only typographic hierarchy and a few simple structural effects to create a more visual display. If space and structure permit, you may choose to take your design approach a step further by creating a visual time continuum on which to place

the entries. The continuum serves as the visual data metaphor and should be divided into equal sections – five, 10 or 20 years per chunk – with each time-based entry placed relative to its time period. This approach also calls for a horizontal presentation because conceptually, the data metaphor (the continuum) is best conveyed in this format. Finally, if you choose this approach, it is also important that you work on a grid to ensure a clean organization of entries both above and below the time line. In most cases, too few or too many entries organized erratically along the continuum can really compromise the readability of the graphic. You may also choose to incorporate historic photographs with some or all of the entries on your time line. Photos can really enhance the graphic appeal of a time line by making it more visually interesting and more informative.

Like any other type of information graphic, the technological potential of a Web-based format can also enhance the interactivity and multimedia potential for a time line. The presentation and design of a Web-based time line can be a bit richer if entries are presented in a more non-linear format, allowing the audience a chance to navigate each time period or entry in whatever order he or she likes. In addition, Web-based time lines can incorporate video and audio clips with text-based entries, often providing the audience with a richer interactive experience.

Tables represent another kind of text-based graphic and are best used when the numbers or figures themselves are as important or even more important than a comparison or breakdown of the differences between them. In other words, when comparing the stats of two competing basketball teams, for example, the individual percentages for each category often attract as much interest as whose stats are better between the two teams. In this case, a table would be better than a bar chart because the table calls more attention to the individual data figures, while the bar chart draws more attention to the differences between them. Tables can also be more effective when the individual numbers in a data set have no discernable pattern. As you will find when you read the following sections, pie, bar and fever charts generally show some sort of trend or pattern in the data that facilitates the use of a data metaphor to pull it together visually. Finally, like a time line, a table should incorporate a clear typographic hierarchy and design format that makes the reading

experience quick and easy, and it may also incorporate photographs or illustrations to enhance the graphic appeal.

While time lines and tables tend to be the most common text-based graphics, there are a number of alternative story formats or quick read presentations that could also fit this category. *Fact boxes* and *profile boxes* provide the audience with a schematic look at the *who, what, when, where* and *why* of a story. Similarly, *at issue boxes* can provide the scanning audience with a quick take on what's at the heart of a story, the broader social perspective, if you will. *Lists, Q&As, ratings boxes* and any other graphically designed, or typographically organized set of information could be considered a text-based graphic. In all cases, it is important to write in active voice/present tense. Most of the time, text-based graphics should be accompanied by headlines, introductory chatter, source lines and bylines, and entries should be tightly written. Furthermore, typographic hierarchy and an attractive but clean design structure are the elements that really heighten the visual appeal of a text-based graphic.

Pie Charts

Put simply, pie charts, or circle graphs, are used to represent different parts of a whole. Data displayed in pie charts must *always* be represented in percentages, and because the circle metaphor is associated with a complete amount, 100 percent, the sections of a pie chart should always equate to this sum. In this way, it is possible to see how something is divided among different groups representing a whole. For example, when reporting census data that focuses on the racial makeup of a specific city or town, a pie chart can show both how individual groups (black, white, Asian, Hispanic, etc.) compare to one another as well as show what portion of the total each group represents.

Perhaps more important than knowing what makes a pie chart work well within a presentation is knowing the different ways in which pie charts are often misrepresented. In other words, while they may look like simple illustrations of numerical content, if they aren't correctly executed, pie charts (or any kind of chart, for that matter) can actually skew, distort or completely destroy the accuracy

HEALTH CARE COVERAGE

Private companies provide the majority of health care coverage in the United States. Below is a breakdown of the kinds of health care used by most Americans under the age of 65.

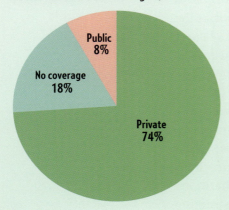

Public
8%

No coverage
18%

Private
74%

PIE CHART TIPS

Represent a whole.

Illustrate a "breakdown."

Sections must add up to 100 percent.

More than two and less than seven wedges.

Each wedge should have its percentage displayed.

Introductory chatter should state the total quantity of the breakdown.

Circles work best to demonstrate percentages at a glance.

Proportions must be accurate.

When stacking pie charts, colors or shadings must be used consistently.

Pie charts are a simple and clear way to show a breakdown of a whole. Perhaps the most important rule for pie charts is that the wedges must add up to 100 percent.

of the data at hand. There are several ways this distortion can occur:

LEAVING OUT ONE OR MORE PARTS OF THE WHOLE: If your pie chart doesn't represent exactly 100 percent *every* time, you have misrepresented the information. Two things will happen. Either the audience will examine the graphic at a glance and simply take the data at face value, causing them to believe the sections of the chart are the *complete* and *entire* set of data, or they will notice that your chart equals more or less than 100 percent and will be left with questions about how this is possible or what has been left out. Either way, you have misled the audience and rendered the data useless as it was presented.

NOT DEFINING WHAT THE "WHOLE" STANDS FOR: If a whole is not defined, then we don't know what the parts represent. Ten percent of 10 is one. Ten percent of 100,000 is 10,000. If your audience isn't given a clear indication of what the whole amount actually is, then they are left with no context or frame of reference for the percentages you have offered. I once sat through an hour-long presentation focused on presenting the results from a survey that questioned media professionals about their attitudes toward media convergence. The presenter showed one pie chart after another that stated large percentages of newspaper editors and television producers had positive and negative attitudes, making the study seem pretty impressive and telling regarding the climate in today's media environment. It wasn't until the end of the presentation that the presenter quickly conveyed to the audience that 14 newspaper editors and 23 television producers responded to the survey. In other words, when the data showed that 50 percent of newspaper editors responded a certain way to a specific question, the raw number amounted to seven. Seven! There are more than 1,000 daily newspapers in the United States, and *seven* hardly represents a scientific

sample! Not only was I extremely frustrated by the presenter's misrepresentation of the numbers, but I was irritated that I had wasted an hour of my life listening to such insignificant findings. Don't put your readers in the same situation I was by not letting them know up front what the sample size is. And, while you're at it, make sure your sample size is large enough to accurately reflect the larger population. Finally, it's also a good idea to label each wedge with the population and the actual percentage figure it represents. Don't leave the audience guessing.

USE PROPER TERMINOLOGY & VISUAL METAPHORS: A pie chart represents a "breakdown." When introducing the information you are presenting in a pie chart, refrain from calling it a "comparison" or a "trend," as these aren't the primary goals of a pie chart. Likewise, circles work best to demonstrate percentages of a whole at a glance. On occasion, I have seen pie charts that make use of other shapes (such as a dollar bill divided into sections) to represent parts of a whole. However, in most cases, because of the more obvious symmetry of a circle and because circles are naturally associated with a "whole," these shapes are generally the most accurate and effective way of presenting a breakdown of data.

PROPORTIONS & DESIGN MUST BE ACCURATE: If a wedge of your pie chart is meant to represent 45 percent of the whole, then the wedge itself should be exactly 45 percent of the circle. This relationship is really at the heart of the effectiveness of the visual metaphor. Also, when reporting several sets of data in pie form or stacking several pie charts representing similar data, make sure colors or shadings are used consistently. For example, if you are presenting a package of pie charts all focused on different facets of the same populations (types of dogs, for example), make sure that the colors or shades used for each category remain the same across multiple pies.

Bar Charts

Also perfected by Playfair in the late 1700s, bar charts are used to compare data using rectangular bars to represent amounts within a data set. Because the bars are sized relative to the amounts they

CHARTING SOFTWARE

Although there are many different types of data-charting software available, most graphics reporters use the charting functions in Macromedia FreeHand or Adobe Illustrator to construct the base chart for their information graphics. Both programs allow a reporter to enter data and choose the type of graph most appropriate for its presentation. When all of the information has been entered, either program will actually provide you with a pie, bar or fever chart that is proportionate and accurate based on the data at hand. Then, because most media organizations have pre-established design styles and typographic palettes, the chart generated by the illustration program is altered to match. Microsoft Excel can also be an effective and helpful program for setting up databases for organizing large chunks of data intended for use in tables or charts.

Bar charts can be either horizontal or vertical. When time is a factor, bar charts must be vertical. In all other cases, they should be horizontal.

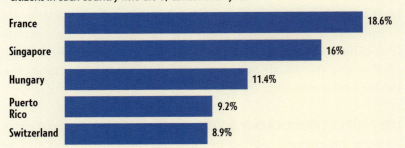

CANCER-RELATED DEATHS

A study of 10,000 men in five countries shows that France has the highest number of cancer-related deaths. The chart below shows a comparison of percentages of male citizens in each country who die of cancer each year.

Country	Percentage
France	18.6%
Singapore	16%
Hungary	11.4%
Puerto Rico	9.2%
Switzerland	8.9%

BAR CHART TIPS

Best used to show comparisons of amounts at a glance.

Vertical bar charts have time as their bases and are best used when intervals are irregular.

Horizontal bar charts compare amounts when time is not a factor.

It's easy to perceive differences in length, especially when lengths are horizontal.

Lines are read left to right.

Horizontal bars should be stacked logically (i.e., longest to shortest).

A background grid is not necessary, but the baseline must be common.

Allow for a consistent minus grid if necessary.

Each bar should have its total displayed.

Stacked bar charts provide comparisons among sets of similar data.

represent, these types of charts make comparisons between different variables very easy to see. Furthermore, they can potentially show trends in data by showing how one variable is affected as the other rises or falls.

HORIZONTAL & VERTICAL BARS HAVE DISTINCT PURPOSES: If bars are presented vertically, the y-axis represents the kind of data (i.e., dollars, amounts, etc.) presented, and the x-axis represents time. Vertical bar charts are best used when the time intervals are *not* equal. If bars are presented horizontally, the x- and y-axes can represent any two variables that share a quantitative relationship.

A CLEAR COMPARISON MUST BE PRESENT: Whenever you stack similar visual devices next to one another in a clear horizontal or vertical pattern, you are implying that there is some comparative relationship among them. Thus, consistent labels for the x- and y-axes must be present, and there must be a clear comparative pattern in the data you are presenting. If a clear and logical comparison doesn't exist, you may be using the wrong type of graphic to present your data.

PROPORTIONS & DESIGN MUST BE ACCURATE AND CONSISTENT: It is generally not necessary to illustrate a background grid with your bar chart because it is relatively easy to perceive differences in length, especially when lengths are horizontal. Like text, lines are generally

read left to right and should be sized proportionately to their numerical partners and consistently from line to line. Bars that differ in width or are disproportionate to the numbers they represent – even slightly – can distract the audience and interfere with the readability of the chart.

EACH BAR SHOULD HAVE ITS TOTAL DISPLAYED: Even if you have a clear and consistent interval displayed along the y-axis, you should display the exact figure along with its bar, especially when the bars fall somewhere in between the intervals. In other words, don't make your audience guess what the exact figure is. The bars make differences clear at a glance and the numbers reinforce the actual numerical differences at hand.

Fever Charts

Also called "line graphs," these types of graphics compare two related variables. The concept of the fever chart originated in 1637 when René Descartes outlined the "Cartesian grid," a system of plotting points on a graph made of intersecting lines. Fever charts require that each variable is plotted along the x- or y-axis, and they are most commonly used to show change over time, necessitating that the x-axis represents equal time intervals (i.e., days of the week, months of the year, consecutive years, etc.) and the y-axis represents related amounts.

Fever charts are great for showing specific values of data, especially when the nature of one variable is directly related to another. They show trends in data clearly by illustrating how one variable affects the other as it increases or decreases. They enable the audience to make educated predictions about the results of data not yet recorded, and they are extremely effective ways to quickly show rises and falls as well as changes in data over specific periods of time. However, like pie and bar charts, fever charts can also be very misleading if they are not developed and used correctly.

INCONSISTENCIES IN SCALES ON THE AXES CAN SKEW THE APPEARANCE OF DATA: The values between the points along each axis must be the same. In other words, if time is the x-axis, then you must

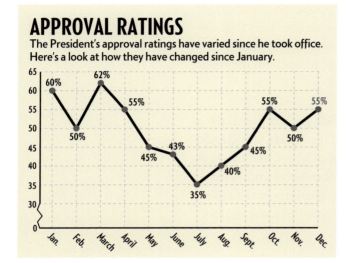

APPROVAL RATINGS

The President's approval ratings have varied since he took office. Here's a look at how they have changed since January.

▲ Fever (or line) charts are great for showing a trend. If the change is not dramatic or varied — in other words, if the line is straight — the trend is likely better reported in text form. However, if the change is varied, as is the case in the above example, a fever chart is a clear metaphor for showing change over time.

maintain equal intervals between years (i.e., one year at a time, three years at a time, five years at a time, etc.). Likewise, if you are comparing two different graphs, you must use identical scales for each if you want the comparison to be accurate and relevant.

IN MOST CASES, A BACKGROUND GRID IS NECESSARY: Without a background grid, it becomes more difficult for the audience to easily discern where the points actually fall in relation to the x- and y-axes. On the other hand, the presence of a background grid makes it much easier for your reader to correlate the numerical data to the time frame to which it relates.

FEVER CHARTS SHOULD ALWAYS DEMONSTRATE A TREND: Because they are best used to illustrate change over time, fever charts provide journalists with an extremely effective way to show the degree of change within a set of data taken over a period of time. The emphasis should be on movement, and generally, little or no movement or extreme increases and decreases can be reported better as plain text. Fever charts are most effective in reporting more sporadic changes in data.

DISPLAY THE BEGINNING AND/OR ENDING TOTALS IF CHANGE IS THE NEWS: Again, the data metaphor (a line) is very effective in reporting a single trend. However, by marking the beginning and ending totals in a fever chart, you provide the audience with the context they need to better define the numerical data. And, in some cases, you may even find cause to accompany *every* point along the line with its numerical partner.

Tips for All Types of Graphics

There are some basic concepts and general rules that you can

Charges brought against U.S. Taliban

American John Walker Lindh faces charges of conspiring to kill American outside the United States and providing aid to terrorist groups. Some wonder how he ended up fighting alongside the Taliban. Below shows events leading up to Walker's arrest.

WALKER'S ASSOCIATION WITH ISLAM

1997
At age 16, Walker converts to Islam after reading The Autobiography of Malcolm X.

1999
Walker returns to U.S. He lives at home with his family for eight months and falls in with large Islamic group, the Tablighi Jamaat.

May 2001
Walker joins paramilitary Arabic-speaking al-Qaeda training camp to fight Kashmir on behalf of terrorist organization.

June 2001
Walker travels to Afghanistan to fight with the Taliban, undergoing seven-week terrorist training program.

January 2002
Walker is charged with conspiring to kill Americans outside the U.S. and with providing aid to terrorist groups.

December 1998
Walker travels to Yemen, enrolling in a language school to study Arabic. His goal is to learn the language so he can read the Koran in its original language. Walker stays in Yemen approximately 10 months.

February 2000
Walker returns to Yemen to resume study and travels with an Islamic missionary from the Tablighi Jamaat.

November 2000
Walker leaves Yemen for Pakistan to study at Islamic school. The school is reputed to provide thousands of soldiers for the Taliban.

November 2001
A CIA agent finds Walker in Qala-i-Jangi prison after Taliban group surrenders to Northern Alliance.

1997　1998　1999　2000　2001　**2002**

INVOLVEMENT IN AFGHANISTAN

1 **Kabul** - Walker joins holy war.

2 **Takhar** - Walker fights in front lines against Northern Alliance.

3 **Kunduz** - Walker surrenders to Northern Alliance.

4 **Mazar-e Sharif** - Walker is found in prison fortress by CIA.

CHINA
TAJIKISTAN
UZBEKISTAN
Shir Khan **3**
Kheyrabad •
Mazar- **4**　Konduz
e Sharif　Bagram **2**
KABUL **1**　• Jalalabad　INDIA
Towraghondi　• Ghazni
• Herat　AFGHANISTAN　PAKISTAN
Shindand　• Kandahar
TURKMENISTAN
IRAN　• Zaranj
0　15　300 mi

KEY PARTICIPANTS IN CASE

John Walker Lindh
American Taliban member; Charged with conspiring to kill Americans outside the U.S. and with providing aid to terrorist groups.

Frank Lindh
Walker's father; claims son was always "intellectually coherent." Lindh states, "None of that changed when he converted to Islam."

Marilyn Walker
Walker's mother; says son has always been nonviolent person. She says, "He would totally freeze. He's totally not streetwise."

James Brosnahan
Chief lawyer for Walker; contends Walker was denied access to a lawyer. He affirms, "He has the right under the Geneva Convention."

John Ashcroft
U.S. Attorney General; says Walker signed formal waiver of his right to an attorney and also verbally waived the same right.

Text-based graphics, such as a time line, often work in conjunction with other types of graphical displays, such as maps, charts or fact boxes. When planning a graphics package, think about ways to combine different types of graphics to enhance storytelling and create a richer reading or viewing experience for the audience.

Graphic by Jessica Fearnow.
Used with permission.

THE **FALL** OF ENRON

Before declaring bankruptcy, Enron was one of the world's largest energy commodities and services companies. Today, the company is slowly piecing together its remains. Below shows Enron's rapid decline.

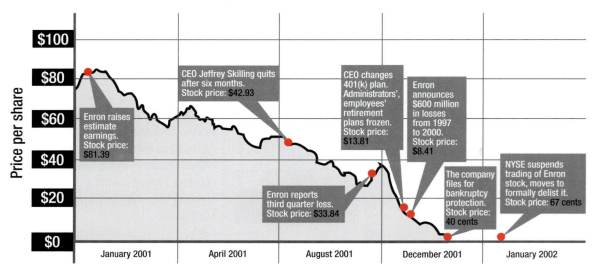

Price per share

$100	
$80	
$60	
$40	
$20	
$0	

Enron raises estimate earnings. Stock price: $81.39

CEO Jeffrey Skilling quits after six months. Stock price: $42.93

CEO changes 401(k) plan. Administrators', employees' retirement plans frozen. Stock price: $13.81

Enron announces $600 million in losses from 1997 to 2000. Stock price: $8.41

The company files for bankruptcy protection. Stock price: 40 cents

NYSE suspends trading of Enron stock, moves to formally delist it. Stock price: 67 cents

Enron reports third quarter loss. Stock price: $33.84

January 2001 April 2001 August 2001 December 2001 January 2002

Company History

1985
Houston Natural Gas and InterNorth merge to create Houston-based Enron.

1994
Enron begins marketing electricity. (Initially, it was a natural gas pipeline company.)

1995
The company enters European energy market.

1999
EnronOnline, a Web-based commodity trading site is launched, making it an e-commerce company.

2000
Enron reports revenues of $101 billion. It stakes in nearly 30,000 miles of gas pipeline, owns a 15,000-mile fiber optic network and has a stake in electricity-generating operations around the world.

Enron figure heads

Enron's former chairman and CEO Kenneth Lay resigned in January 2001, but remains on the company's board of directors. Lay was Enron's CEO from 1985 until Skilling's election in early 2001, and he returned as CEO after Skilling's August 2001 resignation.

KENNETH LAY

Enron's former president and CEO Jeffrey Skilling resigned six months after being named CEO, for "personal reasons" after more than a decade with the company.

JEFFREY SKILLING

> The best graphics attempt to hang as much information from a single visual element as possible. In this example, the graphics reporter combined key events in Enron's troubled history with the rapid decline of stock prices. The graphic is, at once, a time line and a fever chart.
>
> *Graphic by Josh Engleman.*
> *Used with permission.*

apply to all types of graphics in order to ensure that they are always clean, effective and easy to read. Overall, simple is almost always better. Adding too much design "flair," such as unnecessary color, expressive type displays or unstructured white space, is generally a waste of time and space and draws attention away from the most important part of the presentation: the data. Likewise, 3D effects often get in the way and can really distort and even render your graphic inaccurate. Content values draw readers and facilitate the comprehension process. "Chartoons," or graphics that complicate the data metaphor with cliché illustrations or cartoon-like decorations, often complicate and overshadow the data as well. An information graphic should relate to the reader and be able to stand alone. Thus, introductory chatter, numerical data, visual metaphors

and other explainers should all be self-explanatory and leave the audience feeling as though they have engaged in a complete reading experience. Finally, remember to approach all types of information graphics, whether they be simple charts or complex diagrams, with a great deal of care. As always, you should fully understand the data before attempting to display it to avoid choosing the wrong chart, presenting incomplete data or comparing apples to oranges.

In the Eyes of an Expert

What types of stories are best served by adding charts and text-based graphics?

Stories that contain information that can be compared or can show trends. Maybe a business story is written about an airport's boarding numbers being much higher in a particular year, so you could make a chart that compares that year to other years. Perhaps there is a story about how China stacks up to the United States, so you could do a text-based graphic that gives basic info about the two countries side by side.

As a graphics reporter, how often are you asked to develop charts and text-based graphics for your paper?

Almost daily. It's true that work as a graphics reporter doesn't mean that you constantly get to concentrate on rendering beautiful diagrams. Charts and text-based graphics are often needed to make information easier to understand for the audience. You don't want to see a paragraph in a story riddled with numbers and stats when you can put the numbers into some sort of chart that quickly illustrates why the numbers are important.

What are some common mistakes graphics reporters make when displaying numerical data in chart form?

You have to be really careful to not misrepresent the data by stretching or skewing the chart. If you enter numbers into your charting program and you aren't getting dramatic lines or differences, realize that maybe there's not as much there to show as you thought, and scrap it. Don't stretch the chart to make a difference look like it exists when it really doesn't.

ANGELA SMITH

Graphics Reporter,
The State Journal-Register

Angela Smith is a graphics reporter for The State Journal-Register in Springfield, Ill. There, she attends news meetings, watches daily budgets for graphics possibilities and executes both daily and long-term graphics. She joined the staff in January 2002. Prior to working at The State Journal-Register, she studied at Ball State University in Muncie, Ind., earning a Bachelor of Science degree in journalism graphics in 2001. She has received awards from the Illinois Press Association, Copley Ring of Truth Contest, Indiana Collegiate Press Association, Associated Collegiate Press and the Columbia Scholastic Press Association.

What are some common challenges graphics reporters encounter when creating simple charts and text-based graphics?

Editing the data down to what is really important can be a challenge when line after line of a huge spreadsheet is dropped on your desk. Talk with the story's reporter to make sure you know what is necessary. Also, news editors will come to you with a lot of data and say, "We have this list; can you make it look good?" Realize that there will be times that you can't just make something out of nothing.

Are there any significant design/stylistic considerations graphics reporters should be aware of when creating charts, tables and text-based graphics?

Make sure there are some style guidelines, and if there aren't, create some; then, stick with them! You don't want a chart in each day's newspaper that looks significantly different from one that ran the day before it. I even spend a small amount of my time stylizing AP and other wire services' graphics to match our newspaper's style.

List five tips for creating effective charts.

1. Put a headline and explainer text on each one, so that if the graphic happens to be the only thing the readers see, they know what the information means.
2. Double check the accuracy of your numbers. When making a pie chart, make sure that the sum of the wedges equals 100 percent.
3. Take care to watch the ratio between the height and width of bars in bar charts so the audience isn't misled. Keep a zero baseline with bar and line charts.
4. Follow your publication's style guidelines.
5. Don't forget to include the source of your data.

Chapter Seven Exercises

EXERCISE NO. ONE: TEXT-BASED GRAPHICS

Research, write and design a table that compares the key season statistics of two professional athletes. For example, choose two NBA forwards, and create a table that compares their field goal percentages, rebounds, turnovers, free throw percentages, etc., for the current sea-

son. Or, choose two NFL quarterbacks and create a table that compares their current season stats. You are encouraged to add photographs or team logos to enhance the visual appeal of your table.

Next, create a time line that chronicles the history of the political conflict between the United States and Iraq. Conduct all necessary research, edit it down, write 10 to 20 entries and create a design style for your time line. You are encouraged to include photographs or other visual devices.

Each of these text-based graphics should include a headline, introductory chatter, a byline and a source line. Develop your own style, typographic and color palettes for each as well.

EXERCISE NO. TWO: SIMPLE CHARTS

Evaluate the following sets of data to determine which type of chart — pie, fever or bar — would best display the information at hand. Then, create each chart using either Macromedia FreeHand or Adobe Illustrator. Each of these charts should include a headline, introductory chatter and byline. Develop your own style, typographic and color palettes for each as well. (Note: The most appropriate chart may not always be obvious. Analyze the data carefully.)

1. Air show attendance in U.S. soars, annual attendance in millions.
 1987, 14.1; 1988, 18.3; 1989, 22; 1990, 23.1

2. While the number of federal employees has increased, per capita federal employment has decreased.
 1966, 111; 1971, 105; 1976, 102; 1981, 96; 1986, 92; 1991, 91; 1992, 89

3. In the past 20 years, the levels of federal and state aid to families with dependent children have tripled.
 1975 state, $4.7 million; 1975 federal, $3.9 million; 1995 state, $12.7 million; 1995 federal, $10.5 million

4. Where the federal government gets its money:
 1.1%, estate tax; 1.5%, Federal Reserve deposits; 1.6%, Customs duties; 4.2%, excise taxes; 10.2%, corporation taxes; 37.1%, Social Security taxes; 44.2%, income taxes

5. Median age in United States at first marriage:
 Women: 1930, 21.3; 1940, 21.5; 1950, 20.3; 1960, 20.3;
 1970, 20.8; 1980, 24.1; 1990, 23.9
 Men: 1930, 24.3; 1940, 24.3; 1950, 22.8; 1960, 22.8;
 1970, 23.2; 1980, 24.7; 1990, 26.1

6. Top five states in seat belt use:
 Arizona, 73%; Oregon, 72%; Virginia, 72%; California, 70%;
 North Carolina, 68%

EIGHT

Taking the "Numb" Out of Numbers: Statistical Displays

Some of the most frequently published kinds of information graphics attempt to simplify complicated information by presenting it in a form that the average person will understand. Specifically, graphics reporters are often called upon to decipher large and complex sets of numerical data related to stories about the economy, census reports, financial statements, polls, surveys, scientific research and other types of statistical findings. I once worked with a reporter who responded to all questions related to numbers with the same statement: "I am a journalist, not a mathematician, dammit!" However, if you really want to be a graphics reporter you should shun this sentiment immediately and learn to embrace your role as occasional mathematician in the newsroom.

Granted, no one will expect you to be a mathematical genius. However, it will be important for you to understand and be capable of assessing the news value in statistical data to report it in a way that your audience will find enlightening and easy to understand. And, perhaps the most daunting fact of all is that once the information is published, your audience will rarely question its validity until a clear and obvious mistake has been made. In other words, if you have added, subtracted or otherwise "figured" incorrectly, your audience may notice the error. However, if your mistake lies in the *presentation* of the data, your audience is unlikely to notice, and you will be guilty of a great deal of negligence in reporting.

This means you'll need to have a basic understanding of some very specific types of statistical data and some common mathematical equations, as well as

ANALYZING YOUR DATA

When encountering a set of statistical data, you may want to keep the following questions in mind to make sure you are approaching it with a critical eye. The more you are able to assess the data for its news value and accuracy, the better you can serve your audience.

Who is reporting/collecting the data? Is bias present?

What is the size of the sample group?

Are percentages backed up with raw totals?

What is the time period over which data was collected?

Is the manner in which the values are represented appropriate?

Is time or place a factor?

Are there other external variables that could skew the data?

What methodology was used to collect the data?

how to best report that information in a graphic. Knowing the functions of different types of charts, as outlined in the previous chapter, for example, is the first step in effectively assessing the information at hand and determining the most accurate and effective way to present it. Likewise, being able to decipher statistical data and make sense of it yourself is essential to your ability to simplify the information accurately and sensibly for your audience. Being up to speed with some basic equations most common to the types of information you'll likely encounter will also ensure that you are capable of making calculations that are relevant to your story. Finally, knowing how to spot problems with the raw numbers you have been given, as well as knowing some of the more common tactics people may take when attempting to "massage" the numbers to fit their own agendas, will help you make sure your reporting is honest, fair and accurate.

Spotting Problems with Statistics

Perhaps the most important concept you can take away from this chapter is that an effective graphics reporter must lend a critical eye to every set of numbers she encounters. You should *never* take the data at face value, assume it is correct or fail to scrutinize the numbers to make sure they are relevant, accurate and realistically reported within the context of a specific news story. Believe it or not, it's pretty easy to make numbers lie. In fact, depending on how the data is framed, anyone can easily create a context for a data set that serves a specific purpose or agenda without actually fabricating any of the real numbers. But, this doesn't mean that trying to detect and rectify these problems is a hopeless cause. Just being aware of some ways in which data can be misrepresented can protect you from exacerbating the problem.

MAKE SURE YOUR SOURCES ARE CREDIBLE: If a company wants to hide the fact that it's failing financially, it can create an annual report that only reports *some* of the figures, compares incongruent data or misrepresents the data by failing to explain how the figures were actually realized. Thus, when reviewing this information for a chart that will run with a news story about the company, the graph-

ics reporter must really scrutinize the data, looking for any suspicious statements, comparisons or figures. It may even be a good idea to do some additional reporting to make sure that the numbers you have been given are, indeed, accurate. If you notice any questionable citations or missing numbers, for example, don't be afraid to call someone and ask why this is so. And, if the missing data can't be accounted for, then you generally have two options. The first is that you can choose *not* to run a graphic because you can't lay your hands on a complete and therefore accurate set of numbers. The second is to figure out the best way to present the numbers you *do* have while making it clear to the audience that the data isn't exactly complete and why this is the case. The worst thing you can do is simply present the data as it was offered to you, without making an attempt to remedy the problem.

MAKE SURE YOU'RE COMPARING APPLES TO APPLES, ORANGES TO ORANGES: For example, if you want to make it seem as though the price of a particular item has skyrocketed over a period of time, you can do so by failing to account for *inflation*. For example, have you ever rolled your eyes when grandma and grandpa said things like, "When I was a child, a candy bar only cost a nickel!" Although this statement is fundamentally true, the comparison that is so shockingly implied by your elders isn't exactly accurate because it doesn't account for inflation. Inflation is an increase in the price of goods and services that are representative of the economy as a whole. Depending on the state of the economy *and* the value of the dollar, inflation can account for major increases and decreases in the value of things over time. Houses cost more than they used to, minimum wage increases every few years and the cost of all kinds of goods and services will continue to inflate over time, as long as the economy continues to evolve. Thus, although a candy bar did cost mere pennies several decades ago, this raw value can't be compared to the cost of a candy bar today. The only way to make an accurate comparison is to report the inflation-adjusted amounts. Do this by consulting the Bureau of Labor Statistic's inflation calculator (http://www.bls.gov) or by calculating adjusted prices using the Consumer Price Index divisors (http://www.bls.gov/cpi/home.htm) for the specific years you are dealing with. Note that once prices

REFERENCE MATERIALS

It is strongly recommended that students interested in pursuing careers in graphics reporting find a Statistics 101 class to provide a strong foundation for understanding these types of graphic displays. Here are a few additional references for you to consult that will help you collect and evaluate statistical data:

Precision Journalism: A Reporter's Introduction to Social Science Methods. By Phillip Meyer. Fourth Edition, May 2002.

Introduction to the Practice of Statistics. By David S. Moore & George McCabe. Fourth Edition, August 2002.

The Psychology of Survey Response. By Roger Tourangeau, Lance J. Rips and Kenneth Rasinski. March 2000.

Improving Survey Questions: Design and Evaluation. By Floyd J. Fowler, Jr. July 1995.

have been adjusted for inflation, the rate of increase in price becomes much less dramatic.

BE CAREFUL NOT TO MASK RAW NUMBERS BY CONVERTING THEM TO MORE AMBIGUOUS FIGURES: If a researcher wants to make his findings seem more impactful than they really are, he can turn raw numbers into percentages or misrepresent the margin of error so that it's not exactly apparent what the raw findings actually were. For example, 20 percent of 200 is 40, while 20 percent of 200,000 is 4,000. Big difference, right? The larger the sample, the more accurate the survey. Yet, if I only report percentages, my audience may never know the raw totals, and the credibility and accuracy of my report could be in question. Likewise, failing to identify projected figures versus real data or failing to use a consistent scale in charting data may change the implications of the data you are presenting and mislead the audience into believing them to be more or less dramatic than they actually are.

CONSIDER ALL POSSIBLE VARIABLES THAT COULD AFFECT THE DATA: Ask yourself: "Is time or place a factor?" If so, "What is the time period? Is it one day? One month? One year?" If a study attempts to report data gathered over a period of time, the span of time over which the data was actually collected could dramatically affect the credibility of the report. And when data is collected in a number of different places, a graphics reporter must wonder, "Does location become a variable that could skew the data?" In fact, if data is gathered over many years or places, a constant needs to be achieved. When necessary, try to separate yourself from the data, and look for ways in which the report may be tainted by less obvious circumstances. Regardless of whether this has been done intentionally or unintentionally, your efforts in this regard can make a huge difference in terms of the accuracy of a set of data.

Establishing Validity in Polls & Surveys

Polls and surveys can be tricky and must be administered with a well-planned *methodology* as well as a *scientific* approach to the collection and reporting of data in order to be correct and credible.

Methodology refers to a body of practices, procedures and rules used by those who work in a discipline or engage in inquiry. In other words, your methodology is the system you employ to collect and analyze data. This system must be consistent, eliminate as many unnecessary variables as possible, be conducted using tried and true methods for data collection and include an acceptable sample size. In short, developing a sound method for data collection will help you cover your bases and avoid poorly worded or loaded questions or exaggerated or incomplete data, to name a few.

As a graphics reporter, you will encounter poll and survey results on two different levels. On one hand, you may be called upon to help develop a survey and disseminate the results. Newspapers, for example, often poll readers during elections to gauge readers' opinions about the candidates. If this is the case, it is important that you familiarize yourself with sound research methodology and polling and survey techniques in order to ensure that you don't make mistakes that will affect the validity of the results. On the other hand, you may also be given data that has been collected by an outside source and be asked to develop a graphics package to report it. Companies and other types of organizations conduct all types of surveys to gauge the general public's feelings about any number of topics. If this is the case, it is extremely important that you obtain and report the actual survey questions so that you can provide the appropriate context for the data you present. Likewise, be skeptical as you examine the data. Questions that could be interpreted a number of ways or answers that are ambiguous or less specific could be viewed as inconclusive or less meaningful. Regardless of the way in which the data comes to you, it is important that you understand some of the more complex ways poll or survey results can be improperly represented in the context of a news story.

EXAMINE HOW QUESTIONS ARE PHRASED IN A POLL: Tainted, skewed or loaded questions may elicit predicted or misguided responses. For example, if a poll is intended to gauge how people feel about crime in their neighborhoods, even a seemingly simple question, such as, "Do you feel safe?" may not really yield a valid result. In fact, there are a number of extenuating variables, such as an individual's definition of "safe" or his or her past experiences with crime that

COMMON MATHEMATICAL EQUATIONS

Simple interest: Multiply original balance by interest rate; multiply that number as a decimal by number of years.

Example:
$4,000 x .056 (5.6% interest rate) = 224
224 x 5 years = $1,120

Probability: Divide one by the number of equal possibilities; move decimal once to the right for "chance in 10"; twice to right for "chance in 100."

Example:
Heads or Tails = 1/2 = .5
Chance in Ten = 5
Chance in 100 = 50

MARGIN OF ERROR

Depending on the survey or poll you are dealing with, the margin of error will differ depending on the relationship between the sample size and the size of the greater population. Thus, the formula for figuring the margin of error involves three basic parts: the amount of variability within the sample, the degree of precision and the sample size. You can apply this formula for figuring margin of error:

$$\sqrt{\frac{(p)(1-p)}{n}} \times 1.96$$

= Margin of Error

p is an estimate of the percentage of respondents.

A "standard" level of precision is a 95 percent confidence level. This translates into 1.96 for this formula.

n is the number of respondents.

So, if an estimated 50 percent of the greater population answered a particular question in a survey, and 90 out of 100 people surveyed actually completed the survey, a 10 percent margin of error is figured as such:

$$\sqrt{\frac{.50}{90}} \times 1.96$$

= Margin of Error

www.westgroupresearch.com/research/margin.html

may skew the response in a way that doesn't truly reflect your intentions for the question.

CONSIDER HOW THE SURVEY OR POLL WAS ADMINISTERED: How were respondents chosen? Just going through a phone book, for example, and randomly choosing names doesn't make for a *random sample*. A random sample occurs when every element in the population has an equal chance to be selected for the survey or poll. It isn't easy to draw a random sample because the only factor operating when a given item is selected must be chance.

You must also ask when and where the questions were asked. Was every respondent approached in the same way, in the same surroundings at the same time? While these questions may not always be relevant, you should determine whether they affect the outcome or responses. Finally, be aware that certain types of survey methods may actually affect who responds. For example, when conducting phone surveys, you must contend with the notion that some respondents may not be home or may automatically hang up the moment you identify yourself as someone conducting a poll. Likewise, surveys conducted via mail or e-mail often require that the respondent take action by filling out the survey and mailing it back in. Often, respondents in these types of surveys tend to lean toward extremes in their answers. One school of thought insists that only those who have strong feelings about the topic at hand will be motivated enough to actually respond.

CONSIDER WHO WAS POLLED: Depending on the pool from which potential participants for a poll or survey are chosen, it is possible that whole categories of your greater population could be left out. For example, if you are conducting a phone survey, you are eliminating the possibility of contacting people who aren't likely to be listed. College students are one whole category of individuals who may not be represented there. Also, calling at certain times during the day may skew who or what types of people will be around to actually answer the phone.

ESTABLISH OR KNOW THE MARGIN OF ERROR: Understand that whenever you break down data into subgroups – by race, gender, age, etc.

– the margin of error increases. Margin of error is simply a measure of how precise the data are. The margin of error is necessary because you'll never see a survey that actually polls the *entire* population on a particular subject. Because random samples are used to *represent* the general population, the margin of error reflects the variation that may occur in multiple executions of the same survey. For example, suppose a report reflects that 50 percent of the population surveyed says they have visited the local art museum within the past three months, and a margin of error of plus or minus five percent is recorded. This means that realistically, if the *entire* population were actually polled, the percentage would fall somewhere between 45 and 55 percent. Thus, the 50 percent finding is the average of the two, representing the most accurate way to report the data. The smaller the margin of error, the more accurate the results of the survey.

Obviously, determining whether a survey or poll is trustworthy is a tricky task. It really means weighing a number of different aspects of the survey, including the margin of error, the sample size, the number of surveys actually completed, the methodology, the interviewing procedure and the size of the general population the survey or poll is meant to represent. The best polls are those conducted by professional pollsters, such as Gallup or the American Association for Public Opinion Research (AAPOR), because these agencies generally adhere to extremely high standards and tried-and-true statistical methods for gathering their data. If, however, you obtain your data from another type of organization or business or on your own, just make sure you scrutinize every aspect of your research to ensure effective and credible results.

In the Eyes of an Expert
What are the best methods for collecting/reporting statistical data?

I'm not sure that there is one best method. The graphics reporter needs to find and develop relationships with reliable sources. Questions about how the data was gathered, what is the source's reporting methodology, or how long has the source been gathering this sort of data may be relevant to determining

KRIS GOODFELLOW

ESRI

Kris Goodfellow is a media industry manager and journalism liaison for ESRI, the world leader in geographic information system (GIS) software and technology. She consults with news organizations across the country on how to best use GIS technology and has spoken at a number of workshops and conferences on the power of GIS software. Prior to joining ESRI, she was the director of graphics at The Associated Press, and before that, the graphics editor at The New York Times and a graphics coordinator at The Chicago Tribune. She founded and taught the graphics class at Columbia University's graduate school of journalism, and in 2002, she was a judge for the Society for News Design's World's Best Design competition.

WHAT IS A SCIENTIFIC SAMPLE?

The AAPOR Standards Committee writes, "Polls and surveys are an important means for us to learn about people's attitudes, behaviors, and characteristics.... But all surveys are not equal in quality. Polls and surveys conducted by flawed methods are often described as 'not scientific.' A Scientific Sample Survey or Poll will have these characteristics:

It samples members of the defined population in a way such that each member has a known nonzero probability of selection....

It collects data from a sufficient number of sampled units in the population ... (for example, + or - 5%) at a stated level of confidence (e.g., 95%).

It uses reasonable tested methods to reduce and account for unit and item nonresponse error (differences between characteristics of respondents and nonrespondents)....

It uses reasonable tested methods to reduce and account for errors of measurement that may arise from question wording, the order of questions and categories, the behavior of interviewers and of respondents, data entry and the mode of administration of the survey."

if the source is reliable and unbiased. The reporting maxim, "when in doubt, check it out" applies not only to the source but to the data provided.

How should a graphics reporter determine how a set of statistical data is best displayed?

The best graphics grow out of an understanding of the story, the data and the statistical charting options. If you don't know how or why to use a graphic form, you'll fall back on the same old thing again and again. Graphic journalists need to invest in their own understanding of their profession, seeking to know its history as well as current inspiring work. This curiosity will serve you well.

What are some of the greatest challenges or pitfalls graphic journalists face when dealing with statistical data?

The greatest challenge is when you don't have all of the data because there is no complete source. While a reporter can write around gaps in statistical data, a graphic journalist should not. It's far better to tell a reporter that the data does not exist or is unreliable than to take suspect, incomplete or inaccurate numbers.

What are some of the more common mistakes graphics reporters make when developing statistical data displays?

Unnecessary complexity. Simplicity is a key to displaying statistical data. When a graphic looks simple and clear, it is usually because someone has done the hard work to understand and show something complex. When graphic journalists pass that complexity on to the reader, they have missed an opportunity to help aid in understanding.

What are some ways to ensure that you're not missing important details in your statistical graphics?

Be careful and detail oriented. Show it to people in the newsroom who have the time to pay attention, or run it by a statistician.

What should an effective data display add to a story?

Understanding and clarity.

What's the most extensive research you have ever done for a statistical graphic?

The most intensive gathering of statistical data project was working with CBS News on the election mapping for 2003. We spent months gathering statistics for dozens of different data maps. Many, many maps were thrown out because the data just didn't make a strong, instantly understandable point to viewers in a matter of seconds. Clarity was of the utmost importance in this project, and that was a great challenge to someone used to working in print. In print, we assume that people will spend a couple of minutes with the graphic. But in the broadcast format, I was constantly reminded that in today's world, people don't spend much time with things that they don't understand.

Please list five tips for dealing with statistical data in journalistic research and reporting.

1. Compare data to some norm or average. For instance, when charting a stock price, it is useful to see that stock charted against an index of its peers so as to see how its performance relates.

2. Use all of the tools of the graphic journalists to make the point of the graphic clear. Color choice, layout, headline, labeling, classification schema, data charted and, most importantly, the choice of statistical chart should all contribute to making that point clear to readers.

3. Get more data and know that you don't have to use it all. Reporters may only need a couple of telling statistics to tell a good story. However, a good graphic usually needs far, far more detail. Don't be afraid to gather that information yourself or to work with the reporter to get it. You might need to develop good sources to do this. The reporter might rely on a press secretary who will give a great quote, but the graphics reporter may be able to get the data needed from a librarian in the back office.

4. Ask until you understand. When you assume, you can make a big mistake, hurt your credibility and embarrass the newspaper. It's so much better to be humble to a source or a reporter and get it right before it gets into the paper.

5. Strive to make the complex, simple and clear.

INFLATION

Report the adjusted or constant figure, never the current or nominal figure.

Create a multiplier for each year's data to inflate to the present year using the Consumer Price Index (CPI information comes from U.S. Bureau of Labor Statistics; http://stats.bls.gov).

Example:
Your town's annual budget

Unadjusted figures:
1985 = $32,504,333
1990 = $47,010,100

1985 CPI/all items
= 107.6
1990 CPI/all items
= 130.7

Divide the current year's CPI by past year's CPI.

Example: 130.7/107.6
= 1.214684

Multiply the quotient (or multiplier) by past year's dollar amount.

Example: 1.214684 x 32,504,333
= $39,482,493

Adjusted figures:

1985 = $39,482,493

1990 = $47,010,100

Chapter Eight Exercise

Find out how much a cup of coffee and a candy bar cost in 1950, 1960, 1970, 1980, 1990 and 2000. When you have obtained their actual costs for those years, use the Bureau of Labor Statistics inflation calculator to determine the adjusted prices. Finally, using one graphic for each item, plot fever charts for both the actual dollars and the constant dollars. The line for actual dollars should be black. The line for constant dollars should be red. Typeset a headline, chatter, callouts, a byline and a credit line. Develop your own type and design styles for the charts.

Diagrams & Illustrative Graphics

Often the most complex and illustration-driven types of information graphics, diagrammatical graphics combine substantial amounts of textual information with detailed illustrations to dissect the important parts of objects or chronicle a chain of events. Diagrams require strong textual *and* visual reference materials, and graphics reporters may spend a good deal of time away from their desks conducting research for these types of storytelling devices. And, because they are generally illustration-driven, diagrams often require a bit more artistic ability on the part of the graphics reporter than other types of graphics. All in all, diagrams provide journalists with an opportunity to take the audience where cameras or reporters can't. They allow us to show how something happened, the process by which something occurs or the inner workings of both animate and inanimate objects.

Types of Diagrams

Diagrams can be divided into two basic categories, *passive* and *active*. In a *passive diagram*, there is no implied action or movement beyond the rhythm and natural eye flow that is created through the placement of elements within the graphic design. Passive diagrams generally show an object with its "parts" accurately labeled, are often considered to be "simple diagrams" and may include cutaway, angled or multiple views of a particular object. Passive diagrams are used to dissect an object, providing the audience with simple labeling

Passive diagrams like this one generally label and explain different parts of an object. Numbers, letters or other types of labeling devices can be used to help the audience navigate the information.

Graphic by Miranda Mulligan. Used with permission.

Winter automotive checklist

Winter usually brings driving snow, blistering wind and treacherous ice. Advance preparation and planning for the winter driving season can make the difference between a minor inconvenience and a potentially dangerous situation. Use this checklist for your automotive preparations this winter.

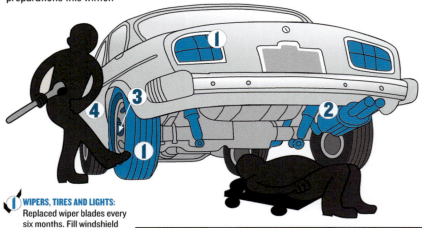

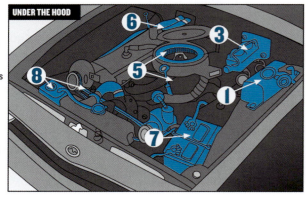

UNDER THE HOOD

1 WIPERS, TIRES AND LIGHTS: Replaced wiper blades every six months. Fill windshield washer fluid consistently. It should have a low freezing point. Inspect tires for wear and properly inflate according to manufacturer recommendations. Before hitting the road, ensure lights and signals are operational.

2 UNDER THE CAR: Lubricate the steerage linkage according to the owner's manual. Inspect the exhaust system for leaks that may affect the engine performance and allow deadly fumes into the car.

3 BRAKING SYSTEM: Check brake fluid level. If your car's brakes squeal or pull the vehicle to one side when applied, or if pedals feel soft when pumped, have the brake system inspected.

4 DOORS AND LOCKS: All parts on the vehicle's door should be working and properly lubricated. If door locks freeze, use commercially available lock de-icers, never use hot water. Other methods for opening frozen locks include aiming a hair dryer at the frozen lock or heating a key with a lighter or match.

5 ENGINE: Check your vehicle's oil and filter every fill-up and the air filter every two months. Check fuel filters for clogs or leaks. Inspect the ignition system, including spark plugs and wires, distributor, emission system components and the fuel-injections system.

6 TRANSMISSION: Check the transmission fluid level often. Add fluid and change the filter if needed. On rear-wheel drive cars, check the level of fluid in the rear differential.

7 BATTERY: Have the battery load tested for weakness. Be sure all contacts are clean and cables are secure.

8 COOLING SYSTEM: Check antifreeze/coolant level weekly. Check the level of radiator fluid. The freezing point should test to at least 35 degrees below zero. If necessary, add a 50/50 mixture of antifreeze and water; water reduces the corrosive nature of antifreeze. Check all hoses; they should not be excessively soft or brittle. Flush the cooling system every other year.

devices or detailed information about the functions of each part of an object. Although a passive diagram may attempt to explain *how* something works or happens in text form, it won't attempt to actually illustrate that action.

On the other hand, *active diagrams* include implied or real motion or movement, in addition to passive labeling to illustrate the action of a process or event. Thus, an effective active diagram should, at once, dissect an object or event, labeling its parts, and attempt to illustrate actual or implied movement. So, while a passive diagram of the human heart would likely just label and perhaps explain the chambers and arteries of the heart, an active diagram of the heart might attempt to actually illustrate how blood flows through the heart.

The media format selected for the graphic – print, online or broadcast – will also determine the illustration method for the action. For example, in print, the active heart diagram might use arrows to illustrate the motion of blood flow. On the Web or in a news broadcast, motion or action should be animated so the action of the graphic could unfold in real time, more like a video. Regardless, it is important to note that all diagrams have passive qualities, because in every case there will be some need to label static parts of the graphic. However, only active diagrams are capable of reenacting an event or process.

Organizing the Content

Diagrams tend to be more complex, both illustratively and informationally, than other types of graphics. Thus, the way elements are organized or designed in relation to one another in a diagrammatical display can make or break the final product. Consult Chapter Five, "Designing Information Graphics," for more detailed organization and design techniques. But in a nutshell, information must be arranged in a logical, easy-to-follow fashion. Consider natural eye flow (i.e., left to right, top to bottom), chronology and the logical pattern your audience will attempt to follow when interacting with the graphic to determine the best way to organize the information in a graphic presentation. And, note that the very worst thing you can do when creating a diagram or explanatory graphic is

Say What?

Concern for auditory health among students is rising as exposure to damaging levels among youth has tripled, from 6.7 percent in the early 1980s to 18.8 percent today. Below shows the function of the auditory mechanism and the impact of loud sounds.

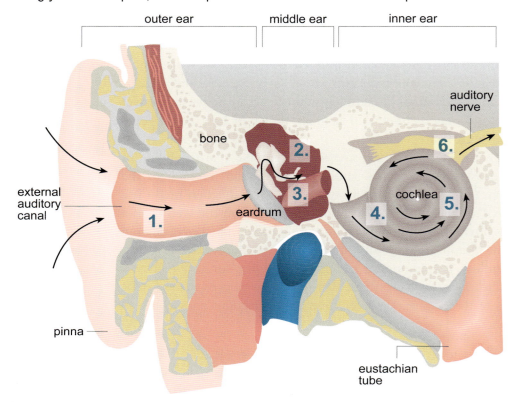

1. Sound enters through outer ear as vibration and reaches middle ear, where it vibrates the eardrum.

2. Vibrations are transmitted through three tiny bones in middle ear, called the ossicles. These bones include the hammer, anvil and stirrup.

3. The stirrup transmits amplified vibrations into the fluid that fills inner ear.

4. Vibrations move through fluid in the cochlea, which contains hair cells.

5. The fluid in cochlea moves hair cells, which bring about nerve impulses.

6. Nerve impulses are carried to the brain to be interpreted as sound. Different sounds move hair cells in different ways, allowing the brain to hear different sounds.

▲ Active diagrams generally explain a process or event in conjunction with an illustration. Arrows, letters or numbers often help show the sequencing of an action through the implication of a chronology or motion. *Graphic by Jessica Fearnow. Used with permission.*

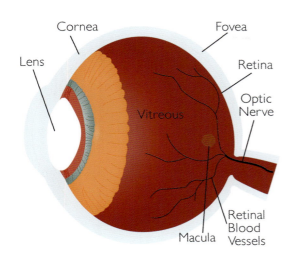

Cutaways are an effective method for taking the audience where a photograph cannot. In this case, the audience is able to see a cross section of the human eye.

Labels on diagram: Cornea, Fovea, Lens, Retina, Optic Nerve, Vitreous, Retinal Blood Vessels, Macula

to muddle the pieces in a way that causes the audience to become confused or that makes the information difficult to follow.

Also, you can never remind yourself enough that as a graphics reporter, your job is to simplify complicated information. Because diagrams can often be the most complex types of graphics you will develop, this concept is especially important to these types of displays. In an article in the Society for News Design's *Design* magazine titled, "Why Function Always Trumps Format," explanation graphics guru Nigel Holmes writes, "It seems to me that for editors, sometimes the point is to dress up the page with some color, to make a splash (or) to give the graphics department their go in the paper. None of these are good reasons. But they are hard to resist. Who doesn't want a nice big colorful graphic to put in their portfolio? … But to my mind, in this business of information design, more often simpler is better." In other words, *simple* often ensures that the point of your graphic won't be lost among the bells and whistles your artistic skills have unnecessarily added to the presentation. Let the content speak for itself by avoiding the urge to dress it up.

Just as you should edit the "map fat" from your work when developing maps for journalistic presentations, so should you edit the less important visual information from illustrative portions of your diagrams. Of course, you shouldn't eliminate anything that might jeopardize the accuracy of the visual information at hand. However, don't feel obligated to include so much detail in your illus-

Skeleton returns to Olympics after 53 years

Men's skeleton joins the Olympic Winter Games in Salt Lake City for the first time since 1948. The sport has been included in the games only twice before in 1928 and 1948. Women's skeleton is making its Olympic debut. Below shows equipment used during Skeleton competitions.

SPECIFICATIONS
The maximum weight of sled and driver, including equipment, is 253 pounds for men and 202.4 pounds for women.

HISTORY
Skeleton is considered the world's first sliding sport. Started in the Swiss town of St. Moritz in the late 1800s, the first competition was held in 1884. Riders raced down the road from St. Moritz to Celerina, where the winner received a bottle of champagne. It wasn't until 1887 that riders began competing in the head-first, facedown position used today. The sport was named in 1892, when a sled, made mostly of metal and looked like a skeleton, was introduced. In 1923, the Federation Internationale de Bobsleigh et de Tobogganing was founded. Three years later, skeleton was declared an Olympic sport.

STARTING
For the first run, starting order is based on a draw. The second run order is based on times from the first run.

AWARDS
Of the six medals awarded in the Skeleton in past Olympics, the United States has won three.

COMPETITORS
Each nation may enter a maximum of three athletes in the men's competition and two in the women's. Competitors must turn at least 18 years old during the Olympic year.

HELMET
At times, a slider's speed is so great, his or her chin is forced against the track, making a chin guard required. Helmets also have shatterproof visors to protect the driver's face and eyes from chips of ice.

CLOTHING
Tight fitting aerodynamic speed suits are worn during Skeleton competitions. Sliders often wear shoulder, elbow, hip and knee pads for additional protection, but they are not required.

SHOES
A maximum of eight spikes are allowed on the base of the shoes. The spikes can be no longer than seven millimeters long. The sled is often steered by dragging one toe or the other on the track.

SLED
A Skeleton sled is made up of runners; a steel frame to hold the runners together; an aerodynamic fiberglass cowling that covers the chassis; the saddle, which holds the competitor's torso; and bumpers to protect the slider when the edge of the track is hit.

GLOVES
Protection is needed for the hands if the competitor scrapes against the walls of the track.

HANDLES
The slider rides stomach-down between the two handles.

RUNNERS
Runners must be made of solid steel. No plating coating, waxing or warming is allowed. They must be within four degrees of the reference runner, which is exposed to open air for one hour before the competition.

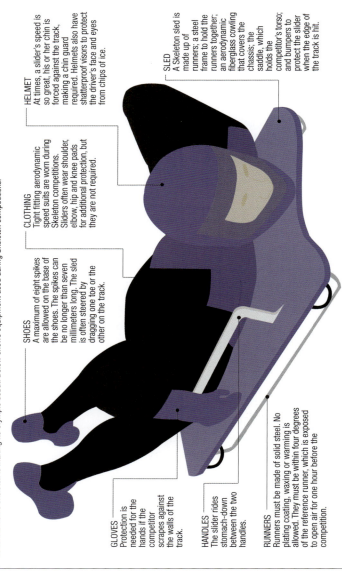

Slides down the icy track can reach speeds of 80 mph

The race is started by an audio and visual signal. The athlete then has 30 seconds to start his or her run. The sled may be pushed, but any other help in acceleration is prohibited. During the race, the competitor can only ride lying on his or her stomach, but can leave the sled in order to push or move it. Devices to assist steering or breaking are not allowed. The finish line must be crossed on the sled. Below shows a typical Skeleton start.

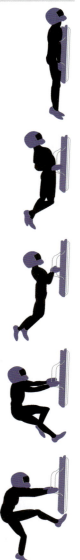

Often, information graphics posess both active and passive qualities. In this graphic, the dominant image displays the labels and definitions relevent to the story, and the secondary images work together to explain action related to the story.

Graphic by Erin Hein. Used with permission.

tration that the visual complexities outweigh the focus of the graphics package.

Illustration Techniques

Obviously, the stronger your artistic skills, the better illustrator you will be. Because diagrammatical graphics tend to be very illustration-driven, these can often require more raw artistic talent than others. Thus, I always encourage graphic journalists to consider taking drawing, painting or color theory courses to help beef up their illustration skills. But don't be fooled. Even the most detailed diagrams are generally based on solid visual reference material, and graphics reporters often develop their own sketches based on these materials to form the foundation for their own graphics. Thus, finding strong reference material is often the first step in developing effective, accurate illustrations. Reference materials for diagrams and explanatory graphics could include diagrams or illustrations that have already been developed by someone else, photographs from the actual scene or maps. Then, after you have found a reliable, accurate visual reference, you can develop your own version. As long as you cite the source in your source line, this method is a perfectly acceptable form of reporting.

As you begin the tracing process, you'll soon notice that even the most complex objects are, in essence, a combination of a number of simple shapes. Break down the object you are illustrating into the smallest squares, rectangles, circles, ovals and triangles that comprise it, and you will soon have the outline for your illustration. And, once the outline is complete, you can begin to add depth and dimension by applying shading, color and texture.

LAYERING COLORS AND SHADES OF COLOR is one of the more common ways illustrations come to life. This technique adds depth and dimension to your graphic by creating a sense of contrast and detail much like that of an oil painting. Layering often requires a great deal of patience, and is best used when the goal is to illustrate a more complex object with a greater degree of detail.

GRADIENTS are also used to create a sense of texture and detail in an illustration. Software programs, such as Macromedia FreeHand and Adobe Illustrator, include gradient tools that allow you to control the intensity, angle and shape of a gradient so that you can create as realistic a sense of texture as possible. Gradients are often easier to apply, and can help create a great deal of depth in a short period of time. Thus, gradient tools can be a lifesaver to graphics reporters working on deadline.

TEXTURE TOOLS can also be helpful when you are trying to develop a graphic quickly or when you simply want to emulate a specific type of texture in your graphic. Illustration software programs also include texture tools that provide you with a quick and easy way to apply common textures, such as gravel, denim or sand. These textures can be applied by simply filling the shape you have created with a pre-illustrated swatch found in the texture or fill palette.

Finally, it is important to note that the *illustration style* you choose for your diagram can often make or break the sense of credibility and accuracy that is attached to it. In other words, the style really must fit the nature and tone of the content in order for your graphic to seem appropriate and believable. Cartoons – simple out-

line that applies bold, bright colors – should be reserved for less serious topics or graphics that illustrate fake scenarios. Sketches (hand-drawn pictures) are often effectively used to illustrate fake scenarios or more feature-oriented topics. Graphics that employ layered colors, gradients and photographs (i.e., more texturally detailed illustrations) are best used in news presentations because they appear to be more visually realistic and thorough. And, while it is true that many graphics reporters may eventually develop a style they are either known for or tend to employ more often, you should never come to rely on a particular illustration style too often because information graphics meant for use in journalistic presentations should *always* be content-driven, and *always* reflect the tone and storytelling mission of the news.

In the Eyes of an Expert

How do diagrams/explanatory graphics enhance storytelling?

By giving the reader/user a clear picture or an actual visualization of the event or process.

What are some common challenges to creating effective diagrams/explanatory graphics?

1. Not having enough hard, credible, factually correct information by deadline.
2. An over-reliance on a particular graphic style or software, even when it's inappropriate (see below, 3D).
3. Lack of cooperation or understanding within the publication about the intent of the graphic. It's hard to do a good explanation if someone up the chain of command thinks of your work as making the page look good, but nothing else (such as informing the readers!).

What are your thoughts about the evolution of interactive graphics and the affects of multimedia technology on graphics reporting?

On the Web, you can easily update and make corrections, so we should be careful not to rush to publish without full consideration of the facts, just because we can change things later. But being able to add movement and sound is wonderful; they make storytelling easier and richer.

NIGEL HOLMES

Explanation Graphics

Holmes was graphics director for Time magazine for 16 years before taking a sabbatical. For ten years, he has run his own business, Explanation Graphics, which explains all manner of things to and for a wide variety of clients including Apple, The Smithsonian Institution, United Healthcare, U.S. Airways, Discover, Harper's, The New Yorker and The New York Times. He's written four books on aspects of information design, and also a series of small books, The Smallest Ever Guides for Busy People, which explain difficult concepts in layman's terms. The latest is for GM called The Smallest Ever Guide to the Hydrogen Economy. His new book, Wordless Diagrams, was published in April 2005. He's lectured all over the world, and with his son, Rowland, he produces short animated films. They are currently working on a film about a new system of electronic health communication.

Because of the transient nature of the Web, the relative permanence of print journalism means that it should concentrate on clarification, a precise alignment of words and pictures and on leading the reader down a path of understanding that does not veer off in irrelevant directions.

How has 3D software affected graphic storytelling?

On storytelling, badly!

On cutaways of buildings and things like that, better. The overuse and inappropriate treatment of 3D has given it a bad name in some graphic circles, but in time, it will become just another tool to be used only when it's really necessary, not as a default stylistic tic.

Aside from the obvious changes in technology, in what significant ways has graphics reporting evolved over the years?

As better work is done, editors and readers realize that graphics can contribute to information on an equal footing with text. Writers are realizing that graphics can explain some things better than their verbal descriptions do, and they are more willing to "give up" some of their valuable text in the interests of getting the story across in the best way.

Who do you consult for inspiration? Who does it well?

The *New York Times* is currently doing the best information graphics in the world. They are on the top of their form and consistently do the right thing, whether it is for a small one-column chart or a blockbuster spread. They are constantly inventing or rediscovering ways to represent numbers and are not afraid to experiment. They have won the trust of the editors who give them lots of room to work in.

Apart from the *Times*, I'm always going back to Otto Neurath and Gerd Arntz and their pioneering work in Europe in the 1920s and 1930s. They are the real forerunners of much of the work we do today, so it's always nice to check in and see that it's all been done before!

Please list five tips for creating effective diagrams/explanatory graphics.

1. Research first, then write, then draw.
2. Clarify, don't simplify.
3. Restrict color.
4. Put things in context.
5. Show your work to colleagues for comment.

Your graphics begin on paper. Can you explain how this traditional approach fits into the world of computers and illustration programs?

Everything still starts on paper, and usually in a smallish notebook/sketchbook. All my very first drawn ideas and written notes are in these books, which I have kept carefully over many years and often refer back to. There are many as yet uncompleted projects in them as well as day-to-day sketches and roughs for current jobs.

When I have a workable idea for a particular job, I'll usually draw it out again larger; probably go through two or three more versions using tracing paper, until it's pretty tight, and then scan it. Then I use the computer to construct the drawing in exactly the same way I used to use French curves and templates to create lines when I did not have a computer. I never use the computer's auto tracing feature.

I started using FreeHand at *Time* and still do. I use no other computer programs (except Word, for writing), and I'm probably only using about 10 percent of the potential of FreeHand, but that's all I need. It keeps the finished work simple. I'm not against computers – they enabled me to leave the corporate world and work by myself – but they are dreadfully misused, to my mind, in information graphics today. I think the computer should be used to take stuff out of an information graphic, rather than loading it up with special effects.

You are widely respected for your work with pictograms. How important is the pictogram in information graphics?

A couple of years ago I wrote a piece on pictograms for the *Information Design Journal*, and it made me think about symbols again. I had written a book (*Designing Pictorial Symbols*, 1985), but that was largely about icons I'd drawn for *Time*. Here I realized that one way we make information graphics is by using little pictograms as building blocks for entire illustrations. We each create our own personal visual language – little bits that we recycle again and again. And as long as it is our own language, it's fine to recycle; in fact it defines our style.

I'm on the fence about everyone adopting one universal visual symbol language, because that suggests that we would all use the same icons (like an alphabet), and while I want people all over the world to understand what I have drawn, I'm not yet ready to give up personal style for a committee-accepted set of pictograms. I hope one day to do some work in the field of completely wordless diagrams, especially if it is for a cause such as helping those in third-world countries who are unable to read.

What do you think are the most important fundamental rules for our business?

I hate rules! They put straightjackets around freedom of expression. However, I guess I do have some personal rules of my own. The first is that the best way to explain things is always the simplest way.

Keeping things simple and clear does not mean dumbing down information, nor does it mean making it look boring and austere. That is why art is important. I mean art in the service of information, not art for art's sake. Sometimes art might mean just beautiful simplicity. At other times it might mean wit, or humor, or fun. My fundamental mantra is enjoyable clarity.

One thing that often seems wrong with information graphics is the use of too much color. These days, I like to start a job with very little color and only add it when the information demands

it. Of course, many editors and art directors still think of information graphics as a sort of colorful decoration for their pages. While the arguments are obvious to me, nothing I say seems to convince them. The rule is: Only use color when it's needed (and get your arguments lined up!).

What are questions every information graphics designer should ask?

What's the point of the graphic I am doing?

What information does the reader/user need to know?

I think many graphics are too big. Perhaps we designers should ask for less space when that's all we need. So ask this question: What is really the best size for this graphic?

NOTE: The last four questions and answers are excerpted from an interview by John Grimwade, Graphics Director of Condé Nast Traveler, and first published with a retrospective look at Holmes' work in the Malofiej Information Graphics Summit Book, 2004. Used with permission.

Chapter Nine Exercises

EXERCISE NO. ONE: PASSIVE DIAGRAM

Research and illustrate a graphic that diagrams the human heart. You'll need to find good visual and textual reference material for your graphic so that you can develop an accurate illustration of the heart, as well as label its most significant parts and explain how they work.

Use Macromedia FreeHand or Adobe Illustrator to create your graphic, and develop your own typographic, style and color palettes. The graphic should be approximately five inches wide. The depth is up to you. Your graphic should include a headline, chatter, labels, explainers, a source line and byline.

EXERCISE NO. TWO: ACTIVE DIAGRAM

After your passive diagram is complete, modify it so that it also shows how blood flows through the human heart. You can use arrows, numbers or any other illustrative technique to imply movement. Use the same typographic, style and color palettes as you did in the first exercise. Your graphic should include a headline, chatter, labels, explainers, a source line and byline.

EXERCISE NO. THREE: ANIMATED DIAGRAM

After you have completed the first two exercises, consider how the passive and active portions of the heart graphic might unfold if it were developed for the Web or broadcast. Sketch storyboards for your animated diagram. Then, use Macromedia Flash to produce the animations. Use the same typographic, style and color palettes as you did in the first two exercises. Your graphic should include a headline, chatter, labels, explainers, a source line and byline.

APPENDIX A

APPENDIX A: FREEHAND WORKSHOP

INSTRUCTIONS BASED ON FREEHAND MX

The following exercise will teach you to create basic charts in Macromedia FreeHand. The appearance of certain functions may differ depending upon whether you are using a MacIntosh or a PC. However, the general operations of the program are the same regardless of the platform on which you are working.

To begin, create a folder on the desktop of your computer, and label it with your name.

Launch the FreeHand program. **FILE** a **NEW** document.

Command the **PAGE RULERS** from the **VIEW** menu. Reset your ruler measurements found at the bottom of your document, from points to picas.

 In the upper, left-hand corner of your document, find the zero guide.
Reset the zero guide to the top left-hand corner of the page by clicking and dragging the crossbars to line up with the top and left-hand edges of the page on your document.

Go to **WINDOWS** and command the **OBJECT** menu. Use the object palette to draw a box. Make the box 15 picas wide and 21 picas deep. Make the line .6 in width. Create a one-pica margin for the box.

Save the document as "pie chart."

Pull down **WINDOW**, **TOOLBARS**, and access the **XTRA TOOLS** palette. Select the charting tool, and click on the FreeHand document. A spreadsheet window should appear.

Plot the following in a spreadsheet. These numbers represent the course topics in a basic design class.

Integrated Editing	4 (days)
Typography	5 (days)
Graphics	6 (days)

Command the **COLOR MIXER** and the **SWATCHES** panels from the **WINDOW** menu. Create these colors:

Jade:	C 80	M 20	Y 90	K 0
Mist:	C 30	M 10	Y 0	K 10
Salmon:	C 0	M 45	Y 55	K 10
Teal:	C 90	M 20	Y 30	K 0

Ungroup the pie from the text, then group only the wedges of the pie together. Make the lines of the pie .6 points, black. Color the respective wedges. Integrated Editing: Teal; Typography: Jade; Graphics: Salmon.

Move the pie to its position within the margins of the frame. Size the grouped pie while holding down the shift key. Select the frame for the graphic.

Fill the background of the graphic with a linear gradient from 30% to 60% Mist.

Place the chart in its position inside the frame. Reduce and reset the text boxes for the callouts of the chart.

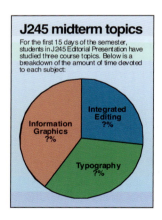

Make the type 10 pt. Helvetica Bold centered. Place each callout on its respective wedge. Be sure to bring the callouts to the front (Modify/Arrange/Bring to Front). Typeset the headline for the graphic in 18 pt. Helvetica Bold. Typeset the explainer for the graphic in 8 pt. Helvetica plain, flush left. Typeset the source line and byline in 8 pt. Helvetica Plain. Place all text blocks in their respective positions.

Save and close this document. Export the document as an eps file if you wish to place it into a design program.

Create a new FreeHand document. Plot the following information for a horizontal bar chart that demonstrates the leading men's basketball scorers in Ball State history.

Bonzi Wells	2,485 (points)
Ray McCallum	2,109 (points)
Larry Bullington	1,747 (points)
Derrick Wesley	1,729 (points)
Jim Regenold	1,685 (points)

NOTE: DO NOT USE COMMAS IN NUMBERS WHEN TYPING THEM INTO THE SPREAD SHEET.

Choose the bar chart style from the chart gallery. Set column width for bars at 60. Click OK.

Click the chart gallery button. Click the pie chart button. Set these parameters for a pie chart:
Legend: None; Separation: 0; Data numbers in chart

Draw a box that is 25 picas wide and 17 picas deep. Create a one-pica margin for the box.

Ungroup the bar chart. Delete all lines, ticks and numerals from the graphic,
keeping only the bars and the names.

Command the **COLOR MIXER** and the **SWATCHES** from the **WINDOW** menu. Create these colors:

Almond:	C 0	M 10	Y 35	K 12
Midnight:	C 70	M 10	Y 0	K 20

Select the bars of the graph and specify no line. Color the bars with Midnight.
Group the bars together. Rotate the bar chart to make it horizontal.

Size down the bars, and place on the box.
Ungroup the bars and space them vertically in their respective
positions marked on the layout. Group each bar one at a time, and make each bar 1p5 picas high (thick).
Reposition the bars.

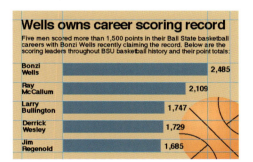

Group all four bars together. Stretch the bars to the right to
the 21.6 ruler without holding the shift key.

Select the frame for the graphic. Fill the background for the
box of the graphic with Almond. The outer box should have
no line.

Command the **LAYERS** from **WINDOW**. Move the Guides in
front of Foreground layer

Reduce and reset the text boxes for the names of each bar. Make the type 9 pt. Helvetica Bold flush left.
Move each name into its position. Be sure to bring the names to the front (Modify/Arrange/Bring to Front).
Typeset the point totals for each bar in 10 pt. Helvetica Bold. Typeset the headline for the graphic in 18 pt.
Helvetica Bold with -3 kerning. Typeset the explainer for the graphic in 9 pt. Helvetica Plain, flush left,
kerning -1, leading +0. Typeset the source line and byline in 8 pt. Helvetica Plain. Place each in its position.

Draw an 8-pica by 8-pica circle with no fill and .6 black lines.
Duplicate the circle two times. Deselect all circles.

Create the color Orange:
C 0 M 60 Y 100 K 0

Fill in one circle with Orange.

Using the **TINTS** area of the **COLOR MIXER**,
radial graduate the circle from Orange

Position the "hot spot" in the circle. Select no line for the colored circle.

Move the duplicate circles into position over the orange circle. Select them both. Then select **EDIT, CUT** and **PASTE INSIDE**.

Position the second duplicate circle. Select **EDIT, CUT** and **PASTE INSIDE**.

Draw the black .6 diagonal lines, and position them to complete the ball. Select **EDIT, CUT** and **PASTE INSIDE**.

Place the basketball artwork in its position on the graphic. Select **EDIT, CUT** and **PASTE INSIDE**.

Export the graphic to your folder on the desktop.

Quit the FreeHand program.

NOTE: This tutorial was authored by Michael Price when he was the journalism graphics sequence coordinator at Ball State University.

GLOSSARY

GLOSSARY

ACTIONSCRIPT: An object-oriented programming language that can facilitate the creation of animated and interactive information graphics because it is an event-based language.

ACTIVE GRAPHICS: Maps or diagrams that contain real or implied motion through the use of animation or visual elements, i.e., arrows or numbers, that imply movement.

ACTIVE VOICE: Occurs when sentences are written using only active verbs, avoiding "verbs of being," such as is, was, am, are, were, etc.

ADDITIVE COLOR: Each hue of the color spectrum has a specific frequency. When combined, additive colors create white light. Red, green and blue (RGB) are the additive colors in the color spectrum and are used to create color on computer monitors and television screens.

ADJUSTED FIGURE: The price of an item adjusted for inflation.

ASYMMETRICAL BALANCE: An informal design composition in which the two vertical halves of a graphic are unequal in balance.

AUDIENCE: Print media readers, television viewers or Web users are all potential audience members for information graphics presentations.

AVERAGE/MEAN: A value computed by dividing the sum of a set of numbers by the number of numbers.

BALANCE: A basic design principle, balance is achieved when the placement or relative proportion of elements in a graphic play against one another to create a display that is not too heavy on either side, top or bottom. There are two types of balance in graphic design, asymmetrical and symmetrical.

BAR CHART: A graphic that uses rectangular bars in varying lengths to represent comparisons of amounts.

BASE MAP: A map used for reference in graphic design.

CALLOUTS: Detailed text blocks within a graphic that point to and explain a specific visual element within the larger package.

CARTESIAN GRID: A system of plotting points on a graph made of intersecting lines, called "coordinates" developed by René Descartes.

CARTOGRAPHY: The making of maps.

CHARTOON: A chart in which the data metaphor (i.e., bar, pie or line) in some way incorporates a cartoonish illustration approach to decorate or embellish the body of the graphic.

CHATTER: Explanatory text used to introduce a graphic.

CHOROPLETH: A map that is divided into sections that correspond to different categories related to the raw data. Each category is then colorized to represent a specific value set.

CMYK: The "process colors," different values of cyan, magenta, yellow and black are mixed together to create every possible color. Process color is used to create full color in print.

COMMUNICATIONS DESIGN: Graphic design for publications which, at the same time, attempt to maintain a high level of aesthetic value and convey information through the process of visual storytelling.

CONSTANT FIGURE: The numeric value that represents the price of a good or service adjusted over time to account for inflation.

CONSUMER PRICE INDEX (CPI): Published every month by the U.S. Department of Labor, the CPI is a key measure of inflation that relates to the rise in prices over a period of time. Using the CPI, one can calculate the change in cost of buying a fixed basket of goods and services.

CONTRAST: A basic design principle, contrast refers to the act of creating visual difference between elements in graphic design. Contrast is most commonly achieved through shape, tone, type and size.

CONVERGENCE: Partnerships between and among various types of media organizations, such as newspapers, Web sites and broadcast news stations.

DATA-INK RATIO: The philosophy that effective graphics give the viewer the greatest number of ideas in the shortest time with the least amount of ink in the smallest amount of space.

DATA METAPHOR: A visual element used to represent key information, such as numbers or values, in a graphic. Common data metaphors include circles to represent a breakdown of whole amounts, bars to represent comparisons of figures and lines to represent change over time. Colors and symbols can also be data metaphors.

DOMINANT ELEMENT: The largest element in a design. All graphics must have a dominant element proportionate to the other elements in a graphic as well as the overall space allotted for the graphic.

DOT DISTRIBUTION: A map that uses different sized dots to represent amounts. The dots are distributed over the map to correspond with locations.

DUAL CODING THEORY (DCT): Memory consists of two separate but interrelated codes for processing information – one verbal and one visual. By integrating illustrations with text or elaborating on illustrations with explanations, the brain will encode information in both verbal and nonverbal forms, and memory is likely to be enhanced.

EDITORIAL CONTENT: All content in a news presentation that is related to news stories.

EXPLAINER: A block of text that points to and explains the significance of a specific portion of a graphic.

EXPLORATIVE: A single online graphics package that includes multiple illustrations, audio and video clips, photo slide shows, etc., that allow the audience a chance to explore the various parts of a single topic.

EYE-TRAC: Research that examined how readers navigate a newspaper and what elements are most salient. Readers tended to engage with more photos and artwork than text and headlines, indicating that visual elements act as main points of entry onto a page.

FAIR USE: A doctrine where partial or limited reproduction of another's work may be permitted where the use advances public interests such as education or scholarship.

FEVER CHART: A graphic that makes use of a line to demonstrate change over time.

FOCAL POINT: Visual elements used in graphic design, such as photos, graphics, illustrations and type, that draw the eye.

FOCUS: A basic design principle that refers to creating emphasis and visual interest within a graphic.

GEOLOGICAL MAPS: Maps that are used to show the Earth's formations, such as fault lines, surface characteristics of a land mass or mountains, valleys and bodies of water.

GRAPHICS REPORTER: A journalist who's job is to report, write and illustrate information graphics as storytelling devices.

GRID: Evenly spaced lines that are used to help graphics reporters ensure that elements are properly aligned and evenly spaced within a graphics package. These lines don't print and can be horizontal and vertical.

HARMONY: A basic design principle, harmony refers to how well the individual elements within a graphic presentation work together.

HIERARCHY: A series of ordered groupings among elements in a graphic presentation. Hierarchical groupings can be by size or shape.

HIEROGLYPHIC: A character in a system of picture writing.

INFLATION: An increase in the volume of money and credit resulting in a substantial and continuing rise in the general price level of goods and services in a specific economic setting.

INFORMAL SOURCE: Observations about audiences, messages and the environment in which the communicator operates, as well as networks of supervisors, colleagues, clients, neighbors, and friends the communicator deals with every day.

INFORMATION GRAPHICS: Visual displays capable of illustrating a story or a portion of a story in a visual manner. Diagrams, maps, charts and tables are all examples of information graphics.

INSET: Map or diagram elements that show either a zoomed-out or zoomed-in view of an area or object to either provide greater context or more detail.

INSTITUTIONAL SOURCE: Social or cultural organizations with particular special interests, political positions, professional goals or governmental roles.

INTERACTIVITY: A feature of online graphics, interactivity refers to the notion that the audience can make choices about the pace and order in which he navigates a graphic presentation.

INVERTED PYRAMID: A traditional news writing style in which the writer orders the information written into a story from most to least important and timely. The same concept can be applied to the construction of information graphics.

ISOLENE: A mapping style that displays data in relation to land by correlating points of similar value. This type of map shows similarities in bands or blocks of value.

JOURNALISTIC SOURCE: Newspapers, magazines, trade publications, television and news and information Web sites.

KINETOSCOPE: The first motion picture camera, the kinetoscope is the foundation for the modern-day film industry.

LAND USE: Maps that show communities and individuals use land, as well as how chunks of land are zoned.

LEGEND: A definition of the representational symbols used in a graphic; a key.

LINEAR: An organization of content that forces the audience to encounter it in a "beginning to end" fashion.

LINOTYPE MACHINE: A typesetting machine that produces castings, each of which corresponds to a line of separate types. By pressing down on keys like those of a typewriter, the matrices for one line are properly arranged.

LOCATOR: A map that shows a place in relation to its surroundings in an "x-marks-the-spot" fashion.

MAP FAT: Information found in a base map that is unnecessary for the audience's reasonable understanding of the story at hand.

MEAN/AVERAGE: A value computed by dividing the sum of a set of numbers by the number of numbers.

MEDIAN: The middlevalue in an ordered set of values for which there are an equal number of values.

METHODOLOGY: A body of rules followed in a science of discipline.

MULTIMEDIA: A display or story package that makes use of a variety of media formats, i.e., text, video, audio, etc.

MULTIPLIER: A number by which another number is multiplied.

NARRATIVE: A graphic that explains by giving the audience a vicarious experience of the intent through a story. A narrative involves very little interactivity and provides a relatively passive viewing experience.

NATURAL EYE MOVEMENT: In Western culture, the natural path of the eye is left to right, top to bottom.

NON-LINEAR: An organization of content that allows the audience to encounter it in no prescribed order.

PASSIVE GRAPHICS: Maps or diagrams that contain no real or implied motion. Elements are simply explained and labeled.

PERCENTAGE: Part of a whole expressed in hundredths.

PERCENTAGE INCREASE/DECREASE: The amount of increase or decrease in a figure expressed in percentages as opposed to real amounts.

PIE CHART: A graphic that makes use of a circle broken into sections to demonstrate parts of a whole.

POINTER BOX: A graphic element that contains explanatory text and points to a particular part of a graphic display.

POLLSTER: Someone who collects data through polling.

PROPORTION: A basic design principle referring to size and shape relationships among graphic elements.

RANDOM SAMPLE: A random sample occurs when every element in the population has an equal chance of being selected for the survey or poll. The only factor operating when a given item is selected must be chance.

RASTER: Digital images created or captured (for example, by scanning a photo) as a set of samples of a given space. A raster is a grid of x and y coordinates on a display space.

READABILITY: The ease with which something can be read based on the clarity of grammar or clarity of illustration.

RELIEF: Also called a topographic map, relief maps show the physical features and surface characteristics of a landmass, or the "lay of the land."

RGB: Red, green and blue are known as the "additive colors."

RHYTHM: A basic design principle, rhythm refers to the ability of a design to move the eye through contrast, size and shape relationships, and placement of elements.

SANS SERIF: A type with little to no differentiation between thick and thin strokes and no design embellishments. Sans serifs are best used in information graphics because they are clean and easy to read when used with detailed illustrations.

SCALE: The size of a sample in relation to the size of the actual thing. Scales are always necessary in maps and sometimes in diagrams.

SCHOLARLY SOURCE: Sources, such as academic institutions or medical and scientific research centers, that exist to expand the body of knowledge about related topics.

SEARCH ENGINE: A Web site that helps users find other sites focused on specific topics.

SERIF: A type with curved or finishing strokes at the ends of each straight line in a letterform.

SIDEBAR: A secondary story or storytelling device that supports the main story topically.

SIMULATIVE: A highly immersive online graphic that enables the user to actually experience the topic by representing some kind of real-word phenomena.

SOURCE LINE: An essential graphic component that cites the source(s) of information displayed in a graphic.

STATISTICAL MAP: Maps that associate numerical data with specified areas of land.

STORYBOARDS: Preliminary sketches developed for online and broadcast graphics. Storyboards show each frame of a graphic in an animated display.

SUBTRACTIVE COLOR: The color we see on paper is created using a subtractive model in which the frequencies that are not absorbed by the object form the color we see.

SYMMETRICAL BALANCE: A formal design composition in which the two vertical halves of a graphic are equal in balance.

TOPOGRAPHIC MAP: Also called a relief map, topographic maps show the physical features and surface characteristics of a landmass, or the "lay of the land."

UNITY: A basic design principle, unity refers to how well elements designed for an entire publication or palette work together.

VECTOR GRAPHICS: A sequence of commands or mathematical statements that place lines and shapes in a given two- or three-dimensional space.

VISUAL CENTER: A space slightly above and to the left of real center in a given space.

VOICE-OVER: An audio clip that serves an explanatory role when combined with video or graphic animation.

INDEX

INDEX